Sister Wendy's Bible Treasury

Sister Wendy's Bible Treasury

Stories and wisdom through
the eyes of the world's great painters

SISTER WENDY BECKETT

ORBIS BOOKS
Maryknoll, New York 10545

Founded in 1970, Orbis Books endeavors to publish works that enlighten the mind, nourish the spirit, and challenge the conscience. The publishing arm of Maryknoll Fathers and Brothers, Orbis seeks to explore the global dimensions of the Christian faith and mission, to invite dialogue with diverse cultures and religious traditions, and to serve the cause of reconciliation and peace. The books published reflect the views of their authors and do not represent the official position of the Maryknoll Society. To learn more about Maryknoll and Orbis Books, please visit our website at www.maryknollsociety.org.

First published in Great Britain in 2012 by

Society for Promoting Christian Knowledge
36 Causton Street
London SW1P 4ST

First published in the United States of America in 2012 by
Orbis Books, Maryknoll, NY 10545

Typeset by Caroline Waldron, Wirral, Cheshire
Printed in Great Britain by Ashford Colour Press
Subsequently digitally printed in Great Britain

Produced on paper from sustainable forests

Library of Congress Cataloging-in-Publication Data

Beckett, Wendy.
 Sister Wendy's Bible treasury : stories and wisdom through the eyes
of great painters / Sister Wendy Beckett.
 pages cm
 Includes bibliographical references.
 ISBN 978–1–57075–972–7
 1. Bible--Illustrations. 2. Painting--Appreciation. I. Title.
 ND1430.B375 2012
 755'.4--dc23
 2012000386

Contents

LIST OF ILLUSTRATIONS

INTRODUCTION

When I was a child, I used to think the word 'bible' meant 'book': THE Book, the Good Book, God's Holy Book of Revelation. But now my knowledge of Greek, pitiably small though it is, informs me better. 'Bible' means 'books'; it is a plural word, a recognition of the fact that there are 40 books in the Old Testament (plus six that were written too late to make the Jewish Scriptures, the Apocryphal Books) and there are 27 in the New Testament. These books are immensely diverse. If the New Testament is relatively homogeneous (Gospels, Acts, Letters, Book of Revelation), the Old Testament ranges through all the varieties of literary genre, as well as encompassing hundreds of years. Everything in the New Testament was written, probably, in the first century; it is likely that the Old Testament ranges from almost 1000 BC to the coming of Christ. So not only do the books of the Old Testament arise from very different times and contexts, but they encompass an extraordinary diversity of style and manner. The first five books, the Pentateuch, were the most sacred to the Jewish people. Known as the Torah, it gave sublime expression to what is called the 'Law'. Then the other 35 books are divided into the Prophets – many prophets, the earlier and the later, the major and the minor – the histories, and the catch-all phrase 'the writings', which include poetry and theology and moral teaching. I think everyone should read through the entire Bible at least once, and know the extraordinary experience of moving from arid regulations, necessary for the moral survival of the early Hebrews, to the soaring religious poetry of the great Prophets or the erotic intensity of a sublime poem such as the Song of Songs. Because it is such a long and diverse book, containing material from so many past centuries, the Old Testament does not give off its spiritual fragrance too easily. Hence this abbreviation, which singles out passages of great beauty and meaning to which all who seek for God cannot but respond. This book, though, is really meant as a taster to entice you to read more deeply into the entire Bible.

Because there are so many books in the Bible, it has been called a 'library', but I think this is a misnomer. The contents of both Testaments may be diverse, but they have a single theme. Every word in the Bible is a word of revelation. Every story, however amusing or – as often happens in the Old Testament – shocking or at least surprising, is not a story to be enjoyed for its own sake. It is there for a purpose. It will reveal something of the nature of God, his plans for us and the way they are fulfilled. The divisions of the Bible, Old and New Testaments, are based upon God's covenant with his creatures. 'Covenant', which means solemn promise, is shorthand for

the obligation God expresses to care for his people and bring them to their fulfilment. Over the centuries – we are talking of the Old Testament – the nature of this promise became more and more evident. It could not be put into the explicitness of words, because it was so utterly extraordinary. God would fulfil his promise by becoming man himself, by dying for us and drawing us with him into his resurrection. This is what the New Testament is all about, the extraordinary culmination of the Old Testament covenant. The Jewish people, listening over the centuries to the teachings of the Scriptures, finally offered God a woman so pure that within her womb he could become incarnate. And in that same turbulent first century, the Jewish people could offer God men who understood his revelation, such as the Twelve Apostles, the four Gospel writers (especially St John) and St Paul. Such profound insight into the divine mysteries could only come from a culture that had striven to be close to God for long and painful periods. In no other nation could Mary have been born. In no other nation could the letters of St Paul have been written, or the Gospels in their luminous simplicity.

We can hear God's word in the strictly spiritual passages of the Bible, but one of its most important messages is that he also speaks through material and secular events. The history of the Israelites, with all their ups and downs, tragedies and triumphs, is God revealing how he guides and shapes the lives of all of us. Nothing is pointless. Everything can be used, and should be used. All that we need to teach us about happiness is within this one sacred book.

In prayer and in the sacraments, God comes very close to us, but he does not speak in words. The words we will hear – and they must be interpreted within the prayer of the Church – are here in the Bible. We cannot truly hear unless we pray. St John of the Cross tells us:

> 'One Word spake the Father, that Word was His Son,
> This Word He speaks ever in silence eternal.'

May looking at these paintings draw us deeper into the silence of that Word.

To all who desire the sincere milk of the word, that they may grow thereby
(1 Peter 2.2)

PART 1

Stories and Wisdom
from the
OLD TESTAMENT

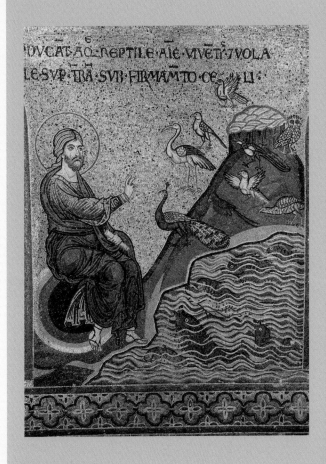

1. In the beginning

The stories in the Book of Genesis come from the profundities of the Jewish imagination, but they are not, strictly, 'Jewish' stories. Before the Bible narrows down to God's dealings with his chosen people, the Jews, it tells us of the beginnings from which every nation and the world itself have arisen. This is our beginning whether we are British or American or Chinese or Nigerian or Brazilian. Many nations have their own creation story, but this is the story as God revealed it. Clearly, it is a 'story' not a history, still less a scientific treatise. Although we know all the details (this is certainly the best known portion of the Bible), it is not the elements of the stories that matter, but their significance. God created out of his own pure goodness; his only motive was to share what he was. So we hear of the wonders of that six day creation and the beauties of the Garden of Eden. Then bitter reality strikes home. We creatures are unwilling to accept what God is so eager to give, and so we have the Fall followed with sinister speed by one brother murdering another. Yet God's involvement continues. The Flood, which other nations also wrote about though with a different emphasis, is intended to be a purifying flood. The writer of Genesis (or maybe 'writers', because there are many styles at work here) does not delude himself; he is ruefully aware that the 'purification' is only partial, and we come to the anger and violence of the Tower of Babel.

The creation of the world

In the beginning God created the heaven and the earth. And the earth was without form, and void; and darkness was upon the face of the deep. And the Spirit of God moved upon the face of the waters.

And God said, Let there be light: and there was light. And God saw the light, that it was good: and God divided the light from the darkness. And God called the light Day, and the darkness he called Night. And the evening and the morning were the first day.

And God said, Let there be a firmament in the midst of the waters, and let it divide the waters from the waters. And God made the firmament, and divided the waters which were under the firmament from the waters which were above the firmament: and it was so. And God called the firmament Heaven. And the evening

and the morning were the second day. And God said, Let the waters under the heaven be gathered together unto one place, and let the dry land appear: and it was so. And God called the dry land Earth; and the gathering together of the waters called he Seas: and God saw that it was good. And God said, Let the earth bring forth grass, the herb yielding seed, and the fruit tree yielding fruit after his kind, whose seed is in itself, upon the earth: and it was so. And God saw that it was good. And the evening and the morning were the third day.

And God said, Let there be lights in the firmament of the heaven to divide the day from the night; and let them be for signs, and for seasons, and for days, and years: and let them be for lights in the firmament of the heaven to give light upon the earth: and it was so. And God saw that it was good. And the evening and the morning were the fourth day.

And God said, Let the waters bring forth abundantly the moving creature that hath life, and fowl that may fly above the earth in the open firmament of heaven. And God created great whales, and every living creature that moveth, which the waters brought forth abundantly, after their kind,

and every winged fowl after his kind: and God saw that it was good. And the evening and the morning were the fifth day. And God said, Let the earth bring forth the living creature after his kind, cattle, and creeping thing, and beast of the earth after his kind: and it was so. And God saw that it was good. And God said,

> Let us make man in our image, after our likeness: and let them have dominion over the fish of the sea, and over the fowl of the air, and over the cattle, and over all the earth, and over every creeping thing that creepeth upon the earth.

So God created man in his own image, in the image of God created he him; male and female created he them. And God blessed them, and God said unto them,

> Be fruitful, and multiply, and replenish the earth, and subdue it: and have dominion over the fish of the sea, and over the fowl of the air, and over every living thing that moveth upon the earth.

And God saw every thing that he had made, and, behold, it was very good. And the evening and the morning were the sixth day.

Thus the heavens and the earth were finished, and all the host of them. And on the seventh day God ended his work which he had made; and he rested on the seventh day from all his work which he had made.

FROM THE BOOK OF GENESIS, CHAPTERS 1—2

THE GARDEN OF EDEN

In the day that the LORD God made the earth and the heavens, the LORD God formed man of the dust of the ground, and breathed into his nostrils the breath of life; and man became a living soul. And the LORD God planted a garden eastward in Eden; and out of the ground made the LORD God to grow every tree that is pleasant to the sight, and good for food; the tree of life also in the midst of the garden, and the tree of knowledge of good and evil. And the LORD God took the man, and put him into the garden of Eden to dress it and to keep it. And the LORD God commanded the man, saying, Of every tree of the garden thou mayest freely eat: But of the tree of the knowledge of good and evil, thou shalt not eat of it: for in the day that thou eatest thereof thou shalt surely die.

God the Father Measuring the Universe, from *The Bible Moralisée (c.1220).*

Obviously, no artist can truly picture God. Our imaginations cannot comprehend him, no concept can encompass him. This is a medieval illustration of God creating the world. The artist wants to show us how small the world is, and yet with what care God fashions it. That majestic and beautiful face is wholly concentrated on making the world as good as it can possibly be. The sweet anachronism of the architect's compasses is a symbol of the divine care and earnestness. This picture seems to show the creation halfway completed. God has separated the waters from the dry land, and hung in the sky the two great lights of sun and moon, and countless stars. Many early people adored the celestial bodies, but for the writer of Genesis they are merely functional. God himself is supremely ordered, a beautiful God in the artist's imagination. He is slowly and carefully fashioning a beautiful world. And yet the artist acknowledges that this work on which God lavishes such intense interest is essentially something very small; his feet stray outside the framework of the painting, as if he has stepped into a circumscribed space simply to perform this act of spontaneous love.

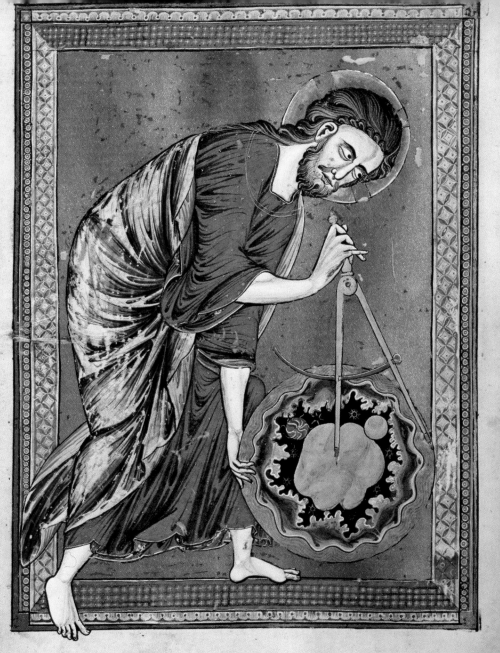

Iv

And the Lord God said, It is not good that the man should be alone; I will make him an help meet for him. And out of the ground the Lord God formed every beast of the field, and every fowl of the air; and brought them unto Adam to see what he would call them: and whatsoever Adam called every living creature, that was the name thereof; but for Adam there was not found an help meet for him.

And the Lord God caused a deep sleep to fall upon Adam and he slept: and he took one of his ribs, and closed up the flesh instead thereof; and the rib, which the Lord God had taken from man, made he a woman, and brought her unto the man. And Adam said,

> This is now bone of my bones,
> and flesh of my flesh:
> she shall be called Woman,
> because she was taken out of Man.

Therefore shall a man leave his father and his mother, and shall cleave unto his wife: and they shall be one flesh. And they were both naked, the man and his wife, and were not ashamed.

From the Book of Genesis, chapter 2

The Fall

Now the serpent was more subtil than any beast of the field which the Lord God had made. And he said unto the woman, Yea, hath God said, Ye shall not eat of every tree of the garden? And the woman said unto the serpent, We may eat of the fruit of the trees of the garden: but of the fruit of the tree which is in the midst of the garden, God hath said, Ye shall not eat of it, neither shall ye touch it, lest ye die.

And the serpent said unto the woman, Ye shall not surely die: for God doth know that in the day ye eat thereof, then your eyes shall be opened, and ye shall be as gods, knowing good and evil. And when the woman saw that the tree was good for food, and that it was pleasant to the eyes, and a tree to be desired to make one wise, she took of the fruit thereof, and did eat, and gave also unto her husband with her; and he did eat.

And the eyes of them both were opened, and they knew that they were naked; and they sewed fig leaves together, and made themselves aprons. And they heard the voice of the Lord God walking in the garden in the cool of the day: and Adam and his wife hid themselves from the

presence of the LORD God amongst the trees of the garden.

And the LORD God called unto Adam, and said unto him, Where art thou? And he said, I heard thy voice in the garden, and I was afraid, because I was naked; and I hid myself. And he said, Who told thee that thou wast naked? Hast thou eaten of the tree, whereof I commanded thee that thou shouldest not eat?

And the man said, The woman whom thou gavest to be with me, she gave me of the tree, and I did eat. And the LORD God said unto the woman, What is this that thou hast done? And the woman said, The serpent beguiled me, and I did eat.

And the LORD God said unto the serpent,

> Because thou hast done this, thou art cursed above all cattle, and above every beast of the field; upon thy belly shalt thou go, and dust shalt thou eat all the days of thy life.

Unto the woman he said,

> I will greatly multiply thy sorrow and thy conception; in sorrow thou shalt bring forth children; and thy desire shall be to thy husband, and he shall rule over thee.

And unto Adam he said,

> Cursed is the ground for thy sake; in sorrow shalt thou eat of it all the days of thy life; thorns also and thistles shall it bring forth to thee; and thou shalt eat the herb of the field; in the sweat of thy face shalt thou eat bread, till thou return unto the ground; for out of it wast thou taken: for dust thou art, and unto dust shalt thou return.

And Adam called his wife's name Eve; because she was the mother of all living.

Unto Adam also and to his wife did the LORD God make coats of skins, and clothed them. And the LORD God said, Behold, the man is become as one of us, to know good and evil: and now, lest he put forth his hand, and take also of the tree of life, and eat, and live for ever: Therefore the LORD God sent him forth from the garden of Eden, to till the ground from whence he was taken.

So he drove out the man; and he placed at the east of the garden of Eden Cherubims, and a flaming sword which turned every way, to keep the way of the tree of life.

FROM THE BOOK OF GENESIS, CHAPTER 3

Expulsion from Paradise, by Masaccio
(1401–*c*.1428)

We do not need to be told that we are
'fallen': the world is not as it should be.
The expulsion of Adam and Eve from the
Garden of Eden, where they were intended
to live, has gripped the imagination
of several artists. No one shows more
poignantly than Masaccio what it means
to leave a world of peace and freedom,
and move out into the violence and
unhappiness that have dominated every
century of human history. He shows
tenderly and sadly the beauty of our first
parents, and their heart-rending grief
as they encounter the consequences of
their actions. Every sin damages us, and
it is a grief to God solely because we have
lessened and abused our capacity for
happiness. Adam cannot bear to look at
what he has done, Eve flings back her head
in the anguish of the primeval scream. Yet,
naked and vulnerable, ashamed and afraid,
they still have above them the radiant
presence of an angel, pointing them into
their future. God has not abandoned
them. They are still beautiful, but now
they must work and suffer for what should
have been pure delight.

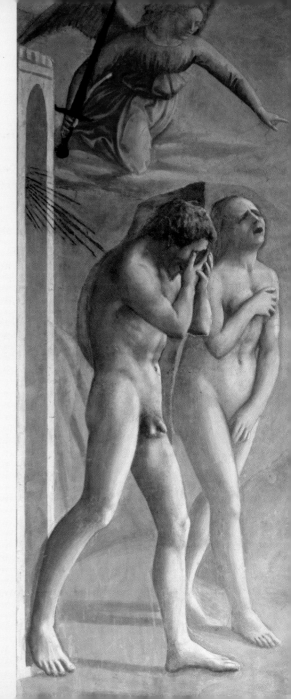

Cain and Abel

Adam knew Eve his wife; and she conceived, and bare Cain, and said, I have gotten a man from the LORD. And she again bare his brother Abel. And Abel was a keeper of sheep, but Cain was a tiller of the ground.

And in process of time it came to pass, that Cain brought of the fruit of the ground an offering unto the LORD. And Abel, he also brought of the firstlings of his flock and of the fat thereof. And the LORD had respect unto Abel and to his offering: but unto Cain and to his offering he had not respect. And Cain was very wroth, and his countenance fell.

And the LORD said unto Cain,

> Why art thou wroth? And why is thy countenance fallen? If thou doest well, shalt thou not be accepted? And if thou doest not well, sin lieth at the door. And unto thee shall be his desire, and thou shalt rule over him.

And Cain talked with Abel his brother: and it came to pass, when they were in the field, that Cain rose up against Abel his brother, and slew him. And the LORD said unto Cain, Where is Abel thy brother?

And he said, I know not: Am I my brother's keeper? And he said,

> What hast thou done? The voice of thy brother's blood crieth unto me from the ground. And now art thou cursed from the earth, which hath opened her mouth to receive thy brother's blood from thy hand; When thou tillest the ground, it shall not henceforth yield unto thee her strength; a fugitive and a vagabond shalt thou be in the earth.

And the LORD set a mark upon Cain, lest any finding him should kill him. And Cain went out from the presence of the LORD, and dwelt in the land of Nod, on the east of Eden.

FROM THE BOOK OF GENESIS, CHAPTER 4

Noah and the Flood

It came to pass, when men began to multiply on the face of the earth, and daughters were born unto them, that the sons of God saw the daughters of men that they were fair; and they took them wives of all which they chose. And GOD saw that the wickedness of man was great

in the earth, and that every imagination of the thoughts of his heart was only evil continually. And it repented the LORD that he had made man on the earth, and it grieved him at his heart. But Noah found grace in the eyes of the LORD. And God said unto Noah,

> Make thee an ark of gopher wood; rooms shalt thou make in the ark, and shalt pitch it within and without with pitch; with lower, second, and third stories shalt thou make it. And, behold, I, even I, do bring a flood of waters upon the earth, to destroy all flesh. But with thee will I establish my covenant; and thou shalt come into the ark, thou, and thy sons, and thy wife, and thy sons' wives with thee. And of every living thing of all flesh, two of every sort shalt thou bring into the ark, to keep them alive with thee; they shall be male and female.

Thus did Noah; according to all that God commanded him, so did he.

And it came to pass after seven days, that the waters of the flood were upon the earth. In the same day were all the fountains of the great deep broken up, and the windows of heaven were opened. And the rain was upon the earth forty days and forty nights. In the selfsame day entered Noah, and Shem, and Ham, and Japheth, the sons of Noah, and Noah's wife, and the three wives of his sons with them, into the ark; They, and every beast after his kind, as God had commanded him: and the LORD shut him in.

And the flood was forty days upon the earth; and the waters increased, and bare up the ark, and it was lift up above the earth. And the waters prevailed exceedingly upon the earth; and all flesh died that moved upon the earth. Noah only remained alive, and they that were with him in the ark.

And God remembered Noah, and every living thing, and all the cattle that was with him in the ark: and God made a wind to pass over the earth, and the waters asswaged. And the ark rested upon the mountains of Ararat. And it came to pass at the end of forty days, that Noah opened the window of the ark which he had made: And he sent forth a raven, which went forth to and fro, until the waters were dried up from off the earth. Also he sent forth a dove from him, to see if the waters were abated from off the face of the ground; but the dove found no rest for the sole of her foot, and she returned unto him into the ark, for the waters were on

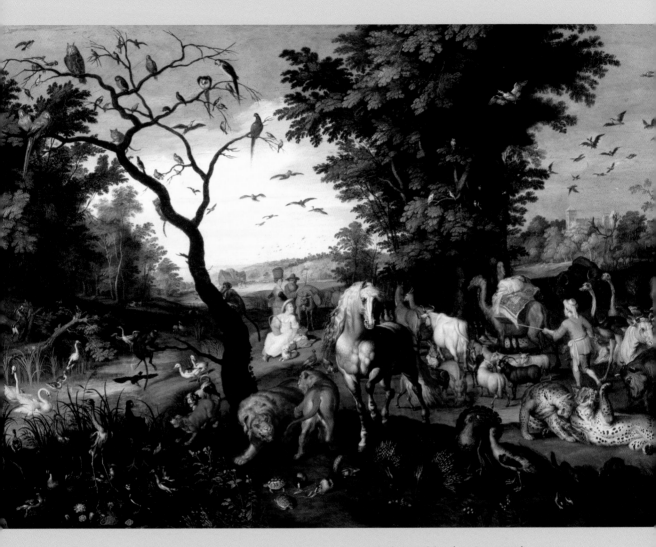

The Animals Entering the Ark, by Jan Brueghel the Elder (1568–1625)

the face of the whole earth: then he put forth his hand, and took her, and pulled her in unto him into the ark.

And he stayed yet other seven days; and again he sent forth the dove out of the ark; and the dove came in to him in the evening; and, lo, in her mouth was an olive leaf pluckt off: so Noah knew that the waters were abated from off the earth. And he stayed yet other seven days; and sent forth the dove; which returned not again unto him any more. And Noah removed the covering of the ark, and looked, and, behold, the face of the ground was dry. And God spake unto Noah, saying,

> Go forth of the ark, thou, and thy wife, and thy sons, and thy sons' wives with thee. Bring forth with thee every living thing that is with thee; that they may breed abundantly in the earth. This is the token of the covenant which I make for perpetual generations: I do set my bow in the cloud, and it shall come to pass, when I bring a cloud over the earth, that the bow shall be seen in the cloud: and I will remember my covenant; and the waters shall no more become a flood to destroy all flesh.

FROM THE BOOK OF GENESIS, CHAPTERS 6—9

THE TOWER OF BABEL

The whole earth was of one language, and of one speech. And it came to pass, as they journeyed from the east, that they said one to another, Go to, let us build us a city and a tower, whose top may reach unto heaven. And the LORD came down to see the city and the tower, which the children of men builded. And the LORD said, Behold, the people is one, and they have all one language; and this they begin to do: let us go down, and there confound their language, that they may not understand one another's speech. So the LORD scattered them abroad from thence upon the face of all the earth: and they left off to build the city. Therefore is the name of it called Babel; because the LORD did there confound the language of all the earth.

FROM THE BOOK OF GENESIS, CHAPTER 11

2. The age of the patriarchs

Up to now the Bible view is worldwide: this is the story of humanity. At this point God singles out one unique individual, Abram (who will later become Abraham), and makes with him a covenant that is to dominate the Scriptures. At first, it is basically a solemn promise that Abraham is to be the ancestor of a great nation which will be especially dear to God. Unfortunately, neither Abram nor his wife have children, and so we have the first instance of our relationship with God being based upon trust in what seems to be impossible. Because of his faith, against all possibilities, Abraham does sire a son, and then we have another profound test of faith: he is asked to sacrifice that son. The stories of Isaac, Abraham's son, and Jacob, Isaac's son, are not altogether edifying, but through them God is working out his promise and his plan. From the patriarchs sprang the chosen people and the sheer ordinariness and, at times, immorality of these great figures is part of the lesson we are being taught. God works through all human activity.

The Promised Land

Now the LORD had said unto Abram,

> Get thee out of thy country, and from thy kindred, and from thy father's house, unto a land that I will shew thee: and I will make of thee a great nation, and in thee shall all families of the earth be blessed.

So Abram departed, as the LORD had spoken unto him; and Abram took Sarai his wife, and Lot his brother's son, and all their substance that they had gathered, and the souls that they had gotten in Haran; and they went forth to go into the land of Canaan.

And when Abram was ninety years old and nine, the LORD appeared to Abram, and said unto him,

> I am the Almighty God; walk before me, and be thou perfect. And I will make my covenant between me and thee, and will multiply thee exceedingly. Neither shall thy name any more be called Abram, but thy name shall be Abraham; for a father of many nations have I made thee. And I will give unto thee, and to thy seed

after thee, the land wherein thou art a stranger, all the land of Canaan, for an everlasting possession; and I will be their God.

<small>FROM THE BOOK OF GENESIS, CHAPTERS 12, 17</small>

ABRAHAM AND THE THREE ANGELS

The LORD appeared unto Abraham in the plains of Mamre: and he sat in the tent door in the heat of the day; and he lift up his eyes and looked, and, lo, three men stood by him: and when he saw them, he ran to meet them from the tent door, and bowed himself toward the ground, and said,

> My Lord, if now I have found favour in thy sight, pass not away, I pray thee, from thy servant: let a little water, I pray you, be fetched, and wash your feet, and rest yourselves under the tree: and I will fetch a morsel of bread, and comfort ye your hearts.

And they said, So do, as thou hast said. And Abraham hastened into the tent unto Sarah, and said, Make ready quickly three

Trinity of the Old Testament, by Andrei Rublev (1360–*c.*1430)

This most beautiful icon commemorates the pivotal moment in Abraham's life, when God solemnly promises that his old and barren wife will bear a child. God communicates this profound message through three 'men' who arrive unexpectedly at Abraham's camp. He welcomes them with reverence and an outpouring of hospitality, and it becomes clear that these 'men' are angels, messengers of God. That there are three of them has always seemed to Christians a foreshadowing of the truth of the Holy Trinity. Of the many artists who have dared to treat this sacred theme, none has surpassed Rublev in his awareness of holiness, tenderness, and the lovely communication, the deep inexpressible relationship, that unites these sacred figures (it is not irrelevant, perhaps, that Rublev has been canonized by the Orthodox Church). They are equal in majesty and beauty, visions of the serenity of heaven. They perch, slender and youthful, on our earth, indicated by the rustic buildings on the left and the flourishing tree to the centre. The exquisite colouring of their garments emphasizes the transcendent message of the promise they have made, and the table at which they sit is reminiscent of an altar.

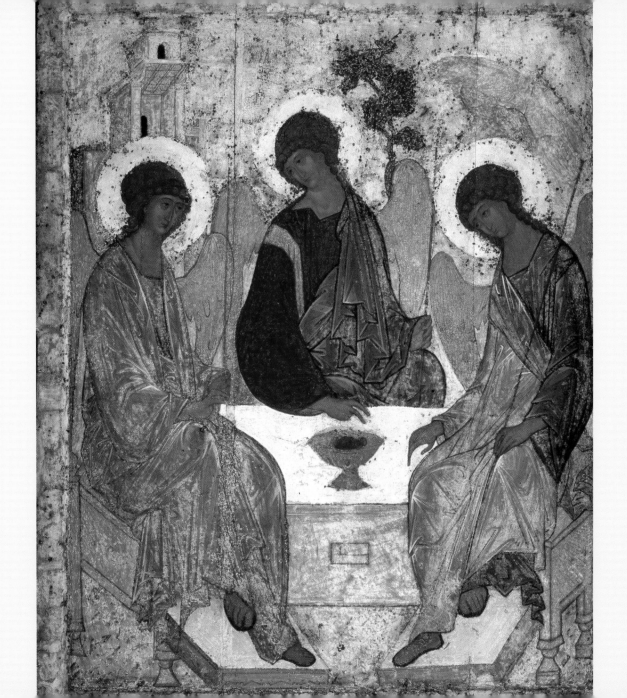

measures of fine meal, knead it, and make cakes upon the hearth. And Abraham ran unto the herd, and fetcht a calf tender and good, and gave it unto a young man; and he hasted to dress it. And he took butter, and milk, and the calf which he had dressed, and set it before them; and he stood by them under the tree, and they did eat.

And they said unto him, Where is Sarah thy wife? And he said, Behold, in the tent. And he said, I will certainly return unto thee according to the time of life; and, lo, Sarah thy wife shall have a son. And Sarah heard it in the tent door, which was behind him.

Now Abraham and Sarah were old and well stricken in age; and it ceased to be with Sarah after the manner of women. Therefore Sarah laughed within herself, saying, After I am waxed old shall I have pleasure, my lord being old also?

And the LORD said unto Abraham,

> Wherefore did Sarah laugh, saying, Shall I of a surety bear a child, which am old? Is any thing too hard for the LORD? At the time appointed I will return unto thee, according to the time of life, and Sarah shall have a son.

Then Sarah denied, saying, I laughed not; for she was afraid.

FROM THE BOOK OF GENESIS, CHAPTER 18

THE BINDING OF ISAAC

The LORD visited Sarah as he had said, and Sarah conceived, and bare Abraham a son in his old age. And Abraham called the name of his son, whom Sarah bare to him, Isaac.

And it came to pass after these things, that God did tempt Abraham, and said unto him, Abraham: and he said, Behold, here I am. And he said, Take now thy son, thine only son Isaac, whom thou lovest, and get thee into the land of Moriah; and offer him there for a burnt offering upon one of the mountains which I will tell thee of.

And Abraham rose up early in the morning, and saddled his ass, and took the wood of the burnt offering, and laid it upon Isaac his son; and he took the fire in his hand, and a knife; and they went both of them together.

And Isaac spake unto Abraham his father, and said, My father: and he said, Here am

I, my son. And he said, Behold the fire and the wood: but where is the lamb for a burnt offering? And Abraham said, My son, God will provide himself a lamb for a burnt offering: so they went both of them together.

And they came to the place which God had told him of; and Abraham built an altar there, and laid the wood in order, and bound Isaac his son, and laid him on the altar upon the wood. And Abraham stretched forth his hand, and took the knife to slay his son. And the angel of the Lord called unto him out of heaven, and said, Abraham, Abraham: and he said, Here am I. And he said, Lay not thine hand upon the lad, neither do thou any thing unto him: for now I know that thou fearest God, seeing thou hast not withheld thy son, thine only son from me.

And Abraham lifted up his eyes, and looked, and behold behind him a ram caught in a thicket by his horns: and Abraham went and took the ram, and offered him up for a burnt offering in the stead of his son.

From the Book of Genesis, chapters 21 and 22

ISAAC AND REBEKAH

Abraham was old, and well stricken in age: and the Lord had blessed Abraham in all things. And Abraham said unto his eldest servant of his house, Go unto my country, and to my kindred, and take a wife unto my son Isaac. And the servant took ten camels of the camels of his master, and went to Mesopotamia, unto the city of Nahor.

And he made his camels to kneel down without the city by a well of water at the time of the evening, even the time that women go out to draw water. And he said, O Lord God of my master Abraham, I pray thee, send me good speed this day, and shew kindness unto my master Abraham.

And it came to pass, before he had done speaking, that, behold, Rebekah came out, who was born to Bethuel, son of Milcah, the wife of Nahor, Abraham's brother, with her pitcher upon her shoulder. And the damsel was very fair to look upon, a virgin, neither had any man known her: and she went down to the well, and filled her pitcher, and came up.

And the servant ran to meet her, and said, Let me, I pray thee, drink a little water of thy pitcher. And she said, Drink, my lord: and she hasted, and let down her pitcher

upon her hand, and gave him drink. And when she had done giving him drink, she said, I will draw water for thy camels also.

And the man said, Whose daughter art thou? Tell me, I pray thee: is there room in thy father's house for us to lodge in? And she said unto him, I am the daughter of Bethuel the son of Milcah, which she bare unto Nahor. She said moreover unto him, We have both straw and provender enough, and room to lodge in. And the damsel ran, and told them of her mother's house these things.

And Rebekah had a brother, and his name was Laban: and Laban ran out unto the man, unto the well. And he said, Come in, thou blessed of the LORD; wherefore standest thou without? And the man came into the house: and there was set meat before him to eat: but he said, I will not eat, until I have told mine errand. And he said, Speak on. And he said,

> I am Abraham's servant. And the LORD hath blessed my master greatly; and he is become great. And Sarah my master's wife bare a son to my master when she was old: and unto him hath he given all that he hath. And my master made me swear, saying, Thou shalt not take a wife to my son of the daughters of the

Eliezer and Rebekah, by Nicolas Poussin (1594–1665)

At first sight the choice of a bride for Isaac seems merely an example of social custom. The servant is not named in the Scriptures but by common consent he is called Eliezer, and it is Poussin's deep and rich imagination that brings this traveller into the midst of this bevy of young beauties. It is one of Poussin's greatest paintings, supremely lovely in its setting and in its human interest. The girls are spread out as in a frieze, all of them graceful and attractive, each reacting to Eliezer's presence according to her temperament. Naturally Rebekah, the heroine of the story, is the most striking and impressive; humble, helpful, and all that a young man would desire in his wife. Poussin is unique in his mastery of both poetry and the architectonics of prose. We see very clearly the majesty of this foreign country, and its difference. In persuading us of the reality of the setting, Poussin draws us into acceptance of the story. It seems simply that – a romantic story – and yet this is an essential stage in God's plan for the chosen people.

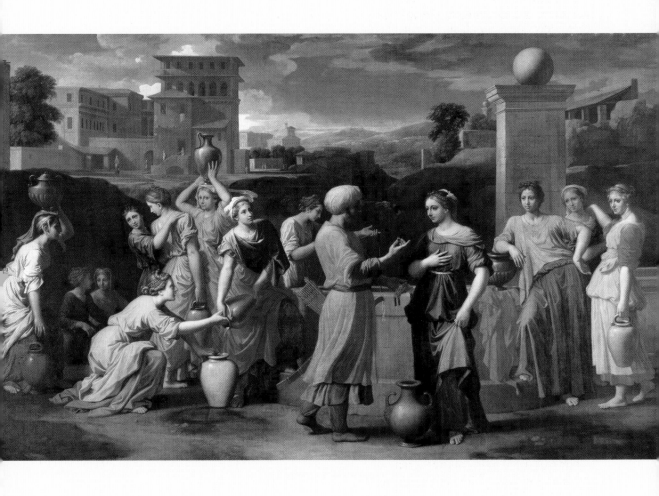

Canaanites, in whose land I dwell: But thou shalt go unto my father's house, and to my kindred, and take a wife unto my son.

Then Laban and Bethuel answered and said, The thing proceedeth from the LORD: we cannot speak unto thee bad or good. Behold, Rebekah is before thee, take her, and go, and let her be thy master's son's wife, as the LORD hath spoken. And it came to pass, that, when Abraham's servant heard their words, he worshipped the LORD, bowing himself to the earth. And the servant brought forth jewels of silver, and jewels of gold, and raiment, and gave them to Rebekah. And Rebekah arose, and her damsels, and they rode upon the camels, and followed the man.

And Isaac came from the way of the well Lahai-roi; for he dwelt in the south country. And Isaac went out to meditate in the field at the eventide. And Rebekah lifted up her eyes, and when she saw Isaac, she lighted off the camel, took a vail, and covered herself. And the servant told Isaac all things that he had done. And Isaac brought her into his mother Sarah's tent, and took Rebekah, and she became his wife; and he loved her.

FROM THE BOOK OF GENESIS, CHAPTER 24

JACOB TRICKS HIS BROTHER

Abraham lived an hundred threescore and fifteen years. Then Abraham gave up the ghost, and died in a good old age, and was gathered to his people.

And Isaac intreated the LORD for his wife, because she was barren: and Rebekah his wife conceived. And when her days to be delivered were fulfilled, behold, there were twins in her womb. And the first came out red, all over like an hairy garment; and they called his name Esau. And after that came his brother out, and his hand took hold on Esau's heel; and his name was called Jacob. And the boys grew: and Esau was a cunning hunter, a man of the field; and Jacob was a plain man, dwelling in tents. And Isaac loved Esau, because he did eat of his venison: but Rebekah loved Jacob.

And Jacob sod pottage: and Esau came from the field, and he was faint: and Esau said to Jacob, Feed me, I pray thee, with that same red pottage; for I am faint. And Jacob said, Sell me this day thy birthright. And Esau said, Behold, I am at the point to die: and what profit shall this birthright do to me? And he sold his birthright unto Jacob.

FROM THE BOOK OF GENESIS, CHAPTER 25

JACOB TRICKS HIS FATHER

It came to pass, that when Isaac was old, and his eyes were dim, so that he could not see, he called Esau his eldest son, and said unto him,

Behold now, I am old, I know not the day of my death: now therefore take, I pray thee, thy weapons, thy quiver and thy bow, and go out to the field, and take me some venison; and make me savoury meat, such as I love, and bring it to me, that I may eat; that my soul may bless thee before I die.

And Rebekah heard when Isaac spake to Esau his son. And Esau went to the field to hunt for venison, and to bring it. And Rebekah spake unto Jacob her son, saying,

Behold, I heard thy father speak unto Esau thy brother, saying, Bring me venison, and make me savoury meat, that I may eat, and bless thee before the LORD before my death. Now therefore, my son, obey my voice according to that which I command thee. Go now to the flock, and fetch me from thence two good kids of the goats; and I will make them savoury meat for thy father, such as he loveth: and thou shalt bring it to thy father, that he may eat, and that he may bless thee before his death.

And Jacob said to Rebekah his mother, Behold, Esau my brother is a hairy man, and I am a smooth man: my father peradventure will feel me, and I shall seem to him as a deceiver; and I shall bring a curse upon me, and not a blessing. And his mother said unto him, Upon me be thy curse, my son: only obey my voice, and go fetch me them.

And he went, and fetched, and brought them to his mother: and his mother made savoury meat, such as his father loved. And Rebekah took goodly raiment of her eldest son Esau, which were with her in the house, and put them upon Jacob her younger son: and she put the skins of the kids of the goats upon his hands, and upon the smooth of his neck: And she gave the savoury meat and the bread, which she had prepared, into the hand of her son Jacob.

And he came unto his father, and said, My father: and he said, Here am I; who art thou, my son? And Jacob said unto his father, I am Esau thy firstborn. And Jacob went near unto Isaac his father; and he felt him, and said, The voice is Jacob's voice, but the hands are the hands of Esau. And he discerned him not, because his hands

were hairy, as his brother Esau's hands: so he blessed him. And it came to pass, as soon as Isaac had made an end of blessing Jacob, and Jacob was yet scarce gone out from the presence of Isaac his father, that Esau his brother came in from his hunting. And he also had made savoury meat, and brought it unto his father, and said unto his father, Let my father arise, and eat of his son's venison, that thy soul may bless me.

And Isaac his father said unto him, Who art thou? And he said, I am thy son, thy firstborn Esau. And Isaac trembled very exceedingly, and said, Who? Where is he that hath taken venison, and brought it me, and I have eaten of all before thou camest, and have blessed him? Yea, and he shall be blessed.

And when Esau heard the words of his father, he cried with a great and exceeding bitter cry, and said unto his father, Bless me, even me also, O my father. And he said, Thy brother came with subtilty, and hath taken away thy blessing.

And Esau hated Jacob because of the blessing wherewith his father blessed him: and Esau said in his heart, The days of mourning for my father are at hand; then will I slay my brother Jacob.

And Rebekah sent and called Jacob her younger son, and said unto him,

> Behold, thy brother Esau doth comfort himself, purposing to kill thee. Now therefore, my son, obey my voice; and arise, flee thou to Laban my brother to Haran; And tarry with him a few days, until thy brother's fury turn away.

FROM THE BOOK OF GENESIS, CHAPTERS 27—28

JACOB'S LADDER

And Jacob went out from Beer-sheba, and went toward Haran. And he lighted upon a certain place, and tarried there all night, because the sun was set; and he took of the stones of that place, and put them for his pillows, and lay down in that place to sleep. And he dreamed, and behold a ladder set up on the earth, and the top of it reached to heaven: and behold the angels of God ascending and descending on it. And, behold, the LORD stood above it, and said, I am the God of Abraham thy father, and the God of Isaac: the land whereon thou liest, to thee will I give it, and to thy seed.

FROM THE BOOK OF GENESIS, CHAPTER 28

Jacob and Rachel

Then Jacob went on his journey, and came into the land of the people of the east. And he looked, and behold a well in the field, and, lo, there were three flocks of sheep lying by it; for out of that well they watered the flocks: and a great stone was upon the well's mouth.

And Jacob said unto them, My brethren, whence be ye? And they said, Of Haran are we. And he said unto them, Know ye Laban the son of Nahor? And they said, We know him. And he said unto them, Is he well? And they said, He is well: and, behold, Rachel his daughter cometh with the sheep.

And it came to pass, when Jacob saw Rachel the daughter of Laban his mother's brother, and the sheep of Laban his mother's brother, that Jacob went near, and rolled the stone from the well's mouth, and watered the flock of Laban his mother's brother. And Jacob kissed Rachel, and lifted up his voice, and wept.

And Jacob told Rachel that he was her father's brother, and that he was Rebekah's son: and she ran and told her father. And it came to pass, when Laban heard the tidings of Jacob his sister's son, that he ran to meet him, and embraced him, and kissed him, and brought him to his house. And he told Laban all these things. And Laban said to him, Surely thou art my bone and my flesh. And he abode with him the space of a month.

And Laban had two daughters: the name of the elder was Leah, and the name of the younger was Rachel. Leah was tender eyed; but Rachel was beautiful and well favoured. And Jacob loved Rachel; and said, I will serve thee seven years for Rachel thy younger daughter. And Laban said, It is better that I give her to thee, than that I should give her to another man: abide with me.

And Jacob served seven years for Rachel; and they seemed unto him but a few days, for the love he had to her. And Jacob said unto Laban, Give me my wife, for my days are fulfilled, that I may go in unto her. And Laban gathered together all the men of the place, and made a feast. And it came to pass in the evening, that he took Leah his daughter, and brought her to him; and he went in unto her. And it came to pass, that in the morning, behold, it was Leah: and he said to Laban, What is this thou hast done unto me? Did not I serve with

thee for Rachel? Wherefore then hast thou beguiled me?

And Laban said, It must not be so done in our country, to give the younger before the firstborn. Fulfil her week, and we will give thee this also for the service which thou shalt serve with me yet seven other years. And Jacob did so, and fulfilled her week: and he gave him Rachel his daughter to wife also. And he went in also unto Rachel, and he loved also Rachel more than Leah, and served with him yet seven other years.

And when the LORD saw that Leah was hated, he opened her womb: but Rachel was barren. And when Rachel saw that she bare Jacob no children, Rachel envied her sister; and said unto Jacob, Give me children, or else I die. And God remembered Rachel, and God hearkened to her, and opened her womb. And she conceived, and bare a son; and said, God hath taken away my reproach: And she called his name Joseph.

And it came to pass, when Rachel had born Joseph, that Jacob said unto Laban, Send me away, that I may go unto mine own place, and to my country. Give me my wives and my children, for whom I have served thee, and let me go. And Jacob took his two wives, and his two womenservants, and his eleven sons, and passed over the ford Jabbok. And he took them, and sent them over the brook, and sent over that he had.

JACOB AND THE ANGEL

And Jacob was left alone; and there wrestled a man with him until the breaking of the day. And when he saw that he prevailed not against him, he touched the hollow of his thigh; and the hollow of Jacob's thigh was out of joint as he wrestled with him. And he said, Let me go, for the day breaketh. And he said, I will not let thee go, except thou bless me. And he said unto him, What is thy name? And he said, Jacob. And he said, Thy name shall be called no more Jacob, but Israel: for as a prince hast thou power with God and with men, and hast prevailed.

FROM THE BOOK OF GENESIS, CHAPTERS 29—32

Opposite: *Jacob Wrestles with the Angel*, by Eugène Delacroix (1798–1863)

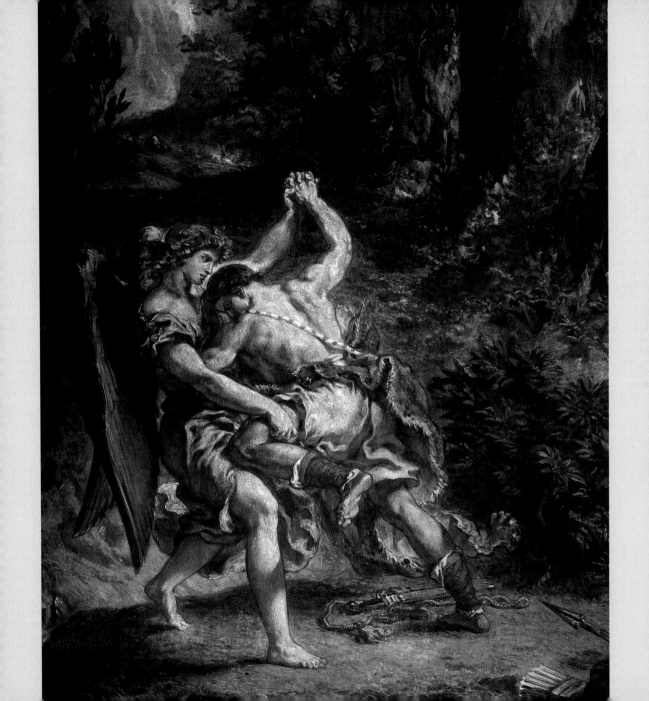

3. Joseph in Egypt

The story of Joseph is one of the longest, most complex and most crucial in the Bible. What strikes us so forcibly is how human sinfulness shapes the form of the events. It is his father's foolish preference for one son above the others that arouses Joseph's brothers' jealousy. Joseph's tactlessness exacerbates this jealousy, and so we have the whole miserable sequence of deceit that brings him to Egypt. He was a man born to succeed (hence probably his father's favouritism), but these very qualities and his good looks once more lead him into trouble and, unjustly, into prison. The see-saw of his life continues: from the depths of prison he rises to the heights of power, all of which will mean that his whole nation, the Israelites, will follow him into Egypt. Novels have been written about Joseph, and indeed the plot is a gripping one. Yet every twist and turn shows us how God achieves his purposes through human weakness as much as through human strength. This is always the subtext of the Bible: God revealing his love, almost despite our actions.

Joseph's dreams

Jacob dwelt in the land wherein his father was a stranger, in the land of Canaan. Now Israel loved Joseph more than all his children, because he was the son of his old age: and he made him a coat of many colours. And when his brethren saw that their father loved him more than all his brethren, they hated him, and could not speak peaceably unto him.

And Joseph dreamed a dream, and he told it his brethren: and they hated him yet the more. And he said unto them, Hear, I pray you, this dream which I have dreamed: for, behold, we were binding sheaves in the field, and, lo, my sheaf arose, and also stood upright; and, behold, your sheaves stood round about, and made obeisance to my sheaf.

And he told it to his father, and to his brethren: and his father rebuked him, and said unto him, What is this dream that thou hast dreamed? Shall I and thy mother and thy brethren indeed come to bow down ourselves to thee to the earth? And his brethren envied him; but his father observed the saying.

And his brethren went to feed their father's flock in Shechem. And Israel said unto Joseph, Go, I pray thee, see whether it be well with thy brethren, and well with the flocks; and bring me word again. And when they saw him afar off, even before he came near unto them, they conspired against him to slay him. And they said one to another, Behold, this dreamer cometh. Come now therefore, and let us slay him, and cast him into some pit, and we will say, Some evil beast hath devoured him: and we shall see what will become of his dreams.

And Reuben heard it, and said unto them, Shed no blood, but cast him into this pit that is in the wilderness, and lay no hand upon him. And it came to pass, when Joseph was come unto his brethren, that they stript Joseph out of his coat, his coat of many colours that was on him; And they took him, and cast him into a pit.

And they sat down to eat bread: and they lifted up their eyes and looked, and, behold, a company of Ishmeelites came from Gilead with their camels bearing spicery and balm and myrrh, going to carry it down to Egypt. And Judah said unto his brethren, What profit is it if we slay our brother, and conceal his blood? Come, and let us sell him to the Ishmeelites, and let not our hand be upon him; for he is our brother and our flesh. And they drew and lifted up Joseph out of the pit, and sold Joseph to the Ishmeelites for twenty pieces of silver. And they took Joseph's coat, and killed a kid of the goats, and dipped the coat in the blood; And they sent the coat of many colours, and they brought it to their father; and said, This have we found: know now whether it be thy son's coat or no. And he knew it, and said, It is my son's coat; an evil beast hath devoured him.

And Jacob rent his clothes, and put sackcloth upon his loins, and mourned for his son many days. And all his sons and all his daughters rose up to comfort him; but he refused to be comforted; and he said, For I will go down into the grave unto my son mourning.

FROM THE BOOK OF GENESIS, CHAPTER 37

POTIPHAR'S WIFE

Joseph was brought down to Egypt; and Potiphar, an officer of Pharaoh, captain of the guard, bought him of the hands of the Ishmeelites, which had brought him down thither. And it came to pass after these things, that his master's wife cast her eyes upon Joseph; and she caught him by his garment, saying, Lie with me: and he left his garment in her hand, and fled, and got him out. And it came to pass, when she saw that he had left his garment in her hand, and was fled forth, that she laid up his garment by her, until his lord came home.

And she spake unto him according to these words, saying, The Hebrew servant, which thou hast brought unto us, came in unto me to mock me: And it came to pass, as I lifted up my voice and cried, that he left his garment with me, and fled out. And it came to pass, when his master heard the words of his wife, that his wrath was kindled. And Joseph's master took him, and put him into the prison, a place where the king's prisoners were bound.

FROM THE BOOK OF GENESIS, CHAPTER 39

Joseph and Potiphar's Wife, by Orazio Gentileschi (1563–1639)

This powerful story of lust and unassailable virtue has attracted many artists. There is an obvious irony in that, in Joseph's case, it is the woman who lusts and the young man who resists. Gentileschi rises splendidly to the drama. Potiphar's wife, poor thing, whose name we never learn, is sprawled shamelessly across the opulence of the matrimonial bed. She is clearly a woman of great wealth and one accustomed to getting her own way. Yet we pity her: she is dishevelled with passion, clearly past the first flush of youth, and reacting with vicious anger to Joseph's rejection. She has pulled his coat from his back, witness to his determination to escape her clutches. Gentileschi depicts her as glowering after him, bent on revenge. His Joseph, unfortunately, comes across as rather priggish in his self-conscious virtue. He stalks out, leaving her with the empty cloak, thrusting aside the sinister blood-red hangings of Potiphar's bed. The very colour of the hangings indicates the danger which he is incurring, though one cannot help but wish he had refused the lady with a little sympathy and kindness.

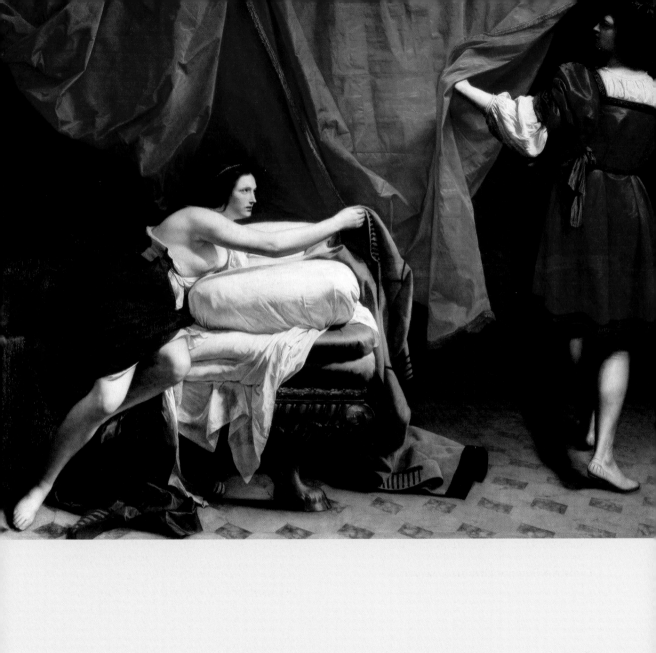

It came to pass after these things, that Pharaoh was wroth against two of his officers, against the chief of the butlers, and against the chief of the bakers. And he put them in ward in the prison, the place where Joseph was bound.

And they dreamed a dream both of them, each man his dream in one night. And Joseph came in unto them in the morning, and looked upon them, and, behold, they were sad. And he asked Pharaoh's officers, Wherefore look ye so sadly to day? And they said unto him, We have dreamed a dream, and there is no interpreter of it. And Joseph said unto them, Do not interpretations belong to God? Tell me them, I pray you. And the chief butler told his dream to Joseph, and said to him,

> In my dream, behold, a vine was before me; and in the vine were three branches: and it was as though it budded, and her blossoms shot forth; and the clusters thereof brought forth ripe grapes: and Pharaoh's cup was in my hand: and I took the grapes, and pressed them into Pharaoh's cup, and I gave the cup into Pharaoh's hand.

And Joseph said unto him,

> This is the interpretation of it: the three branches are three days: yet within three days shall Pharaoh lift up thine head, and restore thee unto thy place: and thou shalt deliver Pharaoh's cup into his hand, after the former manner when thou wast his butler. But think on me when it shall be well with thee, and shew kindness, and make mention of me unto Pharaoh, and bring me out of this house.

When the chief baker saw that the interpretation was good, he said unto Joseph,

> I also was in my dream, and, behold, I had three white baskets on my head: and in the uppermost basket there was of all manner of bakemeats for Pharaoh; and the birds did eat them out of the basket upon my head.

And Joseph answered and said,

> This is the interpretation thereof: the three baskets are three days: yet within three days shall Pharaoh lift up thy head from off thee, and shall hang thee

on a tree; and the birds shall eat thy flesh from off thee.

And it came to pass the third day, which was Pharaoh's birthday, that he made a feast unto all his servants: and he restored the chief butler unto his butlership again; and he gave the cup into Pharaoh's hand: but he hanged the chief baker.

Yet did not the chief butler remember Joseph, but forgat him.

From the Book of Genesis, chapter 40

Pharaoh's dreams

It came to pass at the end of two full years, that Pharaoh dreamed: and he sent and called for all the magicians of Egypt, and all the wise men thereof: and Pharaoh told them his dream; but there was none that could interpret them unto Pharaoh.

Then spake the chief butler unto Pharaoh, saying,

> I do remember my faults this day: Pharaoh was wroth with his servants, and put me in ward, both me and the chief baker: and we dreamed a dream in one night, I and he. And there was there with us a young man, an Hebrew, and we told him, and he interpreted to us our dreams.

Then Pharaoh sent and called Joseph, and they brought him hastily out of the dungeon: and he shaved himself, and changed his raiment, and came in unto Pharaoh. And Pharaoh said unto Joseph, I have dreamed a dream, and there is none that can interpret it: and I have heard say of thee, that thou canst understand a dream to interpret it.

And Pharaoh said unto Joseph,

> In my dream, behold, I stood upon the bank of the river: And, behold, there came up out of the river seven kine, fatfleshed and well favoured; and they fed in a meadow: and, behold, seven other kine came up after them, poor and very ill favoured and leanfleshed, such as I never saw in all the land of Egypt for badness: And the lean and the ill favoured kine did eat up the first seven fat kine: and when they had eaten them up, it could not be known that they had eaten them; but they were still ill favoured, as at the beginning.

And Joseph said unto Pharaoh,

God hath shewed Pharaoh what he is about to do. The seven good kine are seven years; and the seven thin and ill favoured kine that came up after them are seven years. Behold, there come seven years of great plenty throughout all the land of Egypt: And there shall arise after them seven years of famine; and all the plenty shall be forgotten in the land of Egypt; and the famine shall consume the land; And the plenty shall not be known in the land by reason of that famine following; for it shall be very grievous.

Now therefore let Pharaoh look out a man discreet and wise, and set him over the land of Egypt. Let Pharaoh do this, and let him appoint officers over the land, and let them gather all the food of those good years that come. And that food shall be for store to the land against the seven years of famine.

And the thing was good in the eyes of Pharaoh, and in the eyes of all his servants. And Pharaoh said unto his servants, Can we find such a one as this is, a man in whom the Spirit of God is? And Pharaoh took off his ring from his hand, and put it upon Joseph's hand, and arrayed him in vestures of fine linen, and put a gold chain about his neck; and he made him ruler over all the land of Egypt.

From the Book of Genesis, chapter 41

Joseph the Governor

Joseph went out from the presence of Pharaoh, and went throughout all the land of Egypt. And in the seven plenteous years the earth brought forth by handfuls. And he gathered up all the food of the seven years, which were in the land of Egypt, and laid up the food in the cities.

And the seven years of plenteousness, that was in the land of Egypt, were ended. And the seven years of dearth began to come, according as Joseph had said: and the famine waxed sore in the land of Egypt. And all countries came into Egypt to Joseph for to buy corn.

Now when Jacob saw that there was corn in Egypt, Jacob said unto his sons, Why do ye look one upon another? And he said, Behold, I have heard that there is corn in Egypt: get you down thither, and buy for us from thence; that we may live, and not die. And Joseph's ten brethren went

down to buy corn in Egypt. But Benjamin, Joseph's brother, Jacob sent not with his brethren; for he said, Lest peradventure mischief befall him.

And Joseph was the governor over the land, and he it was that sold to all the people of the land: and Joseph's brethren came, and bowed down themselves before him with their faces to the earth. And Joseph saw his brethren, and he knew them, but made himself strange unto them, and spake roughly unto them; and he said unto them, Whence come ye? And they said, From the land of Canaan to buy food.

And Joseph remembered the dreams which he dreamed of them, and said unto them, Ye are spies; to see the nakedness of the land ye are come. And they said unto him, Nay, my lord, but to buy food are thy servants come. We are all one man's sons; we are true men, thy servants are no spies. And he said unto them, Nay, but to see the nakedness of the land ye are come. And they said, Thy servants are twelve brethren, the sons of one man in the land of Canaan; and, behold, the youngest is this day with our father, and one is not.

From the Book of Genesis, chapters 41—42

The Israelites settle in Egypt

Joseph could not refrain himself before all them that stood by him; and he cried, Cause every man to go out from me. And there stood no man with him, while Joseph made himself known unto his brethren. And he wept aloud: and the Egyptians and the house of Pharaoh heard. And Joseph said unto his brethren, Come near to me, I pray you. And they came near. And he said,

> I am Joseph your brother, whom ye sold into Egypt. Now therefore be not grieved, nor angry with yourselves, that ye sold me hither: for God did send me before you to preserve life. Haste ye, and go up to my father, and say unto him, Thus saith thy son Joseph, God hath made me lord of all Egypt: come down unto me, tarry not: And thou shalt dwell in the land of Goshen, and thou shalt be near unto me.

And they went up out of Egypt, and came into the land of Canaan unto Jacob their father, And told him, saying, Joseph is yet alive, and he is governor over all the land of Egypt. And Jacob's heart fainted, for he believed them not. And they told him

all the words of Joseph, which he had said
unto them: and when he saw the wagons
which Joseph had sent to carry him, the
spirit of Jacob their father revived: And
Israel said, It is enough; Joseph my son is
yet alive: I will go and see him before I die.

And Israel took his journey with all that
he had, and came into Egypt, Jacob, and
all his seed with him. And Joseph made
ready his chariot, and went up to meet
Israel his father; and he fell on his neck,
and wept on his neck a good while.

And Jacob lived in the land of Egypt
seventeen years: so the whole age of Jacob
was an hundred forty and seven years.
And the time drew nigh that Israel must
die: and he yielded up the ghost, and was
gathered unto his people.

FROM THE BOOK OF GENESIS, CHAPTERS 45—49

4. Moses and the Exodus

In the New Testament when Jesus is transformed before the gaze of his apostles, they see him talking to the representatives of the law and prophets. The representative of the law is Moses. (In fact, he was considered to be the author of the first five books of Scripture, even though these include his dying words.) It is Moses who begins to crystallize for the Israelites the significance of their vocation. God's choice of them becomes explicit, even to the point of miracle. It is Moses who ventures for the first time in human history into the mystery of God's being. It is Moses who draws upon God's power to force the greatest of earth's rulers – the Egyptian Pharaoh – to allow the Israelites who have domesticated themselves in Egypt (though now as slaves) to depart to find their own country. Moses makes it impossible for his followers to ignore the great reality of God. He receives the Ten Commandments, sets up the Ark of the Covenant, and brings them to the verge of the Promised Land. God's astonishing care for them sets them apart as his own people and opens to them the full extent of what his love demands. The 'covenant' becomes more than reported words, however sacred; it is enshrined in visible form.

The birth of Moses

Joseph died, and all his brethren, and all that generation. And the children of Israel were fruitful, and multiplied, and waxed exceeding mighty; and the land was filled with them.

Now there arose up a new king over Egypt, which knew not Joseph. And he said unto his people,

> Behold, the people of the children of Israel are more and mightier than we: Come on, let us deal wisely with them; lest they multiply, and it come to pass, that, when there falleth out any war, they join also unto our enemies, and fight against us, and so get them up out of the land.

Therefore they did set over them taskmasters to afflict them with their burdens. And they built for Pharaoh treasure cities, Pithom and Raamses. But the more they afflicted them, the more they multiplied and grew. And they were grieved because of the children of Israel. And Pharaoh charged all his people, saying, Every son that is born ye shall cast into the river, and every daughter ye shall save alive.

And there went a man of the house of Levi, and took to wife a daughter of Levi. And the woman conceived, and bare a son: and when she saw him that he was a goodly child, she hid him three months. And when she could not longer hide him, she took for him an ark of bulrushes, and daubed it with slime and with pitch, and put the child therein; and she laid it in the flags by the river's brink. And his sister stood afar off, to wit what would be done to him.

And the daughter of Pharaoh came down to wash herself at the river; and her maidens walked along by the river's side; and when she saw the ark among the flags, she sent her maid to fetch it. And when she had opened it, she saw the child: and, behold, the babe wept. And she had compassion on him, and said, This is one of the Hebrews' children.

Then said his sister to Pharaoh's daughter, Shall I go and call to thee a nurse of the Hebrew women, that she may nurse the child for thee? And Pharaoh's daughter said to her, Go. And the maid went and called the child's mother. And Pharaoh's daughter said unto her, Take this child away, and nurse it for me, and I will give thee thy wages. And the woman took the child, and nursed it. And the child grew, and she brought him unto Pharaoh's daughter, and he became her son. And she called his name Moses.

FROM THE BOOK OF EXODUS, CHAPTERS 1—2

MOSES THE PRINCE

It came to pass in those days, when Moses was grown, that he went out unto his brethren, and looked on their burdens: and he spied an Egyptian smiting an Hebrew, one of his brethren. And he looked this way and that way, and when he saw that there was no man, he slew the Egyptian, and hid him in the sand.

Now when Pharaoh heard this thing, he sought to slay Moses. But Moses fled from the face of Pharaoh, and dwelt in the land of Midian: and he sat down by a well. Now the priest of Midian had seven daughters: and they came and drew water, and filled the troughs to water their father's flock. And the shepherds came and drove them away: but Moses stood up and helped them, and watered their flock.

And when they came to Reuel their father, he said, How is it that ye are come so

soon to day? And they said, An Egyptian delivered us out of the hand of the shepherds, and also drew water enough for us, and watered the flock. And he said unto his daughters, Call him, that he may eat bread. And Moses was content to dwell with the man: and he gave Moses Zipporah his daughter.

<small>From the Book of Exodus, chapter 2</small>

The burning bush

Now Moses kept the flock of Jethro his father in law, the priest of Midian: and he led the flock to the backside of the desert, and came to the mountain of God, even to Horeb. And the angel of the LORD appeared unto him in a flame of fire out of the midst of a bush: and he looked, and, behold, the bush burned with fire, and the bush was not consumed. And when the LORD saw that he turned aside to see, God called unto him out of the midst of the bush, and said, Moses, Moses. And he said, Here am I. And he said, Draw not nigh hither: put off thy shoes from off thy feet, for the place whereon thou standest is holy ground. And Moses hid his face; for he was afraid to look upon God.

And the LORD said,

> I have surely seen the affliction of my people which are in Egypt, and I am come down to deliver them out of the hand of the Egyptians, and to bring them up out of that land unto a good land and a large, unto a land flowing with milk and honey. Come now therefore, and I will send thee unto Pharaoh, that thou mayest bring forth my people the children of Israel out of Egypt.

And Moses said unto God, Behold, when I come unto the children of Israel, and shall say unto them, The God of your fathers hath sent me unto you; and they shall say to me, What is his name? what shall I say unto them? And God said unto Moses, I AM THAT I AM: and he said, Thus shalt thou say unto the children of Israel, I AM hath sent me unto you.

And Moses said unto the LORD, O my LORD, I am not eloquent, neither heretofore, nor since thou hast spoken unto thy servant: but I am slow of speech, and of a slow tongue. And the anger of the LORD was kindled against Moses, and he said, Is not Aaron the Levite thy brother? I know that he can speak well. And also, behold, he cometh forth to meet thee.

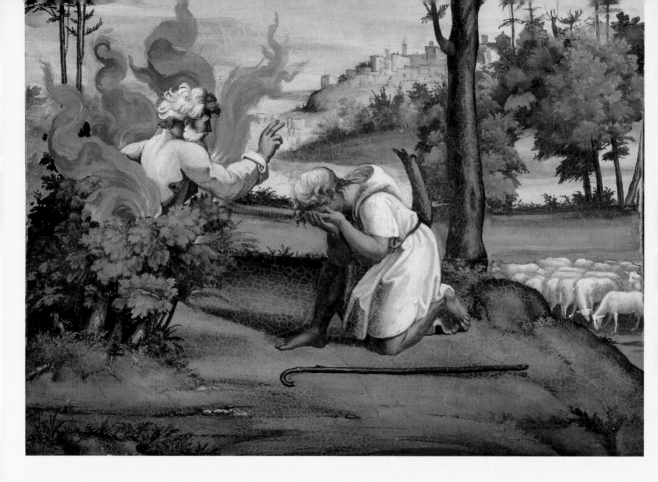

Moses and the Burning Bush, by Raphael
(1483–1520)

Theologians have always loved to meditate
on this mystical event, but artists,
understandably, have been more hesitant.
It is a story luminous in mystery. The Bible
first speaks of an angel in the Burning Bush,

and then we hear the voice of God, and
Moses covers his face because 'he has seen
God'. 'No man can see God and live', as
Scripture tells us, but Moses does indeed
see God, and is bowed to the ground with
reverence. Even that ground is holy: he has
to remove his shoes. Raphael shows us this
young shepherd, called from his habitual

work with his sheep, which are all blissfully ignorant of the miracle taking place (not one ovine head is raised). The young man is clearly overwhelmed by the weight of this encounter. Raphael is less successful in showing us God in the Burning Bush. This is the great problem for all artists: how are they to depict the invisible God? If he takes form, as is clearly the case here, what form is even remotely adequate for the Divinity? Yet, this encounter takes God's revelation of himself to a completely new level. It is not just that our representative, Moses, is overwhelmed by the full holiness of God, or that God specifically gives him a message for the chosen people. The theological importance of this meeting is that Moses dares to ask God his name. Up to now he has been the God of our fathers, but Moses does not feel this is personal enough. Here is humanity searching into the greatest of mysteries, the nature of God. God's astonishing answer is re-echoed more than once by Jesus in the New Testament. His reply to Moses is, 'I am that I am'. God is pure being, contingent on nothing whatsoever, He simply 'is'. Since no artist could possibly depict this, Raphael involves us rather with the trembling Moses, in the green countryside, innocent of the intrigues of the distant cities.

And the LORD said to Aaron, Go into the wilderness to meet Moses. And he went, and met him in the mount of God, and kissed him. And Moses and Aaron went and gathered together all the elders of the children of Israel: and Aaron spake all the words which the LORD had spoken unto Moses.

And afterward Moses and Aaron went in, and told Pharaoh, Thus saith the LORD God of Israel, Let my people go, that they may hold a feast unto me in the wilderness. And Pharaoh said, Who is the LORD, that I should obey his voice to let Israel go? I know not the LORD, neither will I let Israel go.

And Pharaoh said, Behold, the people of the land now are many, and ye make them rest from their burdens. And Pharaoh commanded the same day the taskmasters of the people, and their officers, saying, Ye shall no more give the people straw to make brick, as heretofore: let them go and gather straw for themselves. So the people were scattered abroad throughout all the land of Egypt to gather stubble instead of straw.

FROM THE BOOK OF EXODUS, CHAPTERS 3—5

Then the LORD said unto Moses,

> Now shalt thou see what I will do to Pharaoh: lo, he goeth out unto the water; and thou shalt stand by the river's brink. And thou shalt say unto him, Thus saith the LORD, In this thou shalt know that I am the LORD: behold, I will smite with the rod that is in mine hand upon the waters which are in the river, and they shall be turned to blood.

And Moses and Aaron did so, as the LORD commanded; and all the waters that were in the river were turned to blood. And Pharaoh turned and went into his house. And the LORD spake unto Moses,

> Go unto Pharaoh, and say unto him, Thus saith the LORD, Let my people go, that they may serve me. And if thou refuse to let them go, behold, I will smite all thy borders with frogs.

And Aaron stretched out his hand over the waters of Egypt; and the frogs came up, and covered the land of Egypt. Then Pharaoh called for Moses and Aaron, and said, Intreat the LORD, that he may take away the frogs from me, and from my people; and I will let the people go.

And Moses cried unto the LORD; and the frogs died out of the houses, out of the villages, and out of the fields. And they gathered them together upon heaps: and the land stank. But when Pharaoh saw that there was respite, he hardened his heart, and hearkened not unto them.

And the LORD said unto Moses, Say unto Aaron, Stretch out thy rod, and smite the dust of the land, that it may become lice throughout all the land of Egypt. And they did so; and Pharaoh's heart was hardened, and he hearkened not unto them. And the LORD said unto Moses,

> Rise up early in the morning, and stand before Pharaoh; lo, he cometh forth to the water; and say unto him, Thus saith the LORD, Let my people go, that they may serve me. Else, if thou wilt not let my people go, behold, I will send swarms of flies upon thee.

And the LORD did so; and there came a grievous swarm of flies into the house of Pharaoh, and into his servants' houses, and into all the land of Egypt. And Pharaoh hardened his heart at this time also, neither would he let the people go. Then the LORD said unto Moses,

Go in unto Pharaoh, and tell him, Behold, the hand of the LORD is upon thy cattle: there shall be a very grievous murrain.

And the LORD did that thing on the morrow, and all the cattle of Egypt died: but of the cattle of the children of Israel died not one. And the heart of Pharaoh was hardened, and he did not let the people go.

And the LORD said unto Moses and unto Aaron, Take to you handfuls of ashes of the furnace, and let Moses sprinkle it toward the heaven in the sight of Pharaoh. And they took ashes of the furnace, and stood before Pharaoh; and Moses sprinkled it up toward heaven; and it became a boil breaking forth with blains upon man, and upon beast. And the LORD hardened the heart of Pharaoh, and he hearkened not unto them. And the LORD said unto Moses,

> Rise up early in the morning, and stand before Pharaoh, and say unto him, Behold, to morrow about this time I will cause it to rain a very grievous hail, such as hath not been in Egypt since the foundation thereof even until now.

And Moses stretched forth his rod toward heaven: and the LORD rained hail upon the land of Egypt. Only in the land of Goshen, where the children of Israel were, was there no hail. And Pharaoh sent, and called for Moses and Aaron, and said unto them, I have sinned this time. Intreat the LORD and I will let you go.

And Moses spread abroad his hands unto the LORD: and the thunders and hail ceased, and the rain was not poured upon the earth. And when Pharaoh saw that the rain and the hail and the thunders were ceased, he sinned yet more, and hardened his heart, he and his servants. And Moses and Aaron came in unto Pharaoh, and said unto him,

> Thus saith the LORD God of the Hebrews, If thou refuse to let my people go, behold, to morrow will I bring the locusts into thy coast: and they shall cover the face of the earth.

And Moses stretched forth his rod. And the locusts went up over all the land of Egypt, and they did eat every herb of the land, and all the fruit of the trees which the hail had left: and there remained not any green thing through all the land of Egypt. Then Pharaoh called for Moses and Aaron in haste; and he said,

Forgive, I pray thee, my sin only this once, and intreat the LORD your God, that he may take away from me this death only.

And he went out from Pharaoh, and intreated the LORD. And the LORD turned a mighty strong west wind, which took away the locusts, and cast them into the Red sea; there remained not one locust in all the coasts of Egypt. But the LORD hardened Pharaoh's heart, so that he would not let the children of Israel go.

And the LORD said unto Moses, Stretch out thine hand toward heaven, that there may be darkness over the land of Egypt, even darkness which may be felt. And Moses stretched forth his hand toward heaven; and there was a thick darkness in all the land of Egypt three days. But the LORD hardened Pharaoh's heart, and he would not let them go.

FROM THE BOOK OF EXODUS, CHAPTERS 5—10

THE FIRST PASSOVER

The LORD said unto Moses,

Yet will I bring one plague more upon Pharaoh, and upon Egypt; afterwards he will let you go hence: about midnight will I go out into the midst of Egypt: and all the firstborn in the land of Egypt shall die.

Speak ye unto all the congregation of Israel, saying, In the tenth day of this month they shall take to them every man a lamb, according to the house of their fathers: and the whole assembly of the congregation of Israel shall kill it in the evening. And they shall take of the blood, and strike it on the two side posts and on the upper door post of the houses, wherein they shall eat it.

And thus shall ye eat it; with your loins girded, your shoes on your feet, and your staff in your hand; and ye shall eat it in haste: it is the LORD's passover. For I will pass through the land of Egypt this night, and will smite all the firstborn in the land of Egypt, both man and beast. And the blood shall be to you for a token upon the houses where ye are: and when I see the blood,

I will pass over you, and the plague shall not be upon you to destroy you.

And it came to pass, that at midnight the LORD smote all the firstborn in the land of Egypt, from the firstborn of Pharaoh that sat on his throne unto the firstborn of the captive that was in the dungeon. And Pharaoh called for Moses and Aaron by night, and said, Rise up, and get you forth from among my people, both ye and the children of Israel.

And the children of Israel journeyed from Rameses to Succoth, about six hundred thousand on foot that were men, beside children.

FROM THE BOOK OF EXODUS, CHAPTERS 11—12

THE PASSAGE THROUGH THE RED SEA

It was told the king of Egypt that the people fled: and the heart of Pharaoh and of his servants was turned against the people, and they said, Why have we done this, that we have let Israel go from serving us? And he made ready his chariot, and he pursued after the children of Israel, all the horses and chariots of Pharaoh, and his horsemen, and his army, and overtook them encamping by the sea.

And when Pharaoh drew nigh, the children of Israel lifted up their eyes, and, behold, the Egyptians marched after them; and they were sore afraid. And Moses said unto the people, Fear ye not, stand still, and see the salvation of the LORD, which he will shew to you to day. And Moses stretched out his hand over the sea; and the LORD caused the sea to go back by a strong east wind all that night, and made the sea dry land, and the waters were divided. And the children of Israel went into the midst of the sea upon the dry ground: and the waters were a wall unto them on their right hand, and on their left. And the Egyptians pursued, and went in after them to the midst of the sea, even all Pharaoh's horses, his chariots, and his horsemen.

And the LORD said unto Moses, Stretch out thine hand over the sea. And Moses stretched forth his hand over the sea, and the waters returned, and covered the chariots, and the horsemen, and all the host of Pharaoh that came into the sea after them; there remained not so much as one of them.

FROM THE BOOK OF EXODUS, CHAPTER 14

Pharaoh's Hosts Engulfed in the Red Sea, by Lucas Cranach the Elder (1472–1553)

Of all God's miracles of salvation, their escape from Egypt was the most significant for the Israelites. The Passover is still the great event of the Jewish Liturgical Year, and Christians too rejoice in it. They see it as a forerunner of the passing over of Jesus in his crucifixion and resurrection. The culmination of that great escape from the enemy was the extraordinary passage through the Red Sea. This symbolizes all that God is to us: he leads us from slavery to freedom, and he preserves us in safety against all the threats of the enemy and against all the obstacles of the natural world. Although everybody recognizes the pivotal importance of the crossing of the Red Sea, it has never been easy to display visually such an overthrow of nature. Few artists have tackled it, mostly those who are drawn to the grandiloquent, whose work tends to be over-theatrical.

Cranach is a far more sober artist, and in his very lack of eloquence comes close to showing us utter disaster on the one side, utter salvation on the other. It is a chilling vision, as the Egyptians lie in a great armoured pile, the water blocking their approach to the Israelites, and overwhelming them in disaster. The waves at bottom left suggest to me a clenched hand: God's protection. The Israelites are suitably awed at such a tragedy. Cranach is fully aware that this great miracle does indeed involve a tragedy. There is a moving Rabbinic legend of the rejoicing in heaven at such an overthrow of God's enemies, and God rebuking the angels. How could he be glad at the death of his Egyptian children? However, in this case it is his Hebrew children who must be protected and the marvellous definitiveness of this protection has sunk deep into our religious consciousness. Simply because he does not attempt to depict such depth Cranach, paradoxically, conveys something of its significance. It is worth noting that without the treachery of Pharaoh, who reneges on his word, there would have been no miracle.

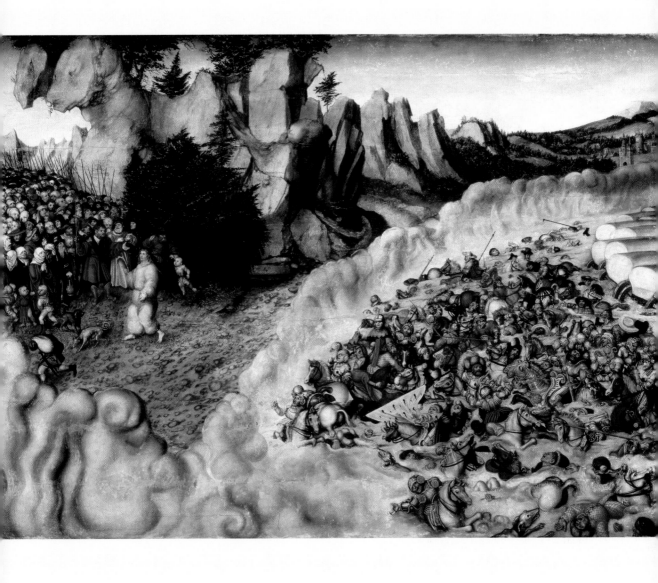

The Ten Commandments

In the third month, when the children of Israel were gone forth out of the land of Egypt, the same day came they into the wilderness of Sinai. And there Israel camped before the mount.

And Moses went up unto God, and the LORD called unto him out of the mountain, saying, Thus shalt thou say to the house of Jacob, and tell the children of Israel; Ye have seen what I did unto the Egyptians, and how I bare you on eagles' wings, and brought you unto myself. Now therefore, if ye will obey my voice indeed, and keep my covenant, then ye shall be a peculiar treasure unto me above all people: for all the earth is mine.

And it came to pass on the third day in the morning, that there were thunders and lightnings, and a thick cloud upon the mount, because the LORD descended upon it in fire: and the smoke thereof ascended as the smoke of a furnace, and the whole mount quaked greatly.

The LORD called Moses up to the top of the mount; and Moses went up. And God spake all these words, saying,

I am the LORD thy God, which have brought thee out of the land of Egypt, out of the house of bondage.

Thou shalt have no other gods before me.

Thou shalt not make unto thee any graven image, or any likeness of any thing that is in heaven above, or that is in the earth beneath, or that is in the water under the earth: Thou shalt not bow down thyself to them, nor serve them.

Thou shalt not take the name of the LORD thy God in vain; for the LORD will not hold him guiltless that taketh his name in vain.

Remember the sabbath day, to keep it holy. Six days shalt thou labour, and do all thy work: but the seventh day is the sabbath of the LORD thy God: in it thou shalt not do any work.

Honour thy father and thy mother: that thy days may be long upon the land which the LORD thy God giveth thee.

Thou shalt not kill.

Thou shalt not commit adultery.

Thou shalt not steal.

Thou shalt not bear false witness against thy neighbour.

Thou shalt not covet thy neighbour's house, thou shalt not covet thy neighbour's wife, nor his manservant, nor his maidservant, nor his ox, nor his ass, nor any thing that is thy neighbour's.

And all the people saw the thunderings, and the lightnings, and the noise of the trumpet, and the mountain smoking: and when the people saw it, they removed, and stood afar off.

And the LORD said unto Moses, I will give thee tables of stone, and a law, and commandments which I have written; that thou mayest teach them. And the glory of the LORD abode upon mount Sinai, and Moses was in the mount forty days and forty nights.

FROM THE BOOK OF EXODUS, CHAPTERS 19—20, 24

THE ARK OF THE COVENANT

The LORD spake unto Moses, saying,

> Speak unto the children of Israel, that they make me a sanctuary; that I may dwell among them. They shall make an ark of shittim wood. And thou shalt overlay it with pure gold, within and without shalt thou overlay it. And thou shalt make a mercy seat of pure gold. And thou shalt make two cherubims of gold, of beaten work shalt thou make them, in the two ends of the mercy seat. And the cherubims shall stretch forth their wings on high, covering the mercy seat with their wings, and their faces shall look one to another. And thou shalt put the mercy seat above upon the ark; and I will commune with thee from above the mercy seat, from between the two cherubims.

FROM THE BOOK OF EXODUS, CHAPTER 25

THE GOLDEN CALF

When the people saw that Moses delayed to come down out of the mount, the people gathered themselves together unto Aaron, and said unto him, Up, make us

gods, which shall go before us; for as for this Moses, the man that brought us up out of the land of Egypt, we wot not what is become of him.

And Aaron said unto them, Break off the golden earrings, which are in the ears of your wives, of your sons, and of your daughters, and bring them unto me. And all the people brake off the golden earrings which were in their ears, and brought them unto Aaron. And he received them at their hand, and fashioned it with a graving tool, after he had made it a molten calf: and they said, These be thy gods, O Israel, which brought thee up out of the land of Egypt.

And the people sat down to eat and to drink, and rose up to play.

And the LORD said unto Moses, Go, get thee down; for thy people, which thou broughtest out of the land of Egypt, have corrupted themselves. And Moses turned, and went down from the mount, and the two tables of the testimony were in his hand. And it came to pass, as soon as he came nigh unto the camp, that he saw the calf, and the dancing: and Moses' anger waxed hot, and he cast the tables out of his hands, and brake them beneath the mount.

Moses with the Tables of the Law, by Rembrandt van Rijn (1606–1699)

It would seem that God could not give his people the Ten Commandments until they had been led out of Egypt and were waiting in the purity of the desert before they reached their Promised Land. These Ten Commandments are central to the living of a life that fulfils us as human beings, and so is pleasing to God. With the greatest solemnity, God summons Moses up Mount Sinai, and there, amidst thunderings and lightnings and extraordinary phenomena, the Lord gives Moses two tables of stone. On them he has written the Commandments. So overwhelming is this experience that Moses remains rapt in God's presence for 40 days. The people murmur, complain and misbehave. When Moses finally comes down from his mountain ecstasy, reverently holding the sacred tables, he finds the people worshipping a golden calf. Rembrandt, so sensitive to high emotion, captures the moment of terrible disillusionment that drives Moses to hurl the Tables of the Law down onto the rocks. Nothing is clear in this great painting except the anguished angry figure of the great prophet and the sacred laws he now feels his people are unworthy to receive.

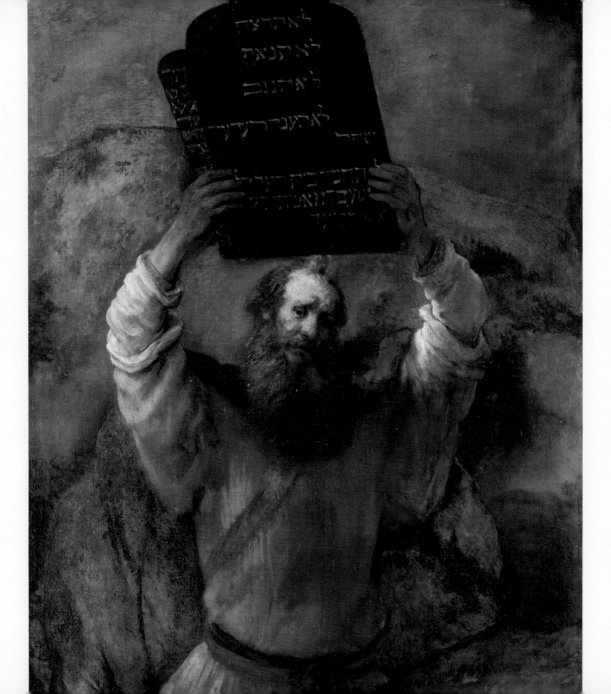

And he took the calf which they had made, and burnt it in the fire, and ground it to powder, and strawed it upon the water, and made the children of Israel drink of it.

And it came to pass on the morrow, that Moses said unto the people, Ye have sinned a great sin: and now I will go up unto the LORD; peradventure I shall make an atonement for your sin. And Moses returned unto the LORD, and said,

> Oh, this people have sinned a great sin, and have made them gods of gold. Yet now, if thou wilt forgive their sin—; and if not, blot me, I pray thee, out of thy book which thou hast written.

And the LORD said unto Moses, Whosoever hath sinned against me, him will I blot out of my book. And the LORD plagued the people, because they made the calf, which Aaron made.

FROM THE BOOK OF EXODUS, CHAPTER 32

THE LAST WORDS OF MOSES

These be the words which Moses spake unto all Israel on this side Jordan in the wilderness, in the plain over against the Red sea:

Hear, O Israel: The LORD our God is one LORD: And thou shalt love the LORD thy God with all thine heart, and with all thy soul, and with all thy might.

Ye shall not go after other gods, of the gods of the people which are round about you; lest the anger of the LORD thy God be kindled against thee, and destroy thee from off the face of the earth. And thou shalt do that which is right and good in the sight of the LORD: that it may be well with thee, and that thou mayest go in and possess the good land which the LORD sware unto thy fathers.

And Moses went up from the plains of Moab unto the mountain of Nebo, to the top of Pisgah, that is over against Jericho. And Moses the servant of the LORD died there in the land of Moab. And he buried him in a valley in the land of Moab, over against Bethpeor: but no man knoweth of his sepulchre unto this day. And the children of Israel wept for Moses in the plains of Moab thirty days. And there arose not a prophet since in Israel like unto Moses, whom the LORD knew face to face.

FROM THE BOOK OF DEUTERONOMY, CHAPTERS 1, 6, 34

5. THE CONQUEST OF CANAAN

Joshua is the hero who brings Moses' work to completion. The vocation of Moses should have been, or so we would think, to lead his people all the way from the misery of Egypt to the happy security of the Promised Land. This was his goal: this is what drove him through the difficult pilgrimage across the barren wastes of Sinai. But before they reach the Jordan, and cross over into that blessed land, Moses dies and leadership passes to Joshua. Somehow, Joshua has never engaged the imagination of readers, as have his great predecessors: Abraham, Isaac, Jacob, Joseph and Moses himself. Yet, his work is crucial. He is a fighting man and a practical man. He puts his mind as well as his military skill to the problem of crossing the Jordan and encountering – and conquering – the people who live in the land that God has promised to the Israelites. God even works miracles in making this goal achievable. This is fine, of course, for the children of Israel, but very hard luck for the people of Canaan. It is not that God rejects this people, or indeed, any people. These stories have a symbolic significance; they are showing us how God will use all circumstances, bad as well as good, to reach an end that will be of universal value. This is a long-term policy; all the nations of the earth will one day be blessed through the chosen people.

RAHAB AND THE SPIES

Now after the death of Moses the servant of the LORD it came to pass, that the LORD spake unto Joshua the son of Nun, Moses' minister, saying,

> Moses my servant is dead; now therefore arise, go over this Jordan, thou, and all this people, unto the land which I do give to them. Be strong and of a good courage; be not afraid, neither be thou dismayed: for the LORD thy God is with thee whithersoever thou goest.

And Joshua the son of Nun sent out of Shittim two men to spy secretly, saying, Go view the land, even Jericho. And they went, and came into an harlot's house, named Rahab, and lodged there.

And it was told the king of Jericho, saying, Behold, there came men in hither to night of the children of Israel to search out the country. And the king of Jericho sent unto Rahab, saying, Bring forth the men that are come to thee, which are entered into thine house. And the woman took the two men, and hid them, and said thus,

There came men unto me, but I wist not whence they were: And it came to pass about the time of shutting of the gate, when it was dark, that the men went out: whither the men went I wot not: pursue after them quickly; for ye shall overtake them.

But she had brought them up to the roof of the house, and hid them with the stalks of flax, which she had laid in order upon the roof. And before they were laid down, she came up unto them upon the roof. And she said unto the men,

> I know that the LORD hath given you the land, and that your terror is fallen upon us. Now therefore, I pray you, swear unto me by the LORD, since I have shewed you kindness, that ye will save alive my father, and my mother, and my brethren, and my sisters, and all that they have, and deliver our lives from death.

And the men answered her, Our life for yours, if ye utter not this our business. And it shall be, when the LORD hath given us the land, that we will deal kindly and truly with thee. Then she let them down by a cord through the window: for her house was upon the town wall. And the men said unto her, Behold, when we come

into the land, thou shalt bind this line of scarlet thread in the window which thou didst let us down by.

So the two men returned, and descended from the mountain, and passed over, and came to Joshua the son of Nun, and told him all things that befell them: And they said unto Joshua, Truly the LORD hath delivered into our hands all the land; for even all the inhabitants of the country do faint because of us.

FROM THE BOOK OF JOSHUA, CHAPTERS 1, 2

THE CROSSING OF THE JORDAN

Joshua came to Jordan, he and all the children of Israel. And Joshua said unto the people,

> Come hither, and hear the words of the LORD your God. Behold, the ark of the covenant of the LORD of all the earth passeth over before you into Jordan.

And it came to pass, when the people removed from their tents, to pass over Jordan, and the priests bearing the ark of the covenant before the people; And as they that bare the ark were come unto

Jordan, and the feet of the priests that bare the ark were dipped in the brim of the water, that the waters which came down from above stood and rose up upon an heap: and the people passed over right against Jericho.

And the priests that bare the ark of the covenant of the LORD stood firm on dry ground in the midst of Jordan, and all the Israelites passed over on dry ground, until all the people were passed clean over Jordan. And the LORD spake unto Joshua, saying, Command the priests that bear the ark of the testimony, that they come up out of Jordan. Joshua therefore commanded the priests, saying, Come ye up out of Jordan.

And it came to pass, when the priests that bare the ark of the covenant of the LORD were come up out of the midst of Jordan, and the soles of the priests' feet were lifted up unto the dry land, that the waters of Jordan returned unto their place, and flowed over all his banks, as they did before.

And it came to pass, when all the kings of the Amorites, which were on the side of Jordan westward, and all the kings of the Canaanites, which were by the sea, heard that the LORD had dried up the waters of Jordan from before the children of Israel, until we were passed over, that their heart melted, neither was there spirit in them any more.

FROM THE BOOK OF JOSHUA, CHAPTERS 3—5

THE BATTLE OF JERICHO

Now Jericho was straitly shut up because of the children of Israel: none went out, and none came in. And the LORD said unto Joshua,

> See, I have given into thine hand Jericho, and the king thereof, and the mighty men of valour. And ye shall compass the city, all ye men of war, and go round about the city once. Thus shalt thou do six days. And seven priests shall bear before the ark seven trumpets of rams' horns: and the seventh day ye shall compass the city seven times, and the priests shall blow with the trumpets.

And it came to pass, when Joshua had spoken unto the people, that the armed men went before the priests that blew with the trumpets, and the rereward came after the ark, the priests going on, and

blowing with the trumpets. So the ark of the LORD compassed the city, going about it once: and they came into the camp, and lodged in the camp. And the second day they compassed the city once, and returned into the camp: so they did six days.

And it came to pass on the seventh day, that they rose early about the dawning of the day, and compassed the city after the same manner seven times: only on that day they compassed the city seven times. And it came to pass at the seventh time, when the priests blew with the trumpets, Joshua said unto the people,

> Shout; for the LORD hath given you the city. And the city shall be accursed, even it, and all that are therein, to the LORD: only Rahab the harlot shall live, she and all that are with her in the house, because she hid the messengers that we sent. But all the silver, and gold, and vessels of brass and iron, are consecrated unto the LORD: they shall come into the treasury of the LORD.

So the people shouted when the priests blew with the trumpets: and it came to pass, when the people heard the sound of the trumpet, and the people shouted with a great shout, that the wall fell down flat,

so that the people went up into the city, every man straight before him, and they took the city. And they utterly destroyed all that was in the city, both man and woman, young and old, and ox, and sheep, and ass, with the edge of the sword.

But Joshua had said unto the two men that had spied out the country, Go into the harlot's house, and bring out thence the woman, and all that she hath, as ye sware unto her. And the young men that were spies went in, and brought out Rahab, and her father, and her mother, and her brethren, and all that she had; and they brought out all her kindred, and left them without the camp of Israel.

And they burnt the city with fire, and all that was therein: only the silver, and the gold, and the vessels of brass and of iron, they put into the treasury of the house of the LORD. And Joshua saved Rahab the harlot alive, and her father's household, and all that she had; and she dwelleth in Israel even unto this day; because she hid the messengers, which Joshua sent to spy out Jericho.

So the LORD was with Joshua; and his fame was noised throughout all the country. And Israel served the LORD all the days of Joshua, and all the days of the

elders that overlived Joshua, and which had known all the works of the LORD, that he had done for Israel.

FROM THE BOOK OF JOSHUA, CHAPTERS 6, 24

THE DEATH OF SISERA

All that generation were gathered unto their fathers: and there arose another generation after them, which knew not the LORD, nor yet the works which he had done for Israel. And the children of Israel did evil in the sight of the LORD, and followed other gods, of the gods of the people that were round about them. And the anger of the LORD was hot against Israel; and the LORD sold them into the hand of Jabin king of Canaan, that reigned in Hazor; the captain of whose host was Sisera, which dwelt in Harosheth of the Gentiles. And the children of Israel cried unto the LORD: for he had nine hundred chariots of iron; and twenty years he mightily oppressed the children of Israel.

And Deborah, a prophetess, the wife of Lapidoth, she judged Israel at that time. And she sent and called Barak the son of Abinoam out of Kedeshnaphtali, and said unto him,

Hath not the LORD God of Israel commanded, saying, Go and draw toward mount Tabor, and take with thee ten thousand men? And I will draw unto thee to the river Kishon Sisera, the captain of Jabin's army, with his chariots and his multitude; and I will deliver him into thine hand.

And Barak went up with ten thousand men at his feet: and Deborah went up with him. And Sisera gathered together all his chariots, even nine hundred chariots of iron, and all the people that were with him, from Harosheth of the Gentiles unto the river of Kishon.

And Deborah said unto Barak, Up; for this is the day in which the LORD hath delivered Sisera into thine hand: is not the LORD gone out before thee? So Barak went down from mount Tabor, and ten thousand men after him.

And the LORD discomfited Sisera, and all his chariots, and all his host, with the edge of the sword before Barak; so that Sisera lighted down off his chariot, and fled away on his feet to the tent of Jael the wife of Heber the Kenite: for there was peace between Jabin the king of Hazor and the house of Heber the Kenite. And Jael went out to meet Sisera, and said unto him,

Turn in, my lord, turn in to me; fear not. And when he had turned in unto her into the tent, she covered him with a mantle.

And he said unto her, Give me, I pray thee, a little water to drink; for I am thirsty. And she opened a bottle of milk, and gave him drink, and covered him. Again he said unto her, Stand in the door of the tent, and it shall be, when any man doth come and enquire of thee, and say, Is there any man here? that thou shalt say, No. Then Jael Heber's wife took a nail of the tent, and took an hammer in her hand, and went softly unto him, and smote the nail into his temples, and fastened it into the ground: for he was fast asleep and weary. So he died.

And, behold, as Barak pursued Sisera, Jael came out to meet him, and said unto him, Come, and I will shew thee the man whom thou seekest. And when he came into her tent, behold, Sisera lay dead, and the nail was in his temples. So God subdued on that day Jabin the king of Canaan before the children of Israel. Then sang Deborah and Barak the son of Abinoam on that day, saying,

> Praise ye the LORD for the avenging of Israel,
> when the people willingly offered
> themselves.

The Death of Sisera, by Palma Il Giovane (Jacopo Negretti) (1548–1628)

The story of Jael and Sisera is one of the great melodramatic set pieces of the Bible. It is a tale of treachery, committed in the cause of righteousness. God is certainly not teaching us to practise hospitality with malicious intent. Vivid though the story is and convincing the characters, we have to consider the wicked Sisera almost as disembodied evil, and the murderous Jael as disembodied virtue. Granted, this is not the interpretation that Palma Il Giovane sets before us. His Jael is a beautiful, vigorous woman and his Sisera an exhausted and defeated man. The brutal method of the murder is horrifyingly real. But in case we miss the spiritual meaning of the tragedy, the prophetess Deborah sings a powerful and moving hymn, to make it clear that this is a case of God's enemies being put to death through the great courage of God's friends. For all her focus on slaughter (notice how carefully she positions the nail), this Jael is obviously one of God's true friends. She wears no jewellery or vain adornments and her hair, which Palma imagines as glowing auburn in colour, is roughly knotted at her neck, without vanity. Her expression too is compassionate, though resolute. All that is Sisera within us must be put to death by our inner Jael.

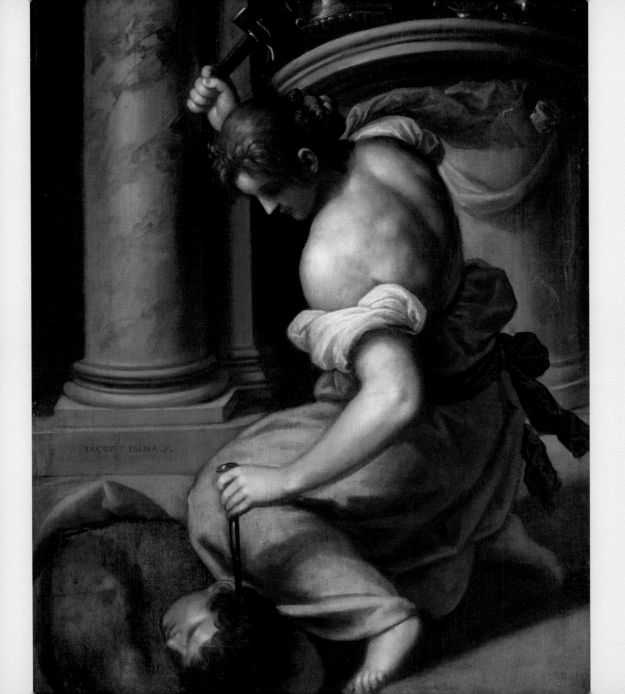

Blessed above women shall Jael the wife
of Heber the Kenite be,
 blessed shall she be above women in
 the tent.
He asked water, and she gave him milk;
 she brought forth butter in a lordly
 dish.
She put her hand to the nail,
 and her right hand to the workmen's
 hammer;
and with the hammer she smote Sisera,
 she smote off his head,
 when she had pierced and stricken
 through his temples.
At her feet he bowed, he fell, he lay
down:
 at her feet he bowed, he fell:
where he bowed, there he fell down
dead.

The mother of Sisera looked out at a
window,
 and cried through the lattice,
Why is his chariot so long in coming?
 why tarry the wheels of his chariots?
Her wise ladies answered her,
 yea, she returned answer to herself,
Have they not sped?
 Have they not divided the prey;
 to every man a damsel or two?

So let all thine enemies perish, O LORD:
 but let them that love him
be as the sun when he goeth forth in
his might.

FROM THE BOOK OF JUDGES, CHAPTERS 2, 4—5

6. Samson and the Philistines

Samson is a great and tragic figure. Here we have a man whose birth is announced by an angel and who is especially chosen to deliver his people from their great enemy the Philistines. He is uniquely gifted, a man of immense physical strength who also possesses an agile and devious mind. His exploits and cunning read like heroic folk tales. Yet all his potential seems to be undermined by his infatuation with the Philistine beauty, Delilah. Certainly, all his happiness, not to mention his freedom, is destroyed by her deceitful wiles: surely, we think, he must have known that she would side with her own people rather than with him? The potential for betrayal seems to us so obvious. Yet, in the end – though not by the means we would have expected – Samson does triumph and does, in a terrible manner, fulfil his vocation. Once again, God is bringing good out of evil, accepting human foolishness and yet still somehow achieving his wise ends. Samson faces bravely the consequences of his mistakes and his repentance allows God to triumph.

Samson's riddle

The children of Israel did evil again in the sight of the LORD; and the LORD delivered them into the hand of the Philistines forty years.

And there was a certain man of Zorah, of the family of the Danites, whose name was Manoah; and his wife was barren, and bare not. And the angel of the LORD appeared unto the woman, and said unto her,

> Behold now, thou art barren, and bearest not: but thou shalt conceive, and bear a son; and no razor shall come on his head: for the child shall be a Nazarite unto God from the womb:

and he shall begin to deliver Israel out of the hand of the Philistines.

And the woman bare a son, and called his name Samson: and the child grew, and the LORD blessed him. And the Spirit of the LORD began to move him at times in the camp of Dan between Zorah and Eshtaol. And Samson went down to Timnath, and saw a woman in Timnath of the daughters of the Philistines. And he came up, and told his father and his mother, and said, I have seen a woman in Timnath of the daughters of the Philistines: now therefore get her for me to wife.

Then went Samson down to the vineyards of Timnath: and, behold, a young lion

roared against him. And the Spirit of the LORD came mightily upon him, and he rent him as he would have rent a kid.

And he went down, and talked with the woman; and she pleased Samson well. And after a time he returned to take her, and he turned aside to see the carcase of the lion: and, behold, there was a swarm of bees and honey in the carcase of the lion. And he took thereof in his hands, and went on eating, and came to his father and mother.

So his father went down unto the woman: and Samson made there a feast; for so used the young men to do. And it came to pass, when they saw him, that they brought thirty companions to be with him. And Samson said unto them, I will now put forth a riddle unto you: if ye can certainly declare it me within the seven days of the feast, and find it out, then I will give you thirty sheets and thirty change of garments: But if ye cannot declare it me, then shall ye give me thirty sheets and thirty change of garments. And they said unto him, Put forth thy riddle, that we may hear it.

And he said unto them, Out of the eater came forth meat, and out of the strong came forth sweetness. And they could not in three days expound the riddle. And it came to pass on the seventh day, that they said unto Samson's wife, Entice thy husband, that he may declare unto us the riddle, lest we burn thee and thy father's house with fire.

And Samson's wife wept before him, and said, Thou dost but hate me, and lovest me not: thou hast put forth a riddle unto the children of my people, and hast not told it me. And he said unto her, Behold, I have not told it my father nor my mother, and shall I tell it thee? And she wept before him the seven days, while their feast lasted: and it came to pass on the seventh day, that he told her, because she lay sore upon him: and she told the riddle to the children of her people.

And the men of the city said unto him on the seventh day before the sun went down, What is sweeter than honey? And what is stronger than a lion? And he said unto them, If ye had not plowed with my heifer, ye had not found out my riddle.

And the Spirit of the LORD came upon him, and he went down to Ashkelon, and slew thirty men of them, and took their spoil, and gave change of garments unto them which expounded the riddle. And his anger was kindled, and he went up to his father's house.

FROM THE BOOK OF JUDGES, CHAPTERS 13—15

Samson and Delilah

Then went Samson to Gaza, and saw there an harlot, and went in unto her. And it was told the Gazites, saying, Samson is come hither. And they compassed him in, and laid wait for him all night in the gate of the city. And Samson lay till midnight, and arose at midnight, and took the doors of the gate of the city, and the two posts, and went away with them, bar and all, and put them upon his shoulders, and carried them up to the top of an hill that is before Hebron.

And it came to pass afterward, that he loved a woman in the valley of Sorek, whose name was Delilah. And the lords of the Philistines came up unto her, and said unto her,

> Entice him, and see wherein his great strength lieth, and by what means we may prevail against him; and we will give thee every one of us eleven hundred pieces of silver.

And Delilah said to Samson, Tell me, I pray thee, wherein thy great strength lieth. And Samson said unto her, If they bind me with seven green withs that were never dried, then shall I be weak, and be as another man. Then the lords of the Philistines brought up to her seven green withs which had not been dried, and she bound him with them. Now there were men lying in wait, abiding with her in the chamber. And she said unto him, The Philistines be upon thee, Samson. And he brake the withs, as a thread of tow is broken when it toucheth the fire.

And Delilah said unto Samson, Behold, thou hast mocked me, and told me lies: now tell me, I pray thee, wherewith thou mightest be bound. And he said unto her, If they bind me fast with new ropes that never were occupied, then shall I be weak, and be as another man. Delilah therefore took new ropes, and bound him therewith, and said unto him, The Philistines be upon thee, Samson. And he brake them from off his arms like a thread.

And Delilah said unto Samson, Hitherto thou hast mocked me, and told me lies: tell me wherewith thou mightest be bound. And he said unto her, If thou weavest the seven locks of my head with the web. And she fastened it with the pin, and said unto him, The Philistines be upon thee, Samson. And he awaked out of his sleep, and went away with the pin of the beam, and with the web.

And she said unto him, How canst thou say, I love thee, when thine heart is not

with me? Thou hast mocked me these three times, and hast not told me wherein thy great strength lieth. And it came to pass, when she pressed him daily with her words, and urged him, so that his soul was vexed unto death; that he told her all his heart, and said unto her,

> There hath not come a razor upon mine head; for I have been a Nazarite unto God from my mother's womb: if I be shaven, then my strength will go from me, and I shall become weak, and be like any other man.

And when Delilah saw that he had told her all his heart, she sent and called for the lords of the Philistines, saying, Come up this once, for he hath shewed me all his heart. Then the lords of the Philistines came up unto her, and brought money in their hand. And she made him sleep upon her knees; and she called for a man, and she caused him to shave off the seven locks of his head; and she began to afflict him, and his strength went from him. And she said, The Philistines be upon thee, Samson. And he awoke out of his sleep, and said, I will go out as at other times before, and shake myself. And he wist not that the LORD was departed from him.

FROM THE BOOK OF JUDGES, CHAPTER 16

Samson and Delilah, by Peter Paul Rubens (1577–1640)

Quite a few artists have been drawn by the poignancy of this tragedy: a great man destroys himself because of his love for an unworthy woman. None has treated this theme with greater insight than Rubens. Here Delilah, by persistence and by charm, has finally coaxed from Samson his secret: his physical strength lies in his hair, uncut from birth. He has long resisted, but has now succumbed, and lies, naked and helpless, asleep in the lap of the woman he trusts. She has summoned a barber, who is shaving his locks with infinite care, so as not to awake him. Delilah's mother (or servant?) holds a candle to facilitate the shearing. At the door the Philistines, in full armour, still terrified of Samson's potential, await her summons. What distinguishes Rubens' treatment of the story is his understanding of Delilah. She has all the full, rich beauty of the typical Rubens woman: we understand Samson's enthralment. But her lovely face is conflicted as she lays a tender hand on that great muscular back. Yes, she has betrayed him, as was her patriotic duty; but she grieves, she wishes it were not so. The old woman, the eager and intent Philistine barber, the warriors at the door, all are straightforward in their emotional intensity. Delilah is torn two ways.

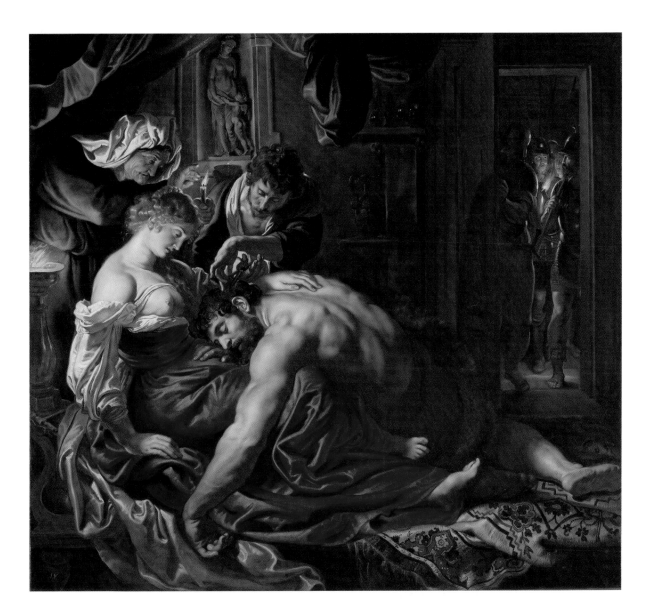

SAMSON'S REVENGE

The Philistines took him, and put out his eyes, and brought him down to Gaza, and bound him with fetters of brass; and he did grind in the prison house. Howbeit the hair of his head began to grow again after he was shaven.

Then the lords of the Philistines gathered them together for to offer a great sacrifice unto Dagon their god, and to rejoice: for they said, Our god hath delivered Samson our enemy into our hand.

And it came to pass, when their hearts were merry, that they said, Call for Samson, that he may make us sport. And they called for Samson out of the prison house; and he made them sport: and they set him between the pillars. And Samson said unto the lad that held him by the hand, Suffer me that I may feel the pillars whereupon the house standeth, that I may lean upon them.

Now the house was full of men and women; and all the lords of the Philistines were there; and there were upon the roof about three thousand men and women, that beheld while Samson made sport. And Samson called unto the LORD, and said, O LORD God, remember me, I pray thee, and strengthen me, I pray thee, only this once, O God, that I may be at once avenged of the Philistines for my two eyes.

And Samson took hold of the two middle pillars upon which the house stood, and on which it was borne up, of the one with his right hand, and of the other with his left. And Samson said, Let me die with the Philistines. And he bowed himself with all his might; and the house fell upon the lords, and upon all the people that were therein.

So the dead which he slew at his death were more than they which he slew in his life.

FROM THE BOOK OF JUDGES, CHAPTER 16

7. The story of Ruth

The Book of Ruth is one of the shortest, and perhaps most surprising, in the Old Testament. If the tragedy of Samson, related in Judges, is a 'she-done-him-wrong thriller', then the story of Ruth, neat and compact, could be called a tender romance. However, the romance is not really between man and woman – though that is still there – but between mother and daughter-in-law. Ruth is one of the ancestors of Christ: she is mentioned in the Gospel genealogy. Perhaps her genealogical significance is that she is not an Israelite, to show that the pagans too had a share in the genetic inheritance of Christ. Yet the beauty of this short story is more than its biological significance. The sweetness of the relationship between Ruth and Naomi is extraordinarily touching, and so is the gentlemanly conduct of Boaz. Everybody in this book acts well. This is how we want God's people to move towards their destiny, with love and dignity and consideration of others. There is not much of it in sacred Scripture, and it may be that there is not much of it in ordinary life. But it does exist to comfort and inspire us, and, as always in the Scriptures, to become part of the greater story that the Bible is always telling us.

Ruth and Naomi

Now it came to pass in the days when the judges ruled, that there was a famine in the land. And a certain man of Bethlehemjudah went to sojourn in the country of Moab, he, and his wife, and his two sons. And the name of the man was Elimelech, and the name of his wife Naomi, and the name of his two sons Mahlon and Chilion.

And Elimelech Naomi's husband died; and she was left, and her two sons. And they took them wives of the women of Moab; the name of the one was Orpah, and the name of the other Ruth: and they dwelled there about ten years. And Mahlon and Chilion died also both of them; and the woman was left of her two sons and her husband. Then she arose with her daughters in law, that she might return from the country of Moab. And Naomi said unto her two daughters in law,

Turn again, my daughters: why will ye go with me? Are there yet any more sons in my womb, that they may be your husbands? Turn again, my daughters, go your way; for it grieveth me much for your sakes that the hand of the LORD is gone out against me. And they lifted up their

voice, and wept: and Orpah kissed her mother in law; but Ruth clave unto her. And she said,

> Intreat me not to leave thee, or to return from following after thee: for whither thou goest, I will go; and where thou lodgest, I will lodge: thy people shall be my people, and thy God my God: Where thou diest, will I die, and there will I be buried: the LORD do so to me, and more also, if ought but death part thee and me.

So they two went until they came to Bethlehem. And it came to pass, when they were come to Bethlehem, that all the city was moved about them, and they said, Is this Naomi? And she said unto them, Call me not Naomi, call me Mara: for the Almighty hath dealt very bitterly with me.

So Naomi returned, and Ruth the Moabitess, her daughter in law, with her, which returned out of the country of Moab: and they came to Bethlehem in the beginning of barley harvest.

FROM THE BOOK OF RUTH, CHAPTER 1

RUTH AND BOAZ

Naomi had a kinsman of her husband's, a mighty man of wealth, of the family of Elimelech; and his name was Boaz. And Ruth the Moabitess said unto Naomi, Let me now go to the field, and glean ears of corn after him in whose sight I shall find grace. And she said unto her, Go, my daughter. And she went, and came, and gleaned in the field after the reapers: and her hap was to light on a part of the field belonging unto Boaz, who was of the kindred of Elimelech. And, behold, Boaz came from Bethlehem, and said unto the reapers, The LORD be with you. And they answered him, The LORD bless thee.

Then said Boaz unto his servant that was set over the reapers, Whose damsel is this? And the servant that was set over the reapers answered and said, It is the Moabitish damsel that came back with Naomi out of the country of Moab.

Then said Boaz unto Ruth, Hearest thou not, my daughter? Go not to glean in another field, neither go from hence, but abide here fast by my maidens: Let thine eyes be on the field that they do reap, and go thou after them: have I not charged the young men that they shall not touch thee?

So she gleaned in the field until even, and beat out that she had gleaned: and it was about an ephah of barley. And she took it up, and went into the city: and her mother in law said unto her, Where hast thou gleaned to day? And where wroughtest thou? Blessed be he that did take knowledge of thee. And she shewed her mother in law with whom she had wrought, and said, The man's name with whom I wrought to day is Boaz. Then Naomi her mother in law said unto her,

> Is not Boaz of our kindred, with whose maidens thou wast? Behold, he winnoweth barley to night in the threshingfloor. Wash thyself therefore, and anoint thee, and put thy raiment upon thee, and get thee down to the floor: but make not thyself known unto the man, until he shall have done eating and drinking. And it shall be, when he lieth down, that thou shalt mark the place where he shall lie, and thou shalt go in, and uncover his feet, and lay thee down; and he will tell thee what thou shalt do.

And she said unto her, All that thou sayest unto me I will do. And she went down unto the floor. And when Boaz had eaten and drunk, and his heart was merry, he went to lie down at the end of the heap of corn: and she came softly, and uncovered his feet, and laid her down.

And it came to pass at midnight, that the man was afraid, and turned himself: and, behold, a woman lay at his feet. And he said, Who art thou? And she answered, I am Ruth thine handmaid: spread therefore thy skirt over thine handmaid; for thou art a near kinsman. And he said,

> Blessed be thou of the LORD, my daughter: for thou hast shewed more kindness in the latter end than at the beginning, inasmuch as thou followedst not young men, whether poor or rich.

And she lay at his feet until the morning: and she rose up before one could know another. And he said, Let it not be known that a woman came into the floor. Also he said, Bring the vail that thou hast upon thee, and hold it. And when she held it, he measured six measures of barley, and laid it on her: and she went into the city. And when she came to her mother in law, she said, Sit still, my daughter, until thou know how the matter will fall: for the man will not be in rest, until he have finished the thing this day.

Then went Boaz up to the gate, and sat him down there. And Boaz said unto the elders, and unto all the people,

> Ye are witnesses this day, that Ruth the Moabitess, the wife of Mahlon, have I purchased to be my wife, to raise up the name of the dead upon his inheritance, that the name of the dead be not cut off from among his brethren, and from the gate of his place: ye are witnesses this day.

And all the people that were in the gate, and the elders, said, We are witnesses. So Boaz took Ruth, and she was his wife: and when he went in unto her, the LORD gave her conception, and she bare a son. And Naomi took the child, and laid it in her bosom, and became nurse unto it; and they called his name Obed: he is the father of Jesse, the father of David.

FROM THE BOOK OF RUTH, CHAPTERS 2—4

Summer (Ruth and Boaz), by Nicolas Poussin (1594–1665)

Towards the end of his life, Poussin produced four great canvases to illustrate the four seasons, using for each an appropriate episode from the Bible. For summer, he took the story of Ruth and Boaz. Since they came to know each other during the harvest season, a field of ripe corn is an apt setting. Poussin is one of the greatest of landscape painters, and this richly glowing plain is unforgettable. Its fertility stretches out to the distant mountains, golden and inviting. It is, of course, a symbol of the fertility that this young widow will bring to her new husband. Poussin shows their first encounter: Ruth is the poor relation kneeling before him begging his help; Boaz, quite unaware of future possibilities, generously orders his servant to give every assistance to his impoverished cousin-in-law, as she goes gleaning. Later, Naomi counsels her to sleep in the field at her benefactor's feet. The language here is very modest, and we need to know that 'uncovering feet', and 'spreading a skirt over' someone, are euphemisms for a physical encounter. Her act and his act make Ruth his wife. She will bear a son and Naomi will be his nurse.

8. SAMUEL AND SAUL

Samuel is one of Scripture's true servants of God. He seems to be there as what one might call a 'facilitator'. God makes use of him, as it were, to drive on the sacred story. It is because he is God's trusted friend that the people can turn to him when they want a king. It is a misguided desire, as Samuel, close as he is to God, has no hesitation in explaining. But as always, God will not treat us as puppets. If we insist on a course of action, though it is against our best interests, God will not manipulate us and prevent it. But his fatherly love will always try to save us from the worst consequences of our actions and enable us to make the best of our choices. So it is Samuel who chooses Saul as the first human king of Israel. Up to now, as Scripture makes plain, God has been their King. Now they have to cope with the vagaries and instabilities of even the strongest candidate that Samuel can discover. Saul's is a tragic story: his is a conflicted character, desirous of the good yet often incapable of adhering to it. Despite all of Samuel's help, Saul's life will end, sadly, in suicide. In fact, the greatest significance of poor Saul might well be to emphasize the qualities of his successor, David.

THE BIRTH OF SAMUEL

Now there was a certain man of Ramathaimzophim, of mount Ephraim, and his name was Elkanah. And he had two wives; the name of the one was Hannah, and the name of the other Peninnah: and Peninnah had children, but Hannah had no children.

And this man went up out of his city yearly to worship and to sacrifice unto the LORD of hosts in Shiloh. And when the time was that Elkanah offered, he gave to Peninnah his wife, and to all her sons and her daughters, portions: But unto Hannah he gave a worthy portion; for he loved Hannah: but the LORD had shut up her womb.

And her adversary also provoked her sore, for to make her fret, because the LORD had shut up her womb. And as he did so year by year, when she went up to the house of the LORD, so she provoked her; therefore she wept, and did not eat.

Then said Elkanah her husband to her, Hannah, why weepest thou? Am not I better to thee than ten sons?

So Hannah rose up after they had eaten

in Shiloh, and after they had drunk. Now Eli the priest sat upon a seat by a post of the temple of the LORD. And she was in bitterness of soul, and prayed unto the LORD, and wept sore. And she vowed a vow, and said,

> O LORD of hosts, if thou wilt indeed look on the affliction of thine handmaid, and wilt give unto thine handmaid a man child, then I will give him unto the LORD all the days of his life, and there shall no razor come upon his head.

And it came to pass, as she continued praying before the LORD, that Eli marked her mouth. Now Hannah, she spake in her heart; only her lips moved, but her voice was not heard: therefore Eli thought she had been drunken.

And Eli said unto her, How long wilt thou be drunken? Put away thy wine from thee. And Hannah answered and said, No, my lord, I am a woman of a sorrowful spirit: I have drunk neither wine nor strong drink, but have poured out my soul before the LORD.

Then Eli answered and said, Go in peace: and the God of Israel grant thee thy petition that thou hast asked of him.

And they rose up in the morning early, and worshipped before the LORD, and returned, and came to their house to Ramah: and Elkanah knew Hannah his wife; and the LORD remembered her. Wherefore it came to pass, when the time was come about after Hannah had conceived, that she bare a son, and called his name Samuel, saying, Because I have asked him of the LORD.

And when she had weaned him, she took him up with her, and brought the child to Eli. And she said,

> Oh my lord, as thy soul liveth, my lord, I am the woman that stood by thee here, praying unto the LORD. For this child I prayed; and the LORD hath given me my petition which I asked of him: therefore also I have lent him to the LORD; as long as he liveth he shall be lent to the LORD.

And he worshipped the LORD there. And Hannah prayed, and said,

> My heart rejoiceth in the LORD,
> Mine horn is exalted in the LORD:
> my mouth is enlarged over mine enemies;
> because I rejoice in thy salvation.

And Elkanah went to Ramah to his house. And the child did minister unto the LORD before Eli the priest. Moreover his mother made him a little coat, and brought it to him from year to year, when she came up with her husband to offer the yearly sacrifice.

And Samuel grew on, and was in favour both with the LORD, and also with men. And Samuel judged Israel all the days of his life. And he went from year to year in circuit to Bethel, and Gilgal, and Mizpeh, and judged Israel in all those places. And his return was to Ramah; for there was his house; and there he judged Israel; and there he built an altar unto the LORD.

FROM THE FIRST BOOK OF SAMUEL, CHAPTERS 1—2, 7

THE PEOPLE DEMAND A KING

It came to pass, when Samuel was old, that all the elders of Israel gathered themselves together, and came to Samuel unto Ramah, And said unto him, Behold, thou art old, and thy sons walk not in thy ways: now make us a king to judge us like all the nations.

But the thing displeased Samuel, when they said, Give us a king to judge us. And Samuel prayed unto the LORD. And the LORD said unto Samuel, Hearken unto the voice of the people in all that they say unto thee: for they have not rejected thee, but they have rejected me, that I should not reign over them. And Samuel told all the words of the LORD unto the people that asked of him a king.

Now there was a man of Benjamin, whose name was Kish. And he had a son, whose name was Saul, a choice young man, and a goodly: and there was not among the children of Israel a goodlier person than he: from his shoulders and upward he was higher than any of the people.

And Samuel called the people together unto the LORD to Mizpeh; And said unto the children of Israel, Thus saith the LORD God of Israel, Present yourselves before the LORD by your tribes, and by your thousands. And when Samuel had caused all the tribes of Israel to come near, the tribe of Benjamin was taken. When he had caused the tribe of Benjamin to come near by their families, the family of Matri was taken, and Saul the son of Kish was taken: and when they sought him, he could not be found. Therefore they

enquired of the LORD further, if the man should yet come thither. And the LORD answered, Behold he hath hid himself among the stuff.

And they ran and fetched him thence: and when he stood among the people, he was higher than any of the people from his shoulders and upward. And Samuel said to all the people, See ye him whom the LORD hath chosen, that there is none like him among all the people? And all the people shouted, and said, God save the king.

So Saul took the kingdom over Israel, and fought against all his enemies on every side: and whithersoever he turned himself, he vexed them.

Now the sons of Saul were Jonathan, and Ishui, and Melchi-shua: and the names of his two daughters were these; the name of the firstborn Merab, and the name of the younger Michal.

And there was sore war against the Philistines all the days of Saul: and when Saul saw any strong man, or any valiant man, he took him unto him.

FROM THE FIRST BOOK OF SAMUEL, CHAPTERS 8—10, 14

9. THE EXPLOITS OF DAVID

When Jesus, centuries later, entered Jerusalem on Palm Sunday, the most fervent acclamation that the crowd offered him was: hosanna to the son of David. All the previous scriptural leaders had brought the chosen people out of obscurity, through slavery, through conquest, into the Promised Land and consolidation there. Now David comes to raise them to their highest national status. He was not only their greatest king, but he is the most appealing of all the Old Testament heroes. We feel a kinship with David. He sins so grievously, yet he repents so genuinely. His life reads like an exciting and moving story, to which we instinctively relate because of David's deep humanity. Of all the ancestors of Christ, he has stayed in our minds as the one who matters. It seems fitting, somehow, that the sinless Son of God should have in his lineage a man so gifted, with a heart so large and passions so strong. For all his extraordinary courage, he can stoop to an ignoble murder; the tenderness he feels for Jonathan can turn to weakness over his son Absalom. If Jerusalem is central to Jewish history, then it is David who is central to Jerusalem.

DAVID AND GOLIATH

Now the Philistines gathered together their armies to battle. And Saul and the men of Israel were gathered together, and pitched by the valley of Elah, and set the battle in array against the Philistines. And the Philistines stood on a mountain on the one side, and Israel stood on a mountain on the other side: and there was a valley between them.

And there went out a champion out of the camp of the Philistines, named Goliath, of Gath, whose height was six cubits and a span. And he had an helmet of brass upon his head, and he was armed with a coat of mail; and the weight of the coat was five thousand shekels of brass. And he had greaves of brass upon his legs, and a target of brass between his shoulders. And the staff of his spear was like a weaver's beam; and his spear's head weighed six hundred shekels of iron: and one bearing a shield went before him. And he stood and cried unto the armies of Israel, and said unto them,

Why are ye come out to set your battle in array? Am not I a Philistine, and ye servants to Saul? Choose you a man for you, and let him come down to me. If

he be able to fight with me, and to kill me, then will we be your servants: but if I prevail against him, and kill him, then shall ye be our servants, and serve us.

When Saul and all Israel heard those words of the Philistine, they were dismayed, and greatly afraid.

Now David was the son of that Ephrathite of Bethlehemjudah, whose name was Jesse; and he had eight sons: and the man went among men for an old man in the days of Saul.

And the three eldest sons of Jesse went and followed Saul to the battle: and the names of his three sons that went to the battle were Eliab the firstborn, and next unto him Abinadab, and the third Shammah. And David was the youngest: and the three eldest followed Saul.

But David went and returned from Saul to feed his father's sheep at Bethlehem. And Jesse said unto David his son,

> Take now for thy brethren an ephah of this parched corn, and these ten loaves, and run to the camp of thy brethren; And carry these ten cheeses unto the captain of their thousand, and look how thy brethren fare, and take their pledge.

And David rose up early in the morning, and left the sheep with a keeper, and took, and went, as Jesse had commanded him; and he came to the trench, as the host was going forth to the fight, and shouted for the battle. For Israel and the Philistines had put the battle in array, army against army.

And David left his carriage in the hand of the keeper of the carriage, and ran into the army, and came and saluted his brethren. And as he talked with them, behold, there came up the champion, the Philistine of Gath, Goliath by name, out of the armies of the Philistines, and spake according to the same words: and David heard them. And all the men of Israel, when they saw the man, fled from him, and were sore afraid. And the men of Israel said,

> Have ye seen this man that is come up? surely to defy Israel is he come up: and it shall be, that the man who killeth him, the king will enrich him with great riches, and will give him his daughter, and make his father's house free in Israel.

And David spake to the men that stood by him, saying, What shall be done to the man that killeth this Philistine, and taketh away the reproach from Israel? for who

is this uncircumcised Philistine, that he should defy the armies of the living God? And the people answered him after this manner, saying, So shall it be done to the man that killeth him.

And Eliab his eldest brother heard when he spake unto the men; and Eliab's anger was kindled against David, and he said,

> Why camest thou down hither? and with whom hast thou left those few sheep in the wilderness? I know thy pride, and the naughtiness of thine heart; for thou art come down that thou mightest see the battle.

And David said, What have I now done? Is there not a cause? And he turned from him toward another, and spake after the same manner. And when the words were heard which David spake, they rehearsed them before Saul: and he sent for him.

And David said to Saul, Let no man's heart fail because of him; thy servant will go and fight with this Philistine. And Saul said to David, Thou art not able to go against this Philistine to fight with him: for thou art but a youth, and he a man of war from his youth. And David said unto Saul, Thy servant kept his father's sheep, and there came a lion, and a bear, and took a lamb out of the flock: and I went out after him, and smote him, and delivered it out of his mouth: and when he arose against me, I caught him by his beard, and smote him, and slew him. And Saul said unto David, Go, and the LORD be with thee.

And Saul armed David with his armour, and he put an helmet of brass upon his head; also he armed him with a coat of mail. And David girded his sword upon his armour, and he assayed to go; for he had not proved it. And David said unto Saul, I cannot go with these; for I have not proved them. And David put them off him.

And he took his staff in his hand, and chose him five smooth stones out of the brook, and put them in a shepherd's bag which he had, even in a scrip; and his sling was in his hand: and he drew near to the Philistine. And the Philistine came on and drew near unto David; and the man that bare the shield went before him. And when the Philistine looked about, and saw David, he disdained him: for he was but a youth, and ruddy, and of a fair countenance.

And the Philistine said unto David, Am I a dog, that thou comest to me with staves? And the Philistine cursed David

by his gods. And the Philistine said to David, Come to me, and I will give thy flesh unto the fowls of the air, and to the beasts of the field. Then said David to the Philistine,

> Thou comest to me with a sword, and with a spear, and with a shield: but I come to thee in the name of the LORD of hosts, the God of the armies of Israel, whom thou hast defied.

And it came to pass, when the Philistine arose, and came, and drew nigh to meet David, that David hastened, and ran toward the army to meet the Philistine. And David put his hand in his bag, and took thence a stone, and slang it, and smote the Philistine in his forehead, that the stone sunk into his forehead; and he fell upon his face to the earth.

So David prevailed over the Philistine with a sling and with a stone, and smote the Philistine, and slew him; but there was no sword in the hand of David. Therefore David ran, and stood upon the Philistine, and took his sword, and drew it out of the sheath thereof, and slew him, and cut off his head therewith.

And when the Philistines saw their champion was dead, they fled. And the men of Israel and of Judah arose, and shouted, and pursued the Philistines, until thou come to the valley, and to the gates of Ekron. And David took the head of the Philistine, and brought it to Jerusalem; but he put his armour in his tent.

And when Saul saw David go forth against the Philistine, he said unto Abner, the captain of the host, Abner, whose son is this youth? And Abner said, As thy soul liveth, O king, I cannot tell. And the king said, Enquire thou whose son the stripling is. And as David returned from the slaughter of the Philistine, Abner took him, and brought him before Saul with the head of the Philistine in his hand.

And Saul said to him, Whose son art thou, thou young man? And David answered, I am the son of thy servant Jesse the Bethlehemite.

FROM THE FIRST BOOK OF SAMUEL, CHAPTER 17

David and Goliath, by Edgar Degas (1834–1917)

Many of the great Bible stories that were once familiar to everybody have fallen out of our cultural consciousness, but not David and Goliath. This is a story that strikes a deep chord within us, the overthrow of the mighty by the weak and vulnerable. It is an achievement formidable in itself, but perhaps even more significant is that it propels this young shepherd boy from obscurity into the halls of power. Here is where David's future kingship really begins. Many of the old masters, both painters and sculptors (think of Michelangelo's David), have risen to the challenge that the story presents, but here is a modern version, relatively speaking. It was rare indeed for an impressionist to tackle a scriptural subject, but Degas does so superbly. His attention is less on the towering bulk of the monstrous Goliath than on the sinewy elegance of the unarmed David. All he has going for him is his wits and his shepherd's sling, and we know already that intelligent courage, against all odds and all authoritarian advice, will topple the enemy. Degas draws us into the sheer physical drama of the duel: we sense David's fear, and yet his energy, his determination, his unquenchable vitality, all that will make him the great ancestor of the Messiah, is here before us.

DAVID AND JONATHAN

It came to pass, when he had made an end of speaking unto Saul, that the soul of Jonathan was knit with the soul of David, and Jonathan loved him as his own soul. And Saul took him that day, and would let him go no more home to his father's house. Then Jonathan and David made a covenant, because he loved him as his own soul. And Jonathan stripped himself of the robe that was upon him, and gave it to David, and his garments, even to his sword, and to his bow, and to his girdle.

And David went out whithersoever Saul sent him, and behaved himself wisely: and Saul set him over the men of war, and he was accepted in the sight of all the people, and also in the sight of Saul's servants.

And it came to pass as they came, when David was returned from the slaughter of the Philistine, that the women came out of all cities of Israel, singing and dancing, to meet king Saul, with tabrets, with joy, and with instruments of musick. And the women answered one another as they played, and said, Saul hath slain his thousands, and David his ten thousands.

And Saul was very wroth, and the saying displeased him; and he said, They have

ascribed unto David ten thousands, and to me they have ascribed but thousands: and what can he have more but the kingdom? And Saul eyed David from that day and forward.

And Michal Saul's daughter loved David: and they told Saul, and the thing pleased him. And Saul said, I will give him her, that she may be a snare to him, and that the hand of the Philistines may be against him. And Saul gave him Michal his daughter to wife.

Saul also sent messengers unto David's house, to watch him, and to slay him in the morning: and Michal David's wife told him, saying, If thou save not thy life to night, to morrow thou shalt be slain. So Michal let David down through a window: and he went, and fled, and escaped.

FROM THE FIRST BOOK OF SAMUEL, CHAPTERS 18—19

THE DEATHS OF SAUL AND JONATHAN

Now the Philistines fought against Israel: and the men of Israel fled from before the Philistines, and fell down slain in mount Gilboa. And the Philistines followed hard upon Saul and upon his sons; and the Philistines slew Jonathan, and Abinadab, and Melchishua, Saul's sons.

And the battle went sore against Saul, and the archers hit him; and he was sore wounded of the archers. Then said Saul unto his armourbearer, Draw thy sword, and thrust me through therewith; lest these uncircumcised come and thrust me through, and abuse me. But his armourbearer would not; for he was sore afraid. Therefore Saul took a sword, and fell upon it. And when his armourbearer saw that Saul was dead, he fell likewise upon his sword, and died with him.

So Saul died, and his three sons, and his armourbearer, and all his men, that same day together.

FROM THE FIRST BOOK OF SAMUEL, CHAPTER 31

DAVID'S LAMENT

Now it came to pass after the death of Saul, that, behold, a man came out of the camp from Saul with his clothes rent, and earth upon his head: and so it was, when he came to David, that he fell to the earth,

and did obeisance. And David said unto him, How went the matter? I pray thee, tell me. And he answered, that the people are fled from the battle, and many of the people also are fallen and dead; and Saul and Jonathan his son are dead also.

Then David took hold on his clothes, and rent them; and likewise all the men that were with him: And David lamented with this lamentation over Saul and over Jonathan his son:

> The beauty of Israel is slain upon thy high places:
> how are the mighty fallen!

> Tell it not in Gath,
> publish it not in the streets of Askelon;
> lest the daughters of the Philistines rejoice,
> lest the daughters of the uncircumcised triumph.

> Saul and Jonathan were lovely and pleasant in their lives,
> and in their death they were not divided:
> they were swifter than eagles,
> they were stronger than lions.

> How are the mighty fallen in the midst of the battle!

> O Jonathan, thou wast slain in thine high places.
> I am distressed for thee, my brother Jonathan:
> very pleasant hast thou been unto me:
> thy love to me was wonderful,
> passing the love of women.

> How are the mighty fallen,
> and the weapons of war perished!

And it came to pass after this, that all the elders of Israel came to Hebron; and David made a league with them in Hebron before the LORD: and they anointed David king over Israel.

FROM THE SECOND BOOK OF SAMUEL, CHAPTERS 1, 5

DAVID AND BATHSHEBA

It came to pass, at the time when kings go forth to battle, that David sent Joab, and his servants with him, and all Israel; and they destroyed the children of Ammon, and besieged Rabbah. But David tarried still at Jerusalem.

And it came to pass in an eveningtide, that David arose from off his bed, and walked upon the roof of the king's house:

and from the roof he saw a woman washing herself; and the woman was very beautiful to look upon. And David sent and enquired after the woman. And one said, Is not this Bathsheba, the daughter of Eliam, the wife of Uriah the Hittite? And David sent messengers, and took her; and she came in unto him, and he lay with her; for she was purified from her uncleanness: and she returned unto her house.

And the woman conceived, and sent and told David, and said, I am with child. And David sent to Joab, saying, Send me Uriah the Hittite. And Joab sent Uriah to David. And when Uriah was come unto him, David demanded of him how Joab did, and how the people did, and how the war prospered.

And David said to Uriah, Go down to thy house, and wash thy feet. And Uriah departed out of the king's house, and there followed him a mess of meat from the king. But Uriah slept at the door of the king's house with all the servants of his lord, and went not down to his house.

And when they had told David, saying, Uriah went not down unto his house, David said unto Uriah, Camest thou not from thy journey? Why then didst thou not go down unto thine house? And Uriah said unto

Bathsheba at her Bath, by Rembrandt van Rijn (1606–1669)

No artist understands body language like Rembrandt. There is a wonderful line by the poet John Donne that says: 'Her body thought', and Rembrandt seems to understand that the whole of Bathsheba – face, limbs, torso – is 'thinking' about this letter she has received from King David. Ironically, while her maid is still washing her feet, purifying her, Bathsheba is pondering her temptation to impurity, to adultery with the king. She cannot know at this stage, as we know, that she will become pregnant by David and that his attempts to conceal this pregnancy will culminate in his underhand destruction of her husband. But the look on that lovely face is not one of gratification; she seems to sense, intuitively, that her marital betrayal will lead to tragedy. We are drawn to her in sympathy, even while we condemn the resolution to which she is coming. One wants to cry out: Bathsheba, don't do it! The body that has betrayed her to the king, and will betray her to herself, gleams in the soft light of evening. Her salvation would require her to step out of the light into the shadows and that, Rembrandt knows, she cannot do.

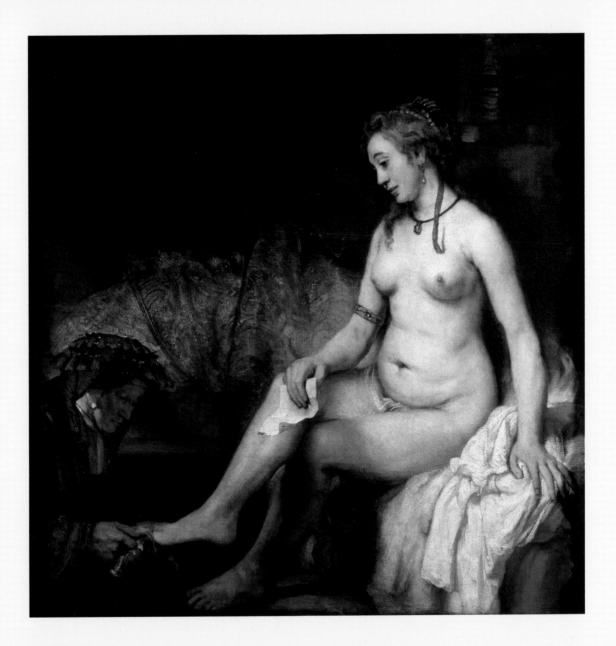

David, My lord Joab, and the servants of my lord, are encamped in the open fields; shall I then go into mine house, to eat and to drink, and to lie with my wife?

And David said to Uriah, Tarry here to day also, and to morrow I will let thee depart. So Uriah abode in Jerusalem that day, and the morrow. And when David had called him, he did eat and drink before him; and he made him drunk: and at even he went out to lie on his bed with the servants of his lord, but went not down to his house.

And it came to pass in the morning, that David wrote a letter to Joab, and sent it by the hand of Uriah. And he wrote in the letter, saying, Set ye Uriah in the forefront of the hottest battle, and retire ye from him, that he may be smitten, and die.

And it came to pass, when Joab observed the city, that he assigned Uriah unto a place where he knew that valiant men were. And the men of the city went out, and fought with Joab: and there fell some of the people of the servants of David; and Uriah the Hittite died also.

And when the wife of Uriah heard that Uriah her husband was dead, she mourned for her husband. And when the mourning was past, David sent and fetched her to his house, and she became his wife.

But the thing that David had done displeased the LORD. And the LORD sent Nathan unto David. And he came unto him, and said unto him,

> There were two men in one city; the one rich, and the other poor. The rich man had exceeding many flocks and herds: But the poor man had nothing, save one little ewe lamb, which he had bought and nourished up: and it grew up together with him, and with his children; it did eat of his own meat, and drank of his own cup, and lay in his bosom, and was unto him as a daughter. And there came a traveller unto the rich man, and he spared to take of his own flock and of his own herd, to dress for the wayfaring man that was come unto him; but took the poor man's lamb, and dressed it for the man that was come to him.

And David's anger was greatly kindled against the man; and he said to Nathan, As the LORD liveth, the man that hath done this thing shall surely die: and he shall restore the lamb fourfold, because he did this thing, and because he had no pity. And Nathan said to David,

Thou art the man. Thus saith the LORD God of Israel, Wherefore hast thou despised the commandment of the LORD, to do evil in his sight? Now therefore the sword shall never depart from thine house; because thou hast despised me, and hast taken the wife of Uriah the Hittite to be thy wife.

And David said unto Nathan, I have sinned against the LORD. And Nathan said unto David, the LORD also hath put away thy sin; thou shalt not die. Howbeit, because by this deed thou hast given great occasion to the enemies of the LORD to blaspheme, the child also that is born unto thee shall surely die.

FROM THE SECOND BOOK OF SAMUEL, CHAPTERS 11—12

ABSALOM'S REBELLION

It came to pass after this, that Absalom the son of David stole the hearts of the men of Israel. And it came to pass after forty years, that Absalom said unto the king, I pray thee, let me go and pay my vow, which I have vowed unto the LORD, in Hebron. And the king said unto him, Go in peace. So he arose, and went to Hebron.

But Absalom sent spies throughout all the tribes of Israel, saying, As soon as ye hear the sound of the trumpet, then ye shall say, Absalom reigneth in Hebron. And with Absalom went two hundred men out of Jerusalem, that were called; and they went in their simplicity, and they knew not any thing. And Absalom sent for Ahithophel the Gilonite, David's counsellor, from his city, even from Giloh, while he offered sacrifices. And the conspiracy was strong; for the people increased continually with Absalom.

And there came a messenger to David, saying, The hearts of the men of Israel are after Absalom. And David said unto all his servants that were with him at Jerusalem, Arise, and let us flee, lest he overtake us suddenly, and bring evil upon us, and smite the city with the edge of the sword. And the king went forth, and all his household after him. And the king left ten women, which were concubines, to keep the house. And the king went forth, and all the people after him, and tarried in a place that was far off. And one told David, saying, Ahithophel is among the conspirators with Absalom. And David said, O LORD, I pray thee, turn the counsel of Ahithophel into foolishness.

And it came to pass, that when David was come to the top of the mount, where he worshipped God, behold, Hushai the Archite came to meet him with his coat rent, and earth upon his head: Unto whom David said,

> If thou passest on with me, then thou shalt be a burden unto me: But if thou return to the city, and say unto Absalom, I will be thy servant, O king; as I have been thy father's servant hitherto, so will I now also be thy servant: then mayest thou for me defeat the counsel of Ahithophel.

Then said Absalom to Ahithophel, Give counsel among you what we shall do. And Ahithophel said unto Absalom, Go in unto thy father's concubines, which he hath left to keep the house; and all Israel shall hear that thou art abhorred of thy father: then shall the hands of all that are with thee be strong. So they spread Absalom a tent upon the top of the house; and Absalom went in unto his father's concubines in the sight of all Israel. Moreover Ahithophel said unto Absalom,

> Let me now choose out twelve thousand men, and I will arise and pursue after David this night: And I will come upon him while he is weary and weak handed, and will make him afraid: and all the people that are with him shall flee; and I will smite the king only.

And the saying pleased Absalom well, and all the elders of Israel. Then said Absalom, Call now Hushai the Archite also, and let us hear likewise what he saith. And when Hushai was come to Absalom, Absalom spake unto him, saying, Ahithophel hath spoken after this manner: shall we do after his saying? If not; speak thou. And Hushai said unto Absalom,

> The counsel that Ahithophel hath given is not good at this time. For thy father is a man of war, and will not lodge with the people. Therefore I counsel that all Israel be generally gathered unto thee, and that thou go to battle in thine own person.

And Absalom and all the men of Israel said, The counsel of Hushai the Archite is better than the counsel of Ahithophel.

Then David came to Mahanaim. And Absalom passed over Jordan, he and all the men of Israel with him. And David numbered the people that were with him, and set captains of thousands, and captains of hundreds over them. And the king said unto the people, I will surely go forth with

you myself also. But the people answered, Thou shalt not go forth: for thou art worth ten thousand of us: therefore now it is better that thou succour us out of the city. And the king said unto them, What seemeth you best I will do. And the king stood by the gate side, and all the people came out by hundreds and by thousands. And the king commanded Joab, saying, Deal gently for my sake with the young man, even with Absalom.

So the people went out into the field against Israel: and the battle was in the wood of Ephraim; where the people of Israel were slain before the servants of David, and there was there a great slaughter that day of twenty thousand men.

And Absalom met the servants of David. And Absalom rode upon a mule, and the mule went under the thick boughs of a great oak, and his head caught hold of the oak, and he was taken up between the heaven and the earth; and the mule that was under him went away. And a certain man saw it, and told Joab, and said, Behold, I saw Absalom hanged in an oak. And Joab said unto the man that told him, And, behold, thou sawest him, and why didst thou not smite him there to the ground? And he took three darts in his hand, and thrust them through the heart

of Absalom, while he was yet alive in the midst of the oak. And ten young men that bare Joab's armour compassed about and smote Absalom, and slew him.

Then said Joab to Cushi, Go tell the king what thou hast seen. And Cushi bowed himself unto Joab, and ran. And David sat between the two gates: and the watchman went up to the roof over the gate unto the wall, and lifted up his eyes, and looked, and behold a man running alone. And the watchman cried, and told the king. And, behold, Cushi came; and Cushi said, Tidings, my lord the king: for the LORD hath avenged thee this day of all them that rose up against thee.

And the king said unto Cushi, Is the young man Absalom safe? And Cushi answered, The enemies of my LORD the king, and all that rise against thee to do thee hurt, be as that young man is. And the king was much moved, and went up to the chamber over the gate, and wept: and as he went, thus he said,

> O my son Absalom, my son, my son Absalom! Would God I had died for thee,
> O Absalom, my son, my son!

From the Second Book of Samuel, chapters 15, 16, 17, 18

THE LAST WORDS OF DAVID

Now king David was old and stricken in years. And king David said,

> Call me Zadok the priest, and Nathan the prophet, and cause Solomon my son to ride upon mine own mule, and bring him down to Gihon: and let Zadok the priest and Nathan the prophet anoint him there king over Israel.

And Zadok the priest took an horn of oil out of the tabernacle, and anointed Solomon. And they blew the trumpet; and all the people said, God save king Solomon.

Now the days of David drew nigh that he should die; and he charged Solomon his son, saying, I go the way of all the earth: be thou strong therefore, and shew thyself a man; And keep the charge of the LORD thy God, to walk in his ways.

David blessed the LORD before all the congregation: and David said,

> Blessed be thou, LORD God of Israel our father, for ever and ever. Thine, O LORD is the greatness, and the power, and the glory, and the victory, and the majesty: for all that is in the heaven and in the earth is thine; thine is the kingdom, O LORD, and thou art exalted as head above all. Both riches and honour come of thee, and thou reignest over all; and in thine hand is power and might; and in thine hand it is to make great, and to give strength unto all. Now therefore, our God, we thank thee, and praise thy glorious name. All things come of thee, and of thine own have we given thee. For we are strangers before thee, and sojourners, as were all our fathers: our days on the earth are as a shadow, and there is none abiding.

Thus David the son of Jesse reigned over all Israel. And he died in a good old age, full of days, riches, and honour: and Solomon his son reigned in his stead.

FROM THE FIRST BOOK OF KINGS, CHAPTERS 1, 2, AND THE FIRST BOOK OF CHRONICLES, CHAPTER 29

10. The golden age of Solomon

Of all David's sons, it is the clever Solomon who succeeds him. Solomon is more than merely clever; like his father at his best he is pleasing to God and, when given a choice, chooses wisdom above all God's gifts. Not only clever then, but wise, and yet Solomon always seems somewhat of an anticlimax. Admittedly, David's is a hard act to follow, and the kingdom that Solomon has inherited is rich and flourishing – his is described as 'a golden age'. There are good stories, too, of how perceptive is his wisdom and of how ambitious are his plans to glorify God. The Temple is one of the defining features of Jerusalem, for ever after. Kings and dignitaries come there to gaze in amazement, the most notable being the legendary Queen of Sheba. Yet despite such a beginning and such achievement, Solomon's reign still seems to dwindle away as he ages. He has his father's weakness: an inordinate love of women that overpowers even his God-given wisdom. He is an important link in the chain to the eventual Messiah, but a weak one.

Solomon's dream

Then sat Solomon upon the throne of David his father; and his kingdom was established greatly. And the king went to Gibeon to sacrifice there. In Gibeon the LORD appeared to Solomon in a dream by night: and God said, Ask what I shall give thee. And Solomon said,

> Thy servant is in the midst of thy people which thou hast chosen, a great people, that cannot be numbered nor counted for multitude. Give therefore thy servant an understanding heart to judge thy people, that I may discern between good and bad: for who is able to judge this thy so great a people?

And the speech pleased the LORD, that Solomon had asked this thing. And God said unto him,

> Because thou hast asked this thing, and hast not asked for thyself long life; neither hast asked riches for thyself, nor hast asked the life of thine enemies; but hast asked for thyself understanding to discern judgment; Behold, I have done according to thy words: lo, I have given thee a wise and an understanding heart. And I have also given thee that which thou hast not asked, both riches, and honour: so that there shall not be any among the kings like unto thee all thy days.

And Solomon awoke; and, behold, it was a dream. And he came to Jerusalem, and stood before the ark of the covenant of the LORD, and offered up burnt offerings, and offered peace offerings, and made a feast to all his servants.

FROM THE FIRST BOOK OF KINGS, CHAPTER 3

SOLOMON'S WISDOM

Then came there two women, that were harlots, unto the king, and stood before him. And the one woman said,

> O my lord, I and this woman dwell in one house; and I was delivered of a child with her in the house. And it came to pass the third day after that I was delivered, that this woman was delivered also: and we were together; there was no stranger with us in the house, save we two in the house. And this woman's child died in the night; because she overlaid it. And she arose at midnight, and took my son from beside me, while thine handmaid slept, and laid it in her bosom, and laid her dead child in my bosom. And when I rose in the morning to give my child suck, behold, it was dead: but when

I had considered it in the morning, behold, it was not my son, which I did bear.

And the other woman said, Nay; but the living is my son, and the dead is thy son. And this said, No; but the dead is thy son, and the living is my son. Thus they spake before the king.

Then said the king, Bring me a sword. And they brought a sword before the king. And the king said, Divide the living child in two, and give half to the one, and half to the other. Then spake the woman whose the living child was unto the king, for her bowels yearned upon her son, and she said, O my lord, give her the living child, and in no wise slay it. But the other said, Let it be neither mine nor thine, but divide it.

Then the king answered and said, Give her the living child, and in no wise slay it: she is the mother thereof.

And all Israel heard of the judgment which the king had judged; and they feared the king: for they saw that the wisdom of God was in him, to do judgment.

FROM THE FIRST BOOK OF KINGS, CHAPTER 3

SOLOMON'S TEMPLE

It came to pass in the four hundred and eightieth year after the children of Israel were come out of the land of Egypt, in the fourth year of Solomon's reign over Israel, that he began to build the house of the LORD.

And the whole house he overlaid with gold, until he had finished all the house: also the whole altar that was by the oracle he overlaid with gold. And within the oracle he made two cherubims of olive tree, each ten cubits high.

And in the eleventh year, in the month Bul, which is the eighth month, was the house finished throughout all the parts thereof, and according to all the fashion of it. So was he seven years in building it.

FROM THE FIRST BOOK OF KINGS, CHAPTER 6

THE VISIT OF THE QUEEN OF SHEBA

When the queen of Sheba heard of the fame of Solomon concerning the name of the LORD, she came to prove him with hard questions. And she came to Jerusalem with a very great train, with camels that bare spices, and very much gold, and precious stones: and when she was come to Solomon, she communed with him of all that was in her heart.

And Solomon told her all her questions: there was not any thing hid from the king, which he told her not. And when the queen of Sheba had seen all Solomon's wisdom, and the house that he had built, and the meat of his table, and the sitting of his servants, and the attendance of his ministers, and their apparel, and his cupbearers, and his ascent by which he went up unto the house of the LORD; there was no more spirit in her. And she said to the king,

> It was a true report that I heard in mine own land of thy acts and of thy wisdom. Howbeit I believed not the words, until I came, and mine eyes had seen it: and, behold, the half was not told me: thy wisdom and prosperity exceedeth the fame which I heard.

And she gave the king an hundred and twenty talents of gold, and of spices very great store, and precious stones. And king Solomon gave unto the queen of Sheba all her desire, whatsoever she asked, beside that which Solomon gave her of his royal bounty.

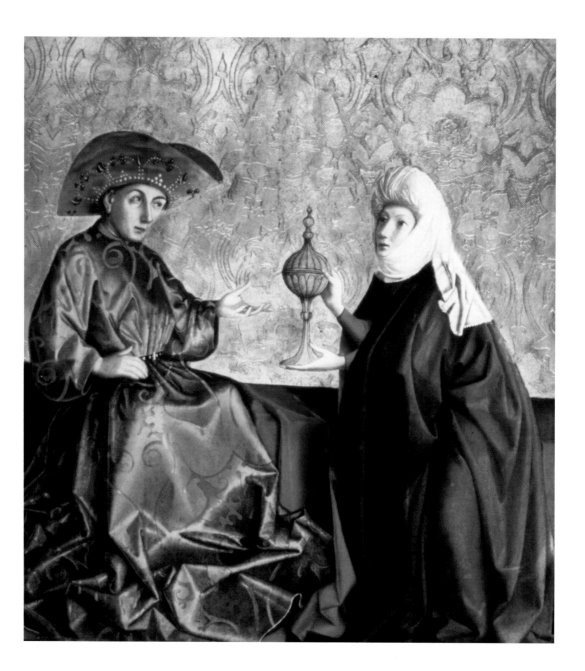

So king Solomon exceeded all the kings of the earth for riches and for wisdom. And all the earth sought to Solomon, to hear his wisdom, which God had put in his heart.

But king Solomon loved many strange women, together with the daughter of Pharaoh, women of the Moabites, Ammonites, Edomites, Zidonians, and Hittites. And he had seven hundred wives, princesses, and three hundred concubines: and it came to pass, when Solomon was old, that his wives turned away his heart after other gods: and his heart was not perfect with the LORD his God, as was the heart of David his father.

FROM THE FIRST BOOK OF KINGS, CHAPTERS 10—11

Opposite: *The Queen of Sheba before Solomon*, by Konrad Witz (*c*.1405–1444)

11. Elijah and Elisha

The Prophets form a special section of the Old Testament; 'the Law and the Prophets' is shorthand for the whole of the Jewish Scriptures. Yet when Jesus is transfigured on Mount Tabor and speaks to the representatives of the law and the prophets, it is Elijah, who has not bequeathed to us a book of prophecy, who is the essential and representative prophet. He does not write his prophecy, he lives it out. He reveals to us in his actions what it means to attack evil (the prophets of Baal), what it means fearlessly to rebuke the highest authority (Naboth's vineyard), what it means to listen to God (his years in the wilderness). Finally, to make clear the heavenly nature of prophecy, he is taken away from the sordidness of human society – exemplified above all by the immoral Jezebel – and whirled up to heaven. But prophecy never dies, so he passes on his role to the next prophet, his disciple Elisha. As his story unfolds, we also gain insight into the workings of the Jewish monarchy. They need the wisdom of a man of God: power notoriously corrupts.

The slaughter of the prophets of Baal

In the thirty and eighth year of Asa king of Judah began Ahab the son of Omri to reign over Israel. And it came to pass that he took to wife Jezebel the daughter of Ethbaal king of the Zidonians, and went and served Baal, and worshipped him. And he reared up an altar for Baal in the house of Baal, which he had built in Samaria. And Ahab made a grove; and Ahab did more to provoke the LORD God of Israel to anger than all the kings of Israel that were before him.

And Elijah the Tishbite, who was of the inhabitants of Gilead, said unto Ahab, As the LORD God of Israel liveth, before whom I stand, there shall not be dew nor rain these years, but according to my word. And it came to pass, when Ahab saw Elijah, that Ahab said unto him, Art thou he that troubleth Israel? And he answered,

I have not troubled Israel; but thou, and thy father's house, in that ye have forsaken the commandments of the LORD, and thou hast followed Baalim. Now therefore send, and gather to me all Israel unto mount Carmel, and the prophets of Baal four hundred and fifty,

and the prophets of the groves four hundred, which eat at Jezebel's table.

So Ahab sent unto all the children of Israel, and gathered the prophets together unto mount Carmel. And Elijah came unto all the people, and said, How long halt ye between two opinions? If the LORD be God, follow him: but if Baal, then follow him. And the people answered him not a word. Then said Elijah unto the people,

> I, even I only, remain a prophet of the LORD; but Baal's prophets are four hundred and fifty men. Let them therefore give us two bullocks; and let them choose one bullock for themselves, and cut it in pieces, and lay it on wood, and put no fire under: and I will dress the other bullock, and lay it on wood, and put no fire under: and call ye on the name of your gods, and I will call on the name of the LORD: and the God that answereth by fire, let him be God.

And all the people answered and said, It is well spoken. And the prophets of Baal took the bullock which was given them, and they dressed it, and called on the name of Baal from morning even until noon, saying, O Baal, hear us. But there was no voice, nor any that answered. And they leaped upon the altar which was made.

And it came to pass at noon, that Elijah mocked them, and said, Cry aloud: for he is a god; either he is talking, or he is pursuing, or he is in a journey, or peradventure he sleepeth, and must be awaked. And they cried aloud, and cut themselves after their manner with knives and lancets, till the blood gushed out upon them. And it came to pass, when midday was past, and they prophesied until the time of the offering of the evening sacrifice, that there was neither voice, nor any to answer, nor any that regarded.

And Elijah said unto all the people, Come near unto me. And all the people came near unto him. And he repaired the altar of the LORD that was broken down. And Elijah made a trench about the altar, as great as would contain two measures of seed. And he put the wood in order, and cut the bullock in pieces, and laid him on the wood, and said, Fill four barrels with water, and pour it on the burnt sacrifice, and on the wood.

And he said, Do it the second time. And they did it the second time. And he said, Do it the third time. And they did it the third time. And the water ran round about the altar; and he filled the trench also with water. And it came to pass at the time of

the offering of the evening sacrifice, that Elijah the prophet came near, and said,

> LORD God of Abraham, Isaac, and of Israel, let it be known this day that thou art God in Israel, and that I am thy servant. Hear me, O LORD, hear me, that this people may know that thou art the LORD God.

Then the fire of the LORD fell, and consumed the burnt sacrifice, and the wood, and the stones, and the dust, and licked up the water that was in the trench.

And when all the people saw it, they fell on their faces: and they said, The LORD, he is the God; the LORD, he is the God. And Elijah said unto them, Take the prophets of Baal; let not one of them escape. And they took them: and Elijah brought them down to the brook Kishon, and slew them there.

And it came to pass in the mean while, that the heaven was black with clouds and wind, and there was a great rain. And Ahab rode, and went to Jezreel. And the hand of the LORD was on Elijah; and he girded up his loins, and ran before Ahab to the entrance of Jezreel.

FROM THE FIRST BOOK OF KINGS, CHAPTERS 16—18

ELIJAH IN THE WILDERNESS

Ahab told Jezebel all that Elijah had done, and withal how he had slain all the prophets with the sword. Then Jezebel sent a messenger unto Elijah, saying, So let the gods do to me, and more also, if I make not thy life as the life of one of them by to morrow about this time. And when he saw that, he arose, and went for his life, and came to Beersheba, which belongeth to Judah, and left his servant there. But he himself went a day's journey into the wilderness, and came and sat down under a juniper tree: and he requested for himself that he might die. And as he lay and slept under a juniper tree, behold, then an angel touched him, and said unto him, Arise and eat. And he looked, and, behold, there was a cake baken on the coals, and a cruse of water at his head. And he arose, and did eat and drink, and went in the strength of that meat forty days and forty nights unto Horeb the mount of God.

And he came thither unto a cave, and lodged there; and, behold, the word of the LORD came to him, and he said unto

Opposite: *Elijah in the Wilderness*, by Dirk Bouts (*c.*1410–1475).

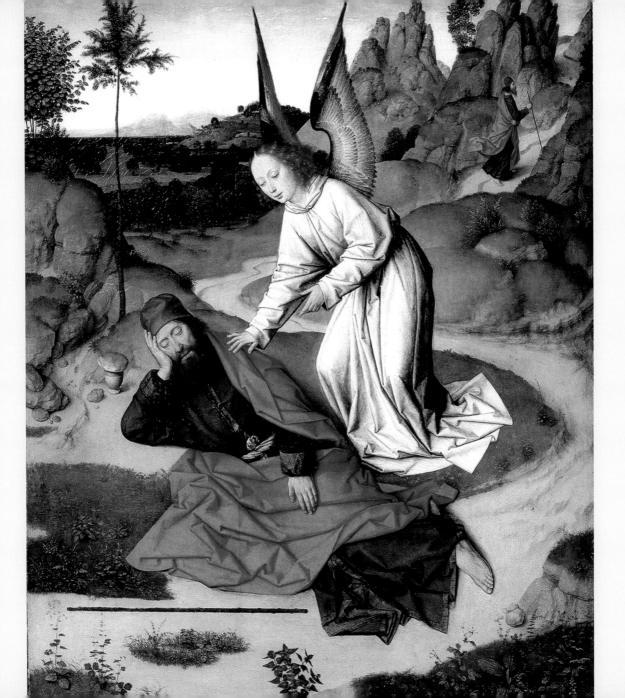

him, Go forth, and stand upon the mount before the LORD. And, behold, the LORD passed by, and a great and strong wind rent the mountains, and brake in pieces the rocks before the LORD; but the LORD was not in the wind: and after the wind an earthquake; but the LORD was not in the earthquake: And after the earthquake a fire; but the LORD was not in the fire: and after the fire a still small voice.

And it was so, when Elijah heard it, that he wrapped his face in his mantle, and went out, and stood in the entering in of the cave. And, behold, there came a voice unto him, and said, What doest thou here, Elijah? And he said,

> I have been very jealous for the LORD God of hosts: because the children of Israel have forsaken thy covenant, thrown down thine altars, and slain thy prophets with the sword; and I, even I only, am left; and they seek my life, to take it away.

And the LORD said unto him,

> Go, return on thy way to the wilderness of Damascus: and when thou comest, Elisha the son of Shaphat of Abelmeholah shalt thou anoint to be prophet in thy room. Yet I have left me

seven thousand in Israel, all the knees which have not bowed unto Baal, and every mouth which hath not kissed him.

So he departed thence, and found Elisha the son of Shaphat, who was plowing with twelve yoke of oxen before him, and he with the twelfth: and Elijah passed by him, and cast his mantle upon him. And he left the oxen, and went after Elijah, and ministered unto him.

FROM THE FIRST BOOK OF KINGS, CHAPTER 19

NABOTH'S VINEYARD

It came to pass after these things, that Naboth the Jezreelite had a vineyard, which was in Jezreel, hard by the palace of Ahab king of Samaria. And Ahab spake unto Naboth, saying, Give me thy vineyard, that I may have it for a garden of herbs, because it is near unto my house. And Naboth said to Ahab, The LORD forbid it me, that I should give the inheritance of my fathers unto thee. And Ahab came into his house heavy and displeased. And he laid him down upon his bed, and turned away his face, and would eat no bread. But Jezebel his wife came to him, and said unto him, Dost

thou now govern the kingdom of Israel? Arise, and eat bread, and let thine heart be merry: I will give thee the vineyard of Naboth the Jezreelite.

So she wrote letters in Ahab's name, and sealed them with his seal, and sent the letters unto the elders and to the nobles that were in his city. And she wrote in the letters, saying, Proclaim a fast, and set Naboth on high among the people: and set two men, sons of Belial, before him, to bear witness against him, saying, Thou didst blaspheme God and the king. And then carry him out, and stone him, that he may die.

And the men of his city did as Jezebel had sent unto them. And it came to pass, when Ahab heard that Naboth was dead, that Ahab rose up to go down to the vineyard of Naboth the Jezreelite, to take possession of it. And the word of the LORD came to Elijah the Tishbite, saying,

> Arise, go down to meet Ahab king of Israel. And thou shalt speak unto him, saying, Hast thou killed, and also taken possession? Thus saith the LORD, In the place where dogs licked the blood of Naboth shall dogs lick thy blood, even thine.

And it came to pass, when Ahab heard those words, that he rent his clothes, and put sackcloth upon his flesh, and fasted, and lay in sackcloth, and went softly.

FROM THE FIRST BOOK OF KINGS, CHAPTER 21

THE CHARIOT OF FIRE

It came to pass that Elijah went with Elisha from Gilgal. And Elijah said unto him, Tarry, I pray thee, here; for the LORD hath sent me to Jordan. And he said, As the LORD liveth, and as thy soul liveth, I will not leave thee. And they two went on. And Elijah took his mantle, and wrapped it together, and smote the waters, and they were divided hither and thither, so that they two went over on dry ground.

And it came to pass, when they were gone over, that Elijah said unto Elisha, Ask what I shall do for thee, before I be taken away from thee. And Elisha said, I pray thee, let a double portion of thy spirit be upon me. And he said, Thou hast asked a hard thing: nevertheless, if thou see me when I am taken from thee, it shall be so unto thee; but if not, it shall not be so. And it came to pass, as they still went on, and talked, that, behold, there appeared a chariot of

fire, and horses of fire, and parted them both asunder; and Elijah went up by a whirlwind into heaven.

And Elisha saw it, and he cried, My father, my father, the chariot of Israel, and the horsemen thereof. And he saw him no more: and he took hold of the mantle of Elijah that fell from him, and went back, and stood by the bank of Jordan; and he took the mantle of Elijah that fell from him, and smote the waters, and said, Where is the LORD God of Elijah? And when he also had smitten the waters, they parted hither and thither: and Elisha went over.

FROM THE SECOND BOOK OF KINGS, CHAPTER 2

Elijah Taken Up in a Chariot of Fire, by Giuseppe Angeli (*c.*1712–1798)

This is a strange and mysterious incident, one very difficult to depict through the material medium of paint. One could legitimately say this was a mystical event: obviously chariots and horses of fire do not belong to the literal world. All that an artist can do, it seems to me, is to evoke our creative imagination, so that we can enter in to the immensity of Elisha's experience and its spiritual meaning. I think Angeli makes a good stab at this. We see the drab figure of Elisha, opening wide his arms, both in farewell and in longing. He needs to be transfigured and revitalized by the fearless ardour of his great master Elijah. Elijah, for his part, has left the disappointments of the world and is set wholly on the beautiful fulfilment of heaven. He is tense and expectant as he reclines amidst the flames, flames that he understands are a visual expression of God's love and power. He is taken from his earthly vocation and yet fulfils it in a heavenly fashion, through his surrogate the willing Elisha.

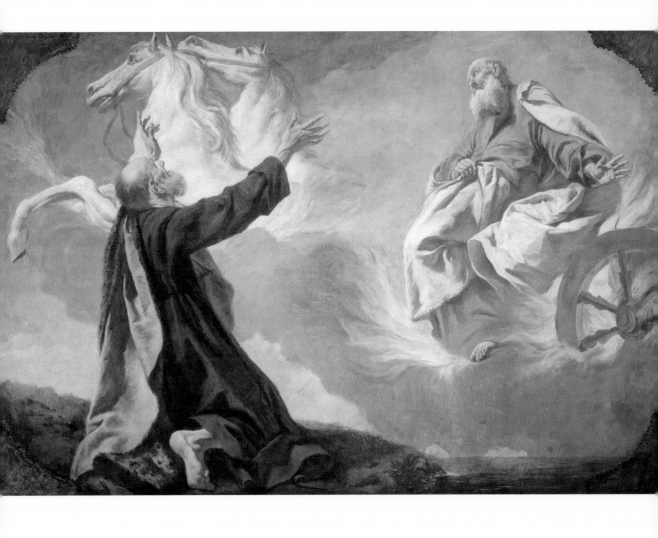

The death of Jezebel

Elisha the prophet called one of the children of the prophets, and said unto him, Gird up thy loins, and take this box of oil in thine hand, and go to Ramothgilead: and when thou comest thither, look out there Jehu the son of Jehoshaphat. Then take the box of oil, and pour it on his head, and say, Thus saith the LORD, I have anointed thee king over Israel.

So the young man went to Ramothgilead. And when he came, behold, the captains of the host were sitting; and he said, I have an errand to thee, O captain. And Jehu said, Unto which of all us? And he said, To thee, O captain. And he arose, and went into the house; and he poured the oil on his head, and said unto him,

> Thus saith the LORD God of Israel,
> I have anointed thee king over the
> people of the LORD, even over Israel.
> And thou shalt smite the house of
> Ahab thy master, that I may avenge
> the blood of my servants the prophets,
> and the blood of all the servants of the
> LORD, at the hand of Jezebel.

And when Jehu was come to Jezreel, Jezebel heard of it; and she painted her face, and tired her head, and looked out at a window. And as Jehu entered in at the gate, he lifted up his face to the window, and said, Who is on my side? Who? And there looked out to him two or three eunuchs. And he said, Throw her down. So they threw her down: and some of her blood was sprinkled on the wall, and on the horses: and he trode her under foot.

And when he was come in, he did eat and drink, and said, Go, see now this cursed woman, and bury her: for she is a king's daughter. And they went to bury her: but they found no more of her than the skull, and the feet, and the palms of her hands.

FROM THE SECOND BOOK OF KINGS, CHAPTER 9

12. The story of Jonah

The story of Jonah, rather like that of Ruth, is a self-contained novella. Its predominant purpose is to reiterate God's faithfulness to his covenant. Twist and turn though Jonah may, in his disobedient desire to escape the will of God, in the end he cannot but reveal God's love. This is one of those rare Bible stories that has survived the cultural pressure of the materialistic twenty-first century. Most people know that Jonah was swallowed by a whale, though in fact the Scripture merely speaks of 'a great fish'. In addition, zoologists assure us that no whale has an alimentary cavity sufficient to engulf the human body. But 'whale' is what we remember, and since the whole story is a form of parable, we need not be sticklers for anatomical correctness. It is a great story, with profound significance. Jesus himself refers to it, seeing in it a foreshadowing of his own resurrection: he is swallowed up by the 'great fish of death' and comes forth into freedom. In the early Christian catacombs, there were frescoes of Jonah that were used as a symbol of Christian rebirth in Christ. This secondary meaning retains all its potency.

Jonah flees from the Lord

Now the word of the LORD came unto Jonah the son of Amittai, saying, Arise, go to Nineveh, that great city, and cry against it; for their wickedness is come up before me. But Jonah rose up to flee unto Tarshish from the presence of the LORD, and went down to Joppa; and he found a ship going to Tarshish.

But the LORD sent out a great wind into the sea, and there was a mighty tempest in the sea, so that the ship was like to be broken. Then the mariners were afraid, and cried every man unto his god, and cast forth the wares that were in the ship into the sea, to lighten it of them. But Jonah was gone down into the sides of the ship; and he lay, and was fast asleep.

So the shipmaster came to him, and said unto him, What meanest thou, O sleeper? arise, call upon thy God, if so be that God will think upon us, that we perish not. And they said every one to his fellow, Come, and let us cast lots, that we may know for whose cause this evil is upon us. So they cast lots, and the lot fell upon Jonah.

Then said they unto him, Tell us, we pray thee, for whose cause this evil is upon us; What is thine occupation? and whence comest thou? what is thy country? and of

what people art thou? And he said unto them, I am an Hebrew; and I fear the LORD, the God of heaven, which hath made the sea and the dry land.

Then were the men exceedingly afraid, and said unto him. Why hast thou done this? For the men knew that he fled from the presence of the LORD, because he had told them. Then said they unto him, What shall we do unto thee, that the sea may be calm unto us? for the sea wrought, and was tempestuous. And he said unto them, Take me up, and cast me forth into the sea; so shall the sea be calm unto you: for I know that for my sake this great tempest is upon you.

Nevertheless the men rowed hard to bring it to the land; but they could not: for the sea wrought, and was tempestuous against them. Wherefore they cried unto the LORD, and said, We beseech thee, O LORD, we beseech thee, let us not perish for this man's life. So they took up Jonah, and cast him forth into the sea: and the sea ceased from her raging.

Now the LORD had prepared a great fish to swallow up Jonah. And Jonah was in the belly of the fish three days and three nights. Then Jonah prayed unto the LORD his God out of the fish's belly, And said,

I cried by reason of mine affliction unto the LORD,
and he heard me;
out of the belly of hell cried I,
and thou heardest my voice.

For thou hadst cast me into the deep,
all thy billows and thy waves
passed over me.

And the LORD spake unto the fish, and it vomited out Jonah upon the dry land.

FROM THE BOOK OF JONAH, CHAPTERS 1—2

JONAH AND THE NINEVITES

The word of the LORD came unto Jonah the second time, saying, Arise, go unto Nineveh, that great city, and preach unto it the preaching that I bid thee. So Jonah arose, and went unto Nineveh, according to the word of the LORD. And Jonah began to enter into the city a day's journey, and he cried, and said, Yet forty days, and Nineveh shall be overthrown. So the people of Nineveh believed God, and proclaimed a fast, and put on sackcloth, from the greatest of them even to the least of them. And God saw their works, that they turned from their evil way; and God

repented of the evil, that he had said that he would do unto them; and he did it not.

But it displeased Jonah exceedingly, and he was very angry. Then said the LORD, Doest thou well to be angry? So Jonah went out of the city, and sat on the east side of the city, and there made him a booth, and sat under it in the shadow, till he might see what would become of the city.

And the LORD God prepared a gourd, and made it to come up over Jonah, that it might be a shadow over his head, to deliver him from his grief. So Jonah was exceeding glad of the gourd. But God prepared a worm when the morning rose the next day, and it smote the gourd that it withered. And it came to pass, when the sun did arise, that God prepared a vehement east wind; and the sun beat upon the head of Jonah, that he fainted, and wished in himself to die, and said, It is better for me to die than to live.

And God said to Jonah, Doest thou well to be angry for the gourd? And he said, I do well to be angry, even unto death. Then said the LORD,

> Thou hast had pity on the gourd, for the which thou hast not laboured,

neither madest it grow; which came up in a night, and perished in a night: And should not I spare Nineveh, that great city, wherein are more then sixscore thousand persons that cannot discern between their right hand and their left hand; and also much cattle?

FROM THE BOOK OF JONAH, CHAPTERS 3—4

13. Daniel in Babylon

The exile in Babylon was one of the formative experiences of the chosen people. It left a deep national wound and a renewed appreciation of their own blessedness in being God's covenanted people. Daniel is one of those dedicated Israelites whose faithfulness to God and whose understanding of his love made a deep impression on his captors. The kings of Babylon might have earthly power but it is God, heavenly lord of the Jews, who has the only power that matters. He asks from his people trust in his goodness, even at the risk of their lives: earthly lives must end, but the life of union with God is eternal. Daniel survives the den of lions, as do his three friends in the fiery furnace. They not only survive amidst the flames, but seem to be accompanied by a mysterious fourth figure. The early Christians, persecuted and powerless like Daniel, saw the relevance of this great story, and painted it on the walls of the catacombs. It will always be relevant though perhaps in far less dramatic but equally taxing conditions.

The fiery furnace

In the third year of the reign of Jehoiakim king of Judah came Nebuchadnezzar king of Babylon unto Jerusalem, and besieged it. And the LORD gave Jehoiakim king of Judah into his hand, with part of the vessels of the house of God: which he carried into the land of Shinar into the treasure house of his god.

And the king spake unto Ashpenaz the master of his eunuchs, that he should bring certain of the children of Israel, and of the king's seed, and such as had ability in them to stand in the king's palace. Now among these were of the children of Judah, Daniel, Hananiah, Mishael, and Azariah: unto whom the prince of the eunuchs gave names: for he gave unto Daniel the name of Belteshazzar; and to Hananiah, of Shadrach; and to Mishael, of Meshach; and to Azariah, of Abed-nego. As for these four children, God gave them knowledge and skill in all learning and wisdom: and Daniel had understanding in all visions and dreams.

And Nebuchadnezzar the king made an image of gold, whose height was threescore cubits, and the breadth thereof six cubits: he set it up in the plain of Dura, in the province of Babylon. Then an herald cried aloud,

To you it is commanded, O people, nations, and languages, that at what time ye hear the sound of the cornet, flute, harp, sackbut, psaltery, dulcimer, and all kinds of musick, ye fall down and worship the golden image that Nebuchadnezzar the king hath set up: And whoso falleth not down and worshippeth shall the same hour be cast into the midst of a burning fiery furnace.

Wherefore at that time certain Chaldeans came near, and accused the Jews. They spake and said to the king Nebuchadnezzar,

O king, live for ever. There are certain Jews whom thou hast set over the affairs of the province of Babylon, Shadrach, Meshach, and Abed-nego; these men, O king, have not regarded thee: they serve not thy gods, nor worship the golden image which thou hast set up.

Then Nebuchadnezzar in his rage and fury commanded to bring Shadrach, Meshach, and Abed-nego, and these men were bound in their coats, their hosen, and their hats, and their other garments, and were cast into the midst of the burning fiery furnace. Therefore because the king's commandment was urgent, and the furnace exceeding hot, the flame of the fire slew those men that took up Shadrach, Meshach, and Abed-nego.

Then Nebuchadnezzar the king was astonied, and rose up in haste, and spake, and said unto his counsellers, Did not we cast three men bound into the midst of the fire? They answered and said unto the king, True, O king. He answered and said, Lo, I see four men loose, walking in the midst of the fire, and they have no hurt; and the form of the fourth is like the Son of God. Then Nebuchadnezzar came near to the mouth of the burning fiery furnace, and said,

Blessed be the God of Shadrach, Meshach, and Abed-nego, who hath sent his angel, and delivered his servants that trusted in him. Therefore I make a decree, that every people, nation, and language, which speak any thing amiss against the God of Shadrach, Meshach, and Abed-nego, shall be cut in pieces, and their houses shall be made a dunghill: because there is no other God that can deliver after this sort.

From the Book of Daniel, chapters 1, 3

The writing on the wall

Belshazzar the king made a great feast to a thousand of his lords, and commanded to bring the golden and silver vessels which his father Nebuchadnezzar had taken out of the temple which was in Jerusalem; and the king, and his princes, his wives, and his concubines, drank in them. They drank wine, and praised the gods of gold, and of silver, of brass, of iron, of wood, and of stone.

In the same hour came forth fingers of a man's hand, and wrote over against the candlestick upon the plaister of the wall of the king's palace: and the king saw the part of the hand that wrote. Then the king's countenance was changed, and his thoughts troubled him, so that the joints of his loins were loosed, and his knees smote one against another.

The king cried aloud to bring in the astrologers, the Chaldeans, and the soothsayers. Then came in all the king's wise men: but they could not read the writing, nor make known to the king the interpretation thereof. Then was Daniel brought in before the king. And the king spake and said unto Daniel,

Belshazzar's Feast,
by Rembrandt van Rijn (1606–1669)

The young Rembrandt was especially attracted to scenes of great emotional excitement, hence this dramatic rendering of Belshazzar's feast. It would be difficult to paint this extraordinary incident without drama. This oriental monarch, Belshazzar, is hosting a great feast with unreserved exuberance to celebrate his father Nebuchadnezzar's triumph over the Israelites (he had ravished their country, taken their people into captivity, destroyed their Temple, and carried away their sacred vessels). Belshazzar is using as wine cups at his feast the sacred gold and silver vessels taken from the Temple. God does not countenance this blasphemy and the king and his guests are terrified by the appearance of a ghostly hand writing on the wall. Rembrandt infuses these mysterious words with an eerie luminosity. When the king recovers a little from his shock, he summons scholars to translate them, but all are baffled until Daniel is brought in. Daniel has no hesitation in telling this mighty monarch that the words condemn him and indicate the end of his dynasty. Belshazzar is killed that very night, and the ominous darkness in which Rembrandt sets this scene is indicative of the tragedy to come.

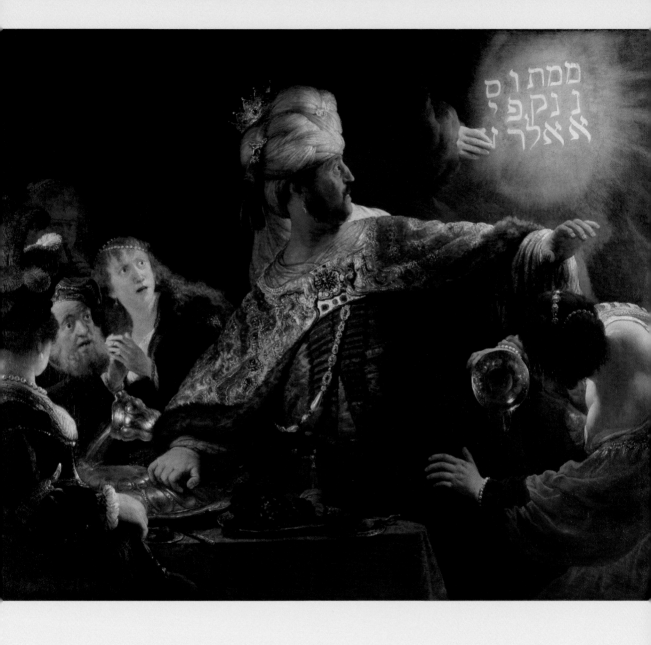

I have even heard of thee, that the spirit of the gods is in thee, and that thou canst make interpretations, and dissolve doubts: now if thou canst read the writing, and make known to me the interpretation thereof, thou shalt be clothed with scarlet, and have a chain of gold about thy neck, and shalt be the third ruler in the kingdom.

Then Daniel answered and said before the king,

O thou king, the most high God gave Nebuchadnezzar thy father a kingdom, and thou his son, O Belshazzar, hast lifted up thyself against the LORD of heaven; and they have brought the vessels of his house before thee, and thou, and thy lords, thy wives, and thy concubines, have drunk wine in them; and thou hast praised the gods of silver, and gold, of brass, iron, wood, and stone, which see not, nor hear, nor know: and the God in whose hand thy breath is, and whose are all thy ways, hast thou not glorified: then was the part of the hand sent from him; and this writing was written.

And this is the writing that was written, MENE, MENE, TEKEL, UPHARSIN. This is the interpretation

of the thing: MENE; God hath numbered thy kingdom, and finished it. TEKEL; Thou art weighed in the balances, and art found wanting. PERES; Thy kingdom is divided, and given to the Medes and Persians.

Then commanded Belshazzar, and they clothed Daniel with scarlet, and put a chain of gold about his neck, and made a proclamation concerning him, that he should be the third ruler in the kingdom.

In that night was Belshazzar the king of the Chaldeans slain. And Darius the Median took the kingdom.

FROM THE BOOK OF DANIEL, CHAPTER 5

DANIEL IN THE DEN OF LIONS

It pleased Darius to set over the kingdom an hundred and twenty princes, which should be over the whole kingdom; and over these three presidents; of whom Daniel was first. Then this Daniel was preferred above the presidents and princes, because an excellent spirit was in him; and the king thought to set him over the whole realm.

Then the presidents and princes sought to find occasion against Daniel concerning the kingdom; but they could find none

occasion nor fault. Then said these men, We shall not find any occasion against this Daniel, except we find it against him concerning the law of his God. Then these presidents and princes assembled together to the king, and said thus unto him,

> King Darius, live for ever. All the presidents of the kingdom, the governors, and the princes, the counsellers, and the captains, have consulted together to establish a royal statute, and to make a firm decree, that whosoever shall ask a petition of any God or man for thirty days, save of thee, O king, he shall be cast into the den of lions. Now, O king, establish the decree, and sign the writing, that it be not changed, according to the law of the Medes and Persians, which altereth not.

Wherefore king Darius signed the writing and the decree.

Now when Daniel knew that the writing was signed, he went into his house; and his windows being open in his chamber toward Jerusalem, he kneeled upon his knees three times a day, and prayed, and gave thanks before his God, as he did aforetime. Then these men assembled, and found Daniel praying and making supplication before his God.

Then they came near, and spake before the king, that Daniel, which is of the children of the captivity of Judah, regardeth not thee, O king, nor the decree that thou hast signed, but maketh his petition three times a day. Then the king, when he heard these words, was sore displeased with himself, and set his heart on Daniel to deliver him: and he laboured till the going down of the sun to deliver him. Then these men assembled unto the king, and said unto the king, Know, O king, that the law of the Medes and Persians is, that no decree nor statute which the king establisheth may be changed.

Then the king commanded, and they brought Daniel, and cast him into the den of lions. Now the king spake and said unto Daniel, Thy God whom thou servest continually, he will deliver thee. And a stone was brought and laid upon the mouth of the den.

Then the king went to his palace, and passed the night fasting: neither were instruments of musick brought before him: and his sleep went from him. Then the king arose very early in the morning, and went in haste unto the den of lions. And when he came to the den, he cried with a lamentable voice, O Daniel, servant of the living God, is thy God, whom thou servest

continually, able to deliver thee from the lions? Then said Daniel unto the king,

> O king, live for ever. My God hath sent his angel, and hath shut the lions' mouths, that they have not hurt me: forasmuch as before him innocency was found in me; and also before thee, O king, have I done no hurt.

Then was the king exceeding glad for him, and commanded that they should take Daniel up out of the den. And the king commanded, and they brought those men which had accused Daniel, and they cast them into the den of lions, them, their children, and their wives; and the lions had the mastery of them, and brake all their bones in pieces or ever they came at the bottom of the den.

Then king Darius wrote unto all people, nations, and languages, that dwell in all the earth,

> I make a decree, that in every dominion of my kingdom men tremble and fear before the God of Daniel: for he is the living God, and stedfast for ever, and his kingdom that which shall not be destroyed, and his dominion shall be even unto the end.

From the Book of Daniel, chapter 6

14. Selections from the Psalms

It was once thought that King David wrote all the Psalms, hence the description of him in old religious books as 'the sweet singer of Israel'. David, of course, was renowned as a harpist and it may well be that he sang psalms while he plucked the strings. But these holy songs do not need music in order to reveal their spiritual beauty: the Book of Psalms is the greatest collection of religious poetry ever known. This is poetry as prayer, revealed poetry, God's poetry. In liturgical worship and in private devotion, the inner truth of the Psalms speaks to the human heart with both tenderness and power. The Psalms encompass an enormous range of emotions and this selection is only a small sample of their beauty. Some rage against God, innocently expressing in their very passion that they count upon his understanding. Some unburden the weight of a grieving spirit, some mourn, some rejoice, some express longing, some are thankful just to rest peacefully upon the heart of God. Monks and nuns spend their lives using the Psalms to bring them closer to God, and that blessedness is open to anyone who is willing to read a psalm – any psalm – with the attentiveness of prayer.

A psalm of trust

The LORD is my shepherd; I shall not want.
He maketh me to lie down in green pastures:
 he leadeth me beside the still waters.
He restoreth my soul:
 he leadeth me in the paths of righteousness
 for his name's sake.
Yea, though I walk
 through the valley of the shadow of death,

I will fear no evil:
 for thou art with me;
thy rod and thy staff
 they comfort me.

Thou preparest a table before me
 in the presence of mine enemies:
thou anointest my head with oil;
 my cup runneth over.
Surely goodness and mercy shall follow me
 all the days of my life:
and I will dwell in the house of the LORD for ever.

Psalm 23

A PSALM OF THANKSGIVING

I will extol thee, O Lord;
 for thou hast lifted me up,
 and hast not made my foes to rejoice
 over me.
O Lord my God, I cried unto thee,
 and thou hast healed me.
O Lord, thou hast brought up my soul
 from the grave:
 thou hast kept me allive,that I should
 not go down to the pit.

Sing unto the Lord, O ye saints of his,
 and give thanks at the remembrance of
 his holiness.
For his anger endureth but a moment;
 in his favour is life:
weeping may endure for a night,
 but joy cometh in the morning.

From Psalm 30

A PSALM OF CONFESSION

Have mercy upon me, O God,
 according to thy lovingkindness:
according unto the multitude of thy
tender mercies
 blot out my transgressions.
Wash me throughly from mine iniquity,
 and cleanse me from my sin.

Create in me a clean heart, O God;
 and renew a right spirit within me.
Cast me not away from thy presence;
 and take not thy holy spirit from me.
Restore unto me the joy of thy salvation;
 and uphold me with thy free spirit.

For thou desirest not sacrifice;
 else would I give it:
 thou delightest not in burnt offering.
The sacrifices of God are a broken spirit:
 a broken and a contrite heart, O God,
 thou wilt not despise.

From Psalm 51

A PSALM OF LAMENTATION

By the rivers of Babylon,
 there we sat down, yea, we wept,
 when we remembered Zion.
We hanged our harps upon the willows
 in the midst thereof.
For there they that carried us away captive
 required of us a song;
and they that wasted us required of us
mirth, saying,
 Sing us one of the songs of Zion.
How shall we sing the Lord's song
 in a strange land?
If I forget thee, O Jerusalem,
 let my right hand forget her cunning.

If I do not remember thee,
 let my tongue cleave to the roof of my
 mouth;
 if I prefer not Jerusalem above my chief
 joy.

FROM PSALM 137

A PSALM OF PRAISE

O LORD, thou hast searched me,
 and known me.
Thou knowest my downsitting and mine
uprising,
 Thou understandest my thought afar off.
For there is not a word in my tongue,
 but, lo, O LORD, thou knowest it
 altogether.

Whither shall I go from thy spirit?
 Or whither shall I flee from thy
 presence?
If I ascend up into heaven, thou art there:
 if I make my bed in hell, behold, thou art
 there.
If I take the wings of the morning,
 and dwell in the uttermost parts of the
 sea;
Even there shall thy hand lead me,
 and thy right hand shall hold me.

I will praise thee;
 for I am fearfully and wonderfully made:
My substance was not hid from thee,
 when I was made in secret,
 and curiously wrought in the lowest
 parts of the earth.

How precious also are thy thoughts unto
me, O God!
 how great is the sum of them!
If I should count them,
 they are more in number than the sand:
when I awake,
 I am still with thee.

FROM PSALM 139

15. Sayings of the Wise

If there is tragic intensity in some books of Scripture, there are also much more humdrum instances of practical wisdom. God is in the heights and the depths, but he is also very much in the middle on the level plain: after all this is where most of us have our emotional home. Some of that extraordinary range may be savoured in this section. The Book of Job is among the most exquisite and sublime creations of an unknown poet, whereas the Books of Proverbs and Ecclesiastes can encompass supreme artistry as well as the short, sharp, bite of proverbial instruction. Some verses can seem cynical even, expressing as they do the human struggle for realism. They have to be put in context. These are the realistic – perhaps bitter – reflections of one disillusioned by life and turning, however implicitly, towards the meaning that only God can offer. So we need to keep our wits about us as we read these books of Scripture, and pay attention not only to what they say, but also to what they intend. All revelation intends to open to us the secrets of God, but this opening may come in unexpected ways.

Job's complaint

Man that is born of a woman
 is of few days and full of trouble.
He cometh forth like a flower, and is cut down:
 he fleeth also as a shadow, and
 continueth not.
Seeing his days are determined,
 the number of his months are with thee,
 thou hast appointed his bounds that he
 cannot pass;
Turn from him, that he may rest,
 till he shall accomplish, as an hireling,
 his day.

For there is hope of a tree, if it be cut down,
 that it will sprout again,
 and that the tender branch thereof will
 not cease.
Though the root thereof wax old in the earth,
 and the stock thereof die in the ground;
Yet through the scent of water it will
 bud, and bring forth boughs like a plant.
But man dieth, and wasteth away:
 yea, man giveth up the ghost, and where
 is he?
As the waters fail from the sea,
 and the flood decayeth and drieth up:

So man lieth down, and riseth not:
 till the heavens be no more, they shall
 not awake,
 nor be raised out of their sleep.

My bone cleaveth to my skin and to my
flesh,
 and I am escaped with the skin of my
 teeth.
Have pity upon me, have pity upon me, O
ye my friends;
 for the hand of God hath touched me.

Oh that my words were now written!
 oh that they were printed in a book!
That they were graven with an iron pen
and lead
 in the rock for ever!
For I know that my redeemer liveth,
 and that he shall stand at the latter day
 upon the earth:
And though after my skin worms destroy
this body,
 yet in my flesh shall I see God:
Whom I shall see for myself,
 and mine eyes shall behold, and not
 another.

From the Book of Job, chapters 14, 19

The Lord's answer to Job

Then the LORD answered Job out of the
whirlwind, and said,

Who is this that darkeneth counsel
 by words without knowledge?
Gird up now thy loins like a man;
 for I will demand of thee,
 and answer thou me.
Where wast thou when I laid the
foundations of the earth?
 Declare, if thou hast understanding.
Who hath laid the measures thereof, if
thou knowest?
 Or who hath stretched the line upon it?
When the morning stars sang together,
 and all the sons of God shouted for joy?

Or who shut up the sea with doors,
 when it brake forth, as if it had issued
 out of the womb?
When I made the cloud the garment
 thereof,
 and thick darkness a swaddlingband for it,
And brake up for it my decreed place,
 and set bars and doors,
and said, Hitherto shalt thou come, but no
 further:
 and here shall thy proud waves be stayed?

From the Book of Job, chapter 38

Job being Scolded by his Wife, by Albrecht
Dürer (1471–1528)

The Book of Job fascinates on two levels.
First, there is the actual trajectory of Job's
life, as God allows his good servant, Satan,
to persecute that other good servant, Job.
Satan is being mischievous, convinced
that Job only serves God because his
life is so very comfortable. God knows
better, and yet he feels that Job's integrity
is endangered by the sheer ease of his
lifestyle. In other words, God uses Satan
to bring Job to a deeper wisdom. In the
course of Job's sufferings, which he does
not accept supinely, there are expressions
of epic grandeur that are unequalled in the
Old Testament. This is the second level of
significance: Job's willingness to argue with
God and complain. He will not accept that
he deserves to suffer (who does?).

Dürer's little masterpiece shows Job at
the nadir of his fortunes. He has lost all
his possessions. That fine muscular body
is scarred with boils and eruptions, and
the wife of his bosom despises him – she
empties on his head a basin of ash. Job
accepts it phlegmatically, without for a
moment regarding it as justified. He bears
with her, poor ignorant young woman,
and reserves his accusations for his creator.

WISDOM'S CALL

Happy is the man that findeth wisdom,
 and the man that getteth understanding.
She is more precious than rubies: and all
the things
 thou canst desire are not to be compared
 unto her.
Length of days is in her right hand;
 and in her left hand riches and honour.
Her ways are ways of pleasantness,
 and all her paths are peace.
She is a tree of life to them that lay hold
upon her:
 and happy is every one that retaineth her.

The LORD possessed me in the beginning
of his way,
 before his works of old.
I was set up from everlasting,
 from the beginning, or ever the earth
 was.
When he prepared the heavens, I was
there:
 when he set a compass upon the face of
 the depth:
When he established the clouds above:
 when he strengthened the fountains of
 the deep:
When he gave to the sea his decree,
 that the waters should not pass his
 commandment:

when he appointed the foundations of
the earth:
Then I was by him, as one brought up with
him:
 and I was daily his delight, rejoicing
 always before him;
Rejoicing in the habitable part of his earth;
 and my delights were with the sons of
 men.
Now therefore hearken unto me, O ye
children:
 for blessed are they that keep my ways.

FROM THE BOOK OF PROVERBS, CHAPTERS 3, 8

THE PURSUIT OF WISDOM

Vanity of vanities, saith the Preacher,
vanity of vanities;
 all is vanity.

What profit hath a man of all his labour
 which he taketh under the sun?
One generation passeth away,
 and another generation cometh:
 but the earth abideth for ever.
The sun also ariseth, and the sun goeth
down,
 and hasteth to his place where he arose.
All the rivers run into the sea; yet the sea is
not full;

unto the place from whence the rivers come,
thither they return again.

The thing that hath been, it is that which shall be;
and that which is done is that which shall be done:
and there is no new thing under the sun.
And I gave my heart to know wisdom,
and to know madness and folly:
I perceived that this also is vexation of spirit.
For in much wisdom is much grief:
and he that increaseth knowledge increaseth sorrow.

FROM THE BOOK OF ECCLESIASTES, CHAPTER 1

A SEASON FOR EVERYTHING

To every thing there is a season,
and a time to every purpose under the heaven:

A time to be born, and a time to die;
a time to plant, and a time to pluck up that which is planted;
A time to kill, and a time to heal;
a time to break down, and a time to build up;

A time to weep, and a time to laugh;
a time to mourn, and a time to dance;
A time to cast away stones, and a time to gather stones together;
a time to embrace, and a time to refrain from embracing;
A time to get, and a time to lose;
a time to keep, and a time to cast away;
A time to rend, and a time to sew;
a time to keep silence, and a time to speak;
A time to love, and a time to hate;
a time of war, and a time of peace.

FROM THE BOOK OF ECCLESIASTES, CHAPTER 3

A SELECTION OF PROVERBS

A soft answer turneth away wrath:
but grievous words stir up anger.
Proverbs 15.1

Pride goeth before destruction,
and an haughty spirit before a fall
Proverbs 16.18

A man that hath friends must shew himself friendly:
and there is a friend that sticketh closer than a brother.
Proverbs 18.24

A word fitly spoken
 is like apples of gold in pictures of silver.
Proverbs 25.11

He that passeth by, and meddleth with
strife belonging not to him,
 is like one that taketh a dog by the ears.
Proverbs 26.17

Iron sharpeneth iron;
 so a man sharpeneth the countenance of
 his friend.
Proverbs 27.17

Where there is no vision,
 the people perish.
Proverbs 29.18

There be three things which are too
wonderful for me,
 yea, four which I know not:
The way of an eagle in the air;
 the way of a serpent upon a rock;
 the way of a ship in the midst of the sea;
 and the way of a man with a maid.
Proverbs 30.18–19

A threefold cord is not quickly broken.
Ecclesiastes 4.12

The sleep of a labouring man is sweet.
Ecclesiastes 5.12

A living dog is better than a dead lion.
Ecclesiastes 9.4

Cast thy bread upon the waters:
 for thou shalt find it after many days.
Ecclesiastes 11.1

What doth the LORD require of thee,
 but to do justly,
 and to love mercy,
 and to walk humbly with thy God?
Micah 6.8

16. Lines from a love song

The Song of Songs is also known as the Song of Solomon, because Solomon was the great lover in the Old Testament. Yet the intensity of this erotic song seems far removed from Solomon's multiplication of wives and concubines. The dialogue between the royal lover and the beautiful black virgin with whom he is enamoured seems too personal and intimate for Solomon of the roving eye. Man and woman in this poem are equal in majesty, equal in passion, equal in sexual joy and desire. Needless to say, over the centuries many have had a difficulty with this book that is part of Revelation. There is no explicit reference to God, no moral exploration of the significance of marriage, only an uninhibited rejoicing in the ecstasy, and the anguish, that lover and beloved share. If we like, we can regard this love song as a hymn in praise of the relationship between God and the believer. Surely that meaning is present, whatever the original impulse of the poet? God reveals himself in many ways, not least in erotic love.

The lover and the beloved

The song of songs, which is Solomon's.

Let him kiss me with the kisses of his mouth:
 for thy love is better than wine.

My beloved spake, and said unto me,
 Rise up, my love, my
 fair one, and come away.
For, lo, the winter is past,
 the rain is over and gone;
The flowers appear on the earth;
 the time of the singing of birds is come,
and the voice of the turtle
 is heard in our land;
The fig tree putteth forth her green figs,

and the vines with the tender grape give
 a good smell.
Arise, my love,
 my fair one, and come away.

From the Song of Solomon, chapters 1, 2

The garden of love

Behold, thou art fair, my love;
 behold, thou art fair;
 thou hast doves' eyes within thy locks:
thy hair is as a flock of goats,
 that appear from mount Gilead.

Thy lips are like a thread of scarlet,
 and thy speech is comely:

thy temples are like a piece of a
pomegranate
 within thy locks.
Thy neck is like the tower of David
 builded for an armoury,
whereon there hang a thousand bucklers,
 all shields of mighty men.
Thy two breasts are like two young roes
 that are twins,
 which feed among the lilies.

A garden inclosed is my sister, my spouse;
 a spring shut up, a fountain sealed.
Thy plants are an orchard of
pomegranates,
 with pleasant fruits;

Awake, O north wind;
 and come, thou south;
blow upon my garden,
 that the spices thereof may flow out.
Let my beloved come into his garden,
 and eat his pleasant fruits.

My beloved put in his hand by the hole of
the door,
 and my bowels were moved for him.
I rose up to open to my beloved;
 and my hands dropped with myrrh,
and my fingers with sweet smelling myrrh,
 upon the handles of the lock.
I opened to my beloved;
 but my beloved had withdrawn himself,

and was gone:
 my soul failed when he spake:
I sought him, but I could not find him;
 I called him, but he gave me no answer.

Set me as a seal upon thine heart,
 as a seal upon thine arm:
for love is strong as death;
 jealousy is cruel as the grave:
the coals thereof are coals of fire,
 which hath a most vehement flame.
Many waters cannot quench love,
 neither can the floods drown it:
if a man would give
 all the substance of his house for love,
 it would utterly be contemned.

From the Song of Solomon, chapters 4, 5, 8

17. WORDS AND VISIONS OF ISAIAH

A prophet is not one who foresees the future. He is rather one who explains the significance of the present. Yet that present is pregnant with the future, and of all the prophets it is Isaiah who most intuits what is to be the fulfilment of Jewish history. His words and his visions would have given great hope to his original followers. He knew, because of the very nature of God, that the future could not be as dark as the present and that we would be taught to live more in accordance with God's destiny for us. Yet the inspiration that Isaiah gave his contemporaries cannot be compared to what subsequent ages have found in his holy words. Here we see Jesus, the saviour who will only be born centuries later, but whose suffering and dedication to the Father Isaiah foretells. He certainly does not dream of the Incarnation, that 'the suffering servant' will actually be the Son of God, or that the child whose birth he hymns will be a divine child. Yet, with the most touching majesty, Isaiah speaks of these mysteries, leaving us breathless with wonder, gratitude and sorrow. Did it have to be like this?

A VISION OF PEACE

It shall come to pass in the last days,
that the mountain of the LORD's house
shall be established in the top of the
mountains,
 and shall be exalted above the hills;
 and all nations shall flow unto it.
And many people shall go and say, Come
ye,
 and let us go up to the mountain of the
 LORD,
 to the house of the God of Jacob.
And he shall judge among the nations,
 and shall rebuke many people:
and they shall beat their swords into
plowshares,
and their spears into pruninghooks:
nation shall not lift up sword against
nation,
 neither shall they learn war any more.

FROM THE BOOK OF ISAIAH, CHAPTER 2

THE PRINCE OF PEACE

The people that walked in darkness have
seen a great light:
 they that dwell in the land of the shadow
 of death,
 upon them hath the light shined.
For unto us a child is born, unto us a son
is given:

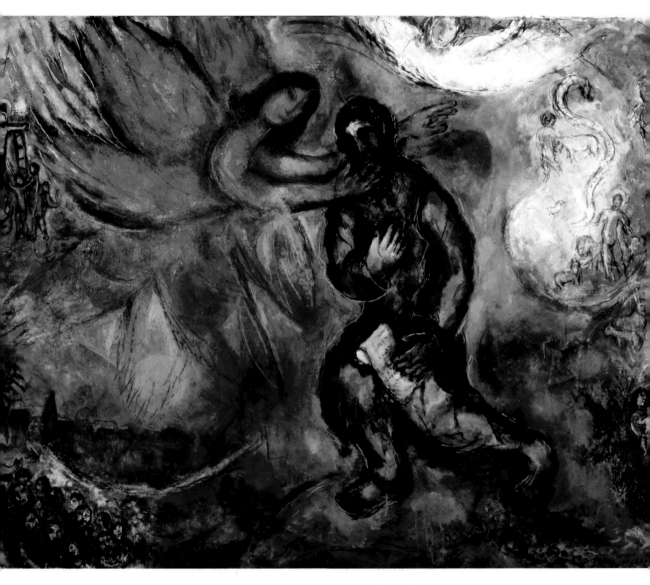

The Prophet Isaiah, by Marc Chagall (1887–1985)

and the government shall be upon his
shoulder:
and his name shall be called
Wonderful, Counsellor,
The mighty God, The everlasting Father,
The Prince of Peace.
Of the increase of his government and
peace
there shall be no end.

FROM THE BOOK OF ISAIAH, CHAPTER 9

A VOICE IN THE WILDERNESS

The voice of him that crieth in the
wilderness,
Prepare ye the way of the LORD,
make straight in the desert a highway for
our God.
Every valley shall be exalted,
and every mountain and hill shall be
made low:
and the crooked shall be made straight,
and the rough places plain:
And the glory of the LORD shall be
revealed,
and all flesh shall see it together:
for the mouth of the LORD hath spoken it.
The voice said, Cry.
And he said, What shall I cry?
All flesh is grass,

and all the goodliness thereof
is as the flower of the field:
The grass withereth, the flower fadeth:
because the spirit of the LORD bloweth
upon it:
surely the people is grass.
The grass withereth, the flower fadeth:
but the word of our God shall stand for
ever.

Who hath measured the waters in the
hollow of his hand,
and meted out heaven with the span,
and comprehended the dust of the earth in
a measure,
and weighed the mountains in scales,
and the hills in a balance?
Who hath directed the Spirit of the LORD,
or being his counsellor hath taught him?
With whom took he counsel, and who
instructed him,
and taught him in the path of judgment,
and taught him knowledge,
and shewed to him the way of
understanding?
Behold, the nations are as a drop of a
bucket,
and are counted as the small dust of the
balance:
behold, he taketh up the isles
as a very little thing.

Have ye not known? Have ye not heard?
 Hath it not been told you from the
 beginning?
 Have ye not understood from the
 foundations of the earth?
It is he that sitteth upon the circle of the
earth,
 and the inhabitants thereof are as
 grasshoppers;
that stretcheth out the heavens as a
curtain,
 and spreadeth them out as a tent to dwell
 in.

From the Book of Isaiah, chapter 40

The man of sorrows

Who hath believed our report?
 And to whom is the arm of the Lord
 revealed?
For he shall grow up before him as a
tender plant,
 and as a root out of a dry ground:
he hath no form nor comeliness;
 and when we shall see him,
 there is no beauty that we should desire
 him.
He is despised and rejected of men;
 a man of sorrows, and acquainted with
 grief:

and we hid as it were our faces from him;
 he was despised, and we esteemed him
 not.

Surely he hath borne our griefs, and
carried our sorrows:
 yet we did esteem him stricken, smitten
 of God, and afflicted.
But he was wounded for our
transgressions,
 he was bruised for our iniquities:
the chastisement of our peace was upon
him;
 and with his stripes we are healed.
All we like sheep have gone astray;
 we have turned every one to his own way;
 and the Lord hath laid on him the
 iniquity of us all.

He was oppressed, and he was afflicted,
 yet he opened not his mouth:
he is brought as a lamb to the slaughter,
 and as a sheep before her shearers is
 dumb,
 so he openeth not his mouth.
He was taken from prison and from
judgment:
 and who shall declare his generation?
for he was cut off out of the land of the
living:
 for the transgression of my people was he
 stricken.

And he made his grave with the wicked,
 and with the rich in his death;
because he had done no violence,
 neither was any deceit in his mouth.

Therefore will I divide him a portion with
the great,
 and he shall divide the spoil with the
 strong;
because he hath poured out his soul unto
death:
 and he was numbered with the
 transgressors;
and he bare the sin of many,
 and made intercession for the
 transgressors.

FROM THE BOOK OF ISAIAH, CHAPTER 53

Christ Crowned with Thorns, by
Hieronymus Bosch (1450–1516)

There are many profound passages in
Isaiah, but most precious for Christians
are the words he writes about 'the
suffering servant', the man of sorrows.
It is impossible to read this harrowing
description of the man of absolute
goodness whom we reject, without seeing
Christ and his Passion. Hieronymus Bosch
and his followers specialized in depicting
the mean, ugly faces of those who afflicted
Jesus. It is the contrast that interests the
artist: sinful, cruel humanity, and the
infinitely loving patient man-who-is-God,
Jesus. This small roundel seems to me to
show the tragedy of our rejection (that
is us, lurking and sneering) and the calm
dignity with which Jesus accepts to suffer.
It is not pointless, as no suffering should
ever be. It is undertaken for our sake, on
our behalf. Jesus would read these moving
words in his scroll of Scripture, and would
have recognized immediately that it was
to him Isaiah referred. The reference
may be implicit but we cannot doubt
it. In shadow, Jesus is there in the Old
Testament.

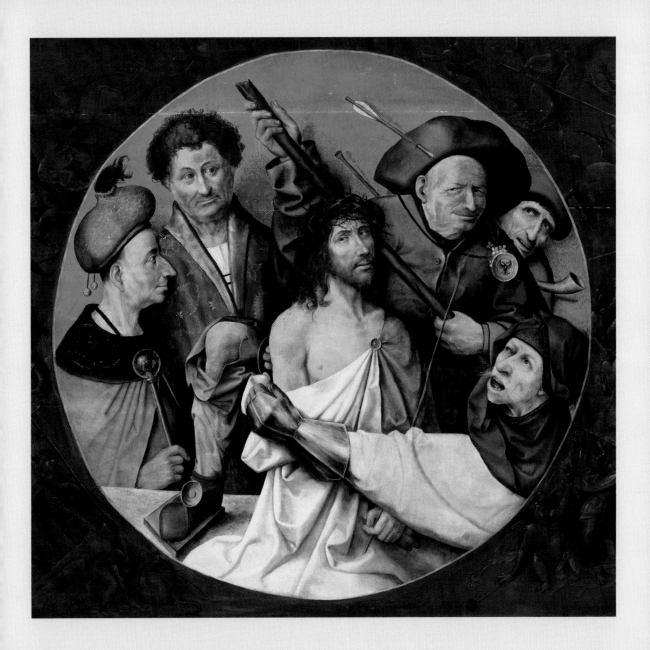

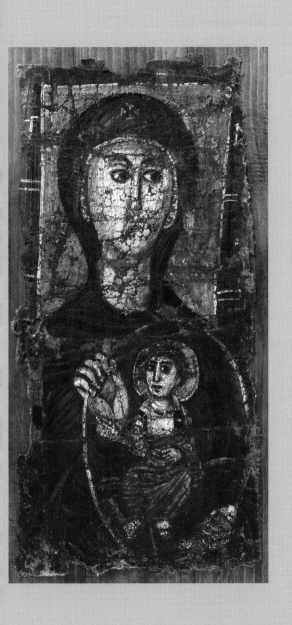

PART 2

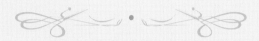

Stories and Wisdom
from the
NEW TESTAMENT

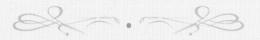

18. The birth and boyhood of Jesus

Everything in the New Testament has one sole all-consuming intention: to lead us to a knowledge and understanding of Jesus Christ. The Gospels are the predominant source of this holy knowledge. They are not strictly 'biographies', although they are structured around the events of his life. They do not even bother to tell us what Jesus looked like; their whole intent is to impart what Jesus meant. It is a wonder of God's grace that we have four different early Christians receiving the light of the Holy Spirit so as to tell us about Jesus. Matthew, Mark, Luke and John have very different approaches, though they all deliver the same message. We may be surprised to realize that the familiar narratives of the annunciation and the nativity are only in Luke. He tells the story from Mary's side, as it were. On the other hand, Matthew concentrates on the experience of Joseph, Mary's husband. Mark ignores the infancy and begins with the story of John the Baptist, whereas John, who also does not describe the birth or boyhood of Jesus, gives us the sublimity of a deeply theological 'prologue'.

THE WORD MADE FLESH

In the beginning was the Word, and the Word was with God, and the Word was God. In him was life; and the life was the light of men. And the light shineth in darkness; and the darkness comprehended it not. He came unto his own, and his own received him not. But as many as received him, to them gave he power to become the sons of God. And the Word was made flesh, and dwelt among us, full of grace and truth.

FROM THE GOSPEL OF ST JOHN, CHAPTER 1

THE ANNUNCIATION

The angel Gabriel was sent from God unto a city of Galilee, named Nazareth, to a virgin espoused to a man whose name was Joseph, of the house of David; and the virgin's name was Mary. And the angel came in unto her, and said, Hail, thou that art highly favoured, the Lord is with thee: blessed art thou among women. And when she saw him, she was troubled at his saying, and cast in her mind what manner of salutation this should be.

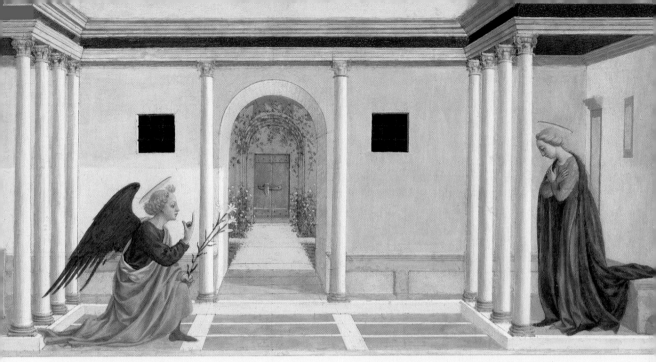

The Annunciation, by Domenico
Veneziano (*c*.1400–1461)

This is a scene very dear to the Christian
heart, and literally hundreds of thousands
of attempts must have been made to
depict it. What I find so beautiful about
Domenico's Annunciation is its sobriety
and simplicity. No human mind can
encompass the supernatural magnitude
of what is taking place: the immensity of
God's mystery, unthinkable, unknowable,
is to take human form within a virgin's
womb. The setting is ordinary: a small
house in a small country. Heaven and

earth are to meet, to be united, as never
before. Domenico shows the distance by
separating the angel from Mary – there is
a vast, silent space between them. Gabriel
has come out of his own place (the pillars
are behind him to signify this), while Mary
stays, as she always will, in the place that
is hers. She will bear a divine child but she
herself will always be human. So intense is
this invisible conception that it is right to
picture it as taking place in a cool, pink,
grey and black setting. The glimpse, in the
centre, of a walled garden emphasizes for
us what Mary is: a pure, sacred garden in
which God will plant his Holy Word.

And the angel said unto her,

> Fear not, Mary: for thou hast found favour with God. And, behold, thou shalt conceive in thy womb, and bring forth a son, and shalt call his name JESUS. He shall be great, and shall be called the Son of the Highest: and the Lord God shall give unto him the throne of his father David: And he shall reign over the house of Jacob for ever; and of his kingdom there shall be no end.

Then said Mary unto the angel, How shall this be, seeing I know not a man? And the angel answered and said unto her,

> The Holy Ghost shall come upon thee, and the power of the Highest shall overshadow thee: therefore also that holy thing which shall be born of thee shall be called the Son of God. And, behold, thy cousin Elisabeth, she hath also conceived a son in her old age. For with God nothing shall be impossible.

And Mary said, Behold the handmaid of the Lord; be it unto me according to thy word.

FROM THE GOSPEL OF ST LUKE, CHAPTER 1

THE VISITATION

Mary arose in those days, and went into the hill country with haste, into a city of Juda; And entered into the house of Zacharias, and saluted Elisabeth. And it came to pass, that, when Elisabeth heard the salutation of Mary, the babe leaped in her womb; and Elisabeth was filled with the Holy Ghost: and she spake out with a loud voice, and said, Blessed art thou among women, and blessed is the fruit of thy womb. And Mary said,

> My soul doth magnify the Lord,
> And my spirit hath rejoiced in God my Saviour.
> For he hath regarded the low estate of his handmaiden:
> for, behold, from henceforth all generations shall call me blessed.

And Mary abode with her about three months, and returned to her own house.

FROM THE GOSPEL OF ST LUKE, CHAPTER 1

THE NATIVITY

It came to pass in those days, that there went out a decree from Caesar Augustus, that all the world should be taxed. And all went to be taxed, every one into his own city. And Joseph also went up from Galilee, out of the city of Nazareth, into Judaea, unto the city of David, which is called Bethlehem (because he was of the house and lineage of David), to be taxed with Mary his espoused wife, being great with child.

And so it was, that, while they were there, the days were accomplished that she should be delivered. And she brought forth her firstborn son, and wrapped him in swaddling clothes, and laid him in a manger; because there was no room for them in the inn.

And there were in the same country shepherds abiding in the field, keeping watch over their flock by night. And, lo, the angel of the Lord came upon them, and the glory of the Lord shone round about them: and they were sore afraid. And the angel said unto them,

> Fear not: for, behold, I bring you good tidings of great joy, which shall be to all people. For unto you is born this day in the city of David a Saviour, which is Christ the Lord.

And suddenly there was with the angel a multitude of the heavenly host praising God, and saying, Glory to God in the highest, and on earth peace, good will toward men.

And it came to pass, as the angels were gone away from them into heaven, the shepherds said one to another, Let us now go even unto Bethlehem, and see this thing which is come to pass, which the Lord hath made known unto us. And they came with haste, and found Mary, and Joseph, and the babe lying in a manger. And all they that heard it wondered at those things which were told them by the shepherds. But Mary kept all these things, and pondered them in her heart.

FROM THE GOSPEL OF ST LUKE, CHAPTER 2

The Mystic Nativity, by Sandro Botticelli
(1445–1510)

Pictures of the nativity are even
more familiar to us than those of the
annunciation. Botticelli's is called the
Mystic Nativity because, unusually, he
tries to spell out the significance of this
birth. We are used to seeing a stable in
which Mary and Joseph adore the new
born Jesus, who is lying in a manger.
Although they are not in Scripture,
artists decided very early on to make this
a functioning stable by adding an ox and
an ass. Botticelli sees the ass as extremely
interested, while the ox gazes vacantly
into the distance (it is not being there
that matters, but being aware). We are
also used to the arrival of the wondering
shepherds, and many nativities have a
few angels around. But Botticelli sees the
angels as deeply significant. In the sky they
dance with heavenly joy over the birth of
Jesus. On the roof of the stable-cave three
blessing angels wear the symbolic colours
of faith, hope and charity. The angels have
not merely announced to the shepherds
the miracle of God's birth among us, but
they have actually accompanied them
to the stable, to make certain that they
will not escape its full significance. Best
of all, below Mary and the Child, we see
heaven and earth embracing as angel clasps
man, a union of heaven and earth that is
embodied in Jesus himself. This love, this
embrace of heaven, is enough to send the
devils back to hell in miserable defeat.

The adoration of the magi

Now when Jesus was born in Bethlehem of Judaea in the days of Herod the king, behold, there came wise men from the east to Jerusalem, saying, Where is he that is born King of the Jews? For we have seen his star in the east, and are come to worship him.

When Herod the king had heard these things, he was troubled, and all Jerusalem with him. Then Herod, when he had privily called the wise men, inquired of them diligently what time the star appeared. And he sent them to Bethlehem, and said, Go and search diligently for the young child; and when ye have found him, bring me word again, that I may come and worship him also.

When they had heard the king, they departed; and, lo, the star, which they saw in the east, went before them, till it came and stood over where the young child was. When they saw the star, they rejoiced with exceeding great joy. And when they were come into the house, they saw the young child with Mary his mother, and fell down, and worshipped him: and when they had opened their treasures, they presented unto him gifts; gold, and frankincense,

and myrrh. And being warned of God in a dream that they should not return to Herod, they departed into their own country another way.

FROM THE GOSPEL OF ST MATTHEW, CHAPTER 2

The flight into Egypt

When they were departed, behold, the angel of the Lord appeareth to Joseph in a dream, saying, Arise, and take the young child and his mother, and flee into Egypt, and be thou there until I bring thee word: for Herod will seek the young child to destroy him. When he arose, he took the young child and his mother by night, and departed into Egypt.

Then Herod, when he saw that he was mocked of the wise men, was exceeding wroth, and sent forth, and slew all the children that were in Bethlehem, and in all the coasts thereof, from two years old and under, according to the time which he had diligently inquired of the wise men.

But when Herod was dead, behold, an angel of the Lord appeareth in a dream to Joseph in Egypt, saying, Arise, and take the young child and his mother, and go into the land of Israel: for they are dead

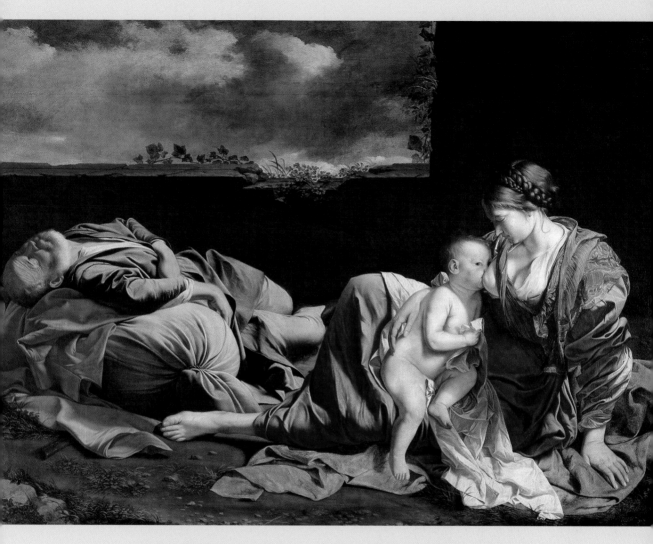

Rest on the Flight into Egypt, by Orazio Gentileschi (1563–1639)

which sought the young child's life. And he arose, and took the young child and his mother, and came into the land of Israel. And he came and dwelt in a city called Nazareth.

FROM THE GOSPEL OF ST MATTHEW, CHAPTER 2

JESUS AMONG THE DOCTORS OF THE LAW

The child grew, and waxed strong in spirit, filled with wisdom: and the grace of God was upon him.

Now his parents went to Jerusalem every year at the feast of the passover. And when he was twelve years old, they went up to Jerusalem after the custom of the feast. And when they had fulfilled the days, as they returned, the child Jesus tarried behind in Jerusalem; and Joseph and his mother knew not of it.

But they, supposing him to have been in the company, went a day's journey; and they sought him among their kinsfolk and acquaintance. And when they found him not, they turned back again to Jerusalem, seeking him. And it came to pass, that after three days they found him in the temple, sitting in the midst of the doctors, both hearing them, and asking them questions. And all that heard him were astonished at his understanding and answers. And when they saw him, they were amazed: and his mother said unto him, Son, why hast thou thus dealt with us? Behold, thy father and I have sought thee sorrowing. And he said unto them, How is it that ye sought me? Wist ye not that I must be about my Father's business? And they understood not the saying which he spake unto them. And he went down with them, and came to Nazareth, and was subject unto them: but his mother kept all these sayings in her heart.

FROM THE GOSPEL OF ST LUKE, CHAPTER 2

19. Jesus begins his ministry

We cannot even begin to imagine what it must have felt like to be Jesus. It is clear to us, after centuries of prayer and theological insight, that Jesus is God, but when did Jesus himself fully understand this, in black and white as it were? When did he see clearly that his heavenly Father was calling him to a ministry? His apostolate was to some extent initiated by and fashioned on that of John the Baptist. John's baptism of Jesus seems to have been the great turning point after which he left home, sought for apostles, and began to preach. All through his life, we can imagine Jesus encountering the temptations that are compressed for us into a single episode. It would have been so much easier to use his divine power to influence his disciples and draw them to God. Yet God became man to show us the divine mind. We must always make our own choices and take responsibility. So the Gospels show us Jesus explaining to people of many different temperaments what it means to love God. Some listened and acted, some listened and were unaffected, some refused to listen.

Jesus is baptized by John

In those days came John the Baptist, preaching in the wilderness of Judaea, and saying, Repent ye: for the kingdom of heaven is at hand. For this is he that was spoken of by the prophet Esaias, saying, The voice of one crying in the wilderness, Prepare ye the way of the Lord, make his paths straight. And the same John had his raiment of camel's hair, and a leathern girdle about his loins; and his meat was locusts and wild honey. Then went out to him Jerusalem, and all Judaea, and all the region round about Jordan, And were baptized of him in Jordan, confessing their sins.

Then cometh Jesus from Galilee to Jordan unto John, to be baptized of him. But John forbad him, saying, I have need to be baptized of thee, and comest thou to me? And Jesus answering said unto him, Suffer it to be so now: for thus it becometh us to fulfil all righteousness. Then he suffered him.

And Jesus, when he was baptized, went up straightway out of the water: and, lo, the heavens were opened unto him, and he saw the Spirit of God descending like a dove, and lighting upon him: and lo a voice from heaven, saying, This is my beloved Son, in whom I am well pleased.

The next day John seeth Jesus coming unto him, and saith, Behold the Lamb of God, which taketh away the sin of the world. And John saw, and bare record that this is the Son of God.

From the Gospel of St Matthew, chapter 3, and the Gospel of St John, chapter 1

The temptations

Jesus being full of the Holy Ghost returned from Jordan, and was led by the Spirit into the wilderness, being forty days tempted of the devil. And in those days he did eat nothing: and when they were ended, he afterward hungered. And the devil said unto him, If thou be the Son of God, command this stone that it be made bread. And Jesus answered him, saying, It is written, that man shall not live by bread alone, but by every word of God.

And the devil, taking him up into an high mountain, shewed unto him all the kingdoms of the world in a moment of time. And the devil said unto him, All this power will I give thee, and the glory of them: if thou therefore wilt worship me, all shall be thine. And Jesus answered and said unto him, Get thee behind me, Satan: for

The Baptism of Christ, by Piero della Francesca (1415/20–1492)

Up to this point, it would seem, Jesus had lived unknown in the small village of Nazareth, probably working as a carpenter. The Gospels suggest that he was about 30 when he came to join the crowds at the River Jordan, whom John was baptizing. It was not the sacrament of baptism but a gesture symbolizing the desire to change one's life. The change in Jesus' life would be dramatic. When John baptized him, the voice of his Father was heard, proclaiming his divine sonship, and the Holy Spirit appeared over his head in the form of a dove. Now Jesus 'knew' in full consciousness, that he was indeed divine. Piero shows him, tall, strong and pale, wholly intent on the revelation of that sacred moment. The artist is daring to show Jesus accepting the fullness of what he is and what he is to do for the Father. It is a moment of intense silence and gravity, a moment of vocation at its purest. Jesus seems unaware of the angels, unaware too of the tremulous John. All his life up to now has led to the prayerful intensity of this experience.

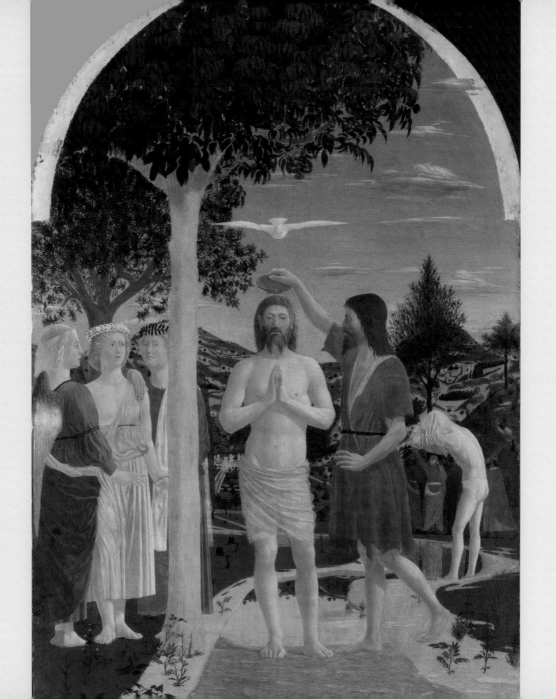

it is written, Thou shalt worship the Lord thy God, and him only shalt thou serve.

And he brought him to Jerusalem, and set him on a pinnacle of the temple, and said unto him, If thou be the Son of God, cast thyself down from hence: for it is written, He shall give his angels charge over thee, to keep thee. And Jesus answering said unto him, It is said, Thou shalt not tempt the Lord thy God.

FROM THE GOSPEL OF ST LUKE, CHAPTER 4

A PROPHET WITHOUT HONOUR

Jesus returned in the power of the Spirit to Nazareth, where he had been brought up: and, as his custom was, he went into the synagogue on the sabbath day, and stood up for to read. There was delivered unto him the book of the prophet Esaias. And he found the place where it was written,

> The Spirit of the Lord is upon me, because he hath anointed me to preach the gospel to the poor; he hath sent me to heal the brokenhearted, to preach deliverance to the captives, and recovering of sight to the blind, to set at liberty them that are bruised, To preach the acceptable year of the Lord.

He closed the book, and he gave it again to the minister, and sat down. The eyes of all that were in the synagogue were fastened on him. And he began to say unto them, This day is this scripture fulfilled in your ears. They said, Is not this Joseph's son? And he said, I say unto you, No prophet is accepted in his own country.

And all they in the synagogue were filled with wrath, And rose up, and thrust him out of the city, and led him unto the brow of the hill whereon their city was built, that they might cast him down headlong. But he passing through the midst of them went his way.

FROM THE GOSPEL OF ST LUKE, CHAPTER 4

THE CALL OF THE DISCIPLES

Now Jesus came into Galilee, preaching the gospel of the kingdom of God, and saying, The time is fulfilled, and the kingdom of God is at hand: repent ye, and believe the gospel. Now as he walked by the sea of Galilee, he saw Simon and Andrew his brother casting a net into the

sea: for they were fishers. And Jesus said unto them, Come ye after me, and I will make you to become fishers of men. And straightway they forsook their nets, and followed him. And when he had gone a little further thence, he saw James the son of Zebedee, and John his brother, who also were in the ship mending their nets. And straightway he called them: and they left their father Zebedee in the ship with the hired servants, and went after him.

And as he passed by, he saw Levi the son of Alphaeus sitting at the receipt of custom, and said unto him, Follow me. And he arose and followed him. And it came to pass, that, as Jesus sat at meat in his house, many publicans and sinners sat also together with Jesus and his disciples. And when the scribes and Pharisees saw him eat with publicans and sinners, they said unto his disciples, How is it that he eateth and drinketh with publicans and sinners? When Jesus heard it, he saith unto them, They that are whole have no need of the physician, but they that are sick: I came not to call the righteous, but sinners to repentance.

From the Gospel of St Mark, chapters 1—2

Jesus and Nicodemus

There was a man of the Pharisees, named Nicodemus, a ruler of the Jews: the same came to Jesus by night, and said unto him, Rabbi, we know that thou art a teacher come from God. Jesus answered and said unto him, Verily, verily, I say unto thee, Except a man be born again, he cannot see the kingdom of God. Nicodemus saith unto him, How can a man be born when he is old? Can he enter the second time into his mother's womb, and be born? Jesus answered,

> Verily, verily, I say unto thee, Except a man be born of water and of the Spirit, he cannot enter into the kingdom of God. That which is born of the flesh is flesh; and that which is born of the Spirit is spirit. Marvel not that I said unto thee, Ye must be born again. The wind bloweth where it listeth, and thou hearest the sound thereof, but canst not tell whence it cometh, and whither it goeth: so is every one that is born of the Spirit.

Nicodemus answered and said unto him, How can these things be? Jesus answered and said unto him,

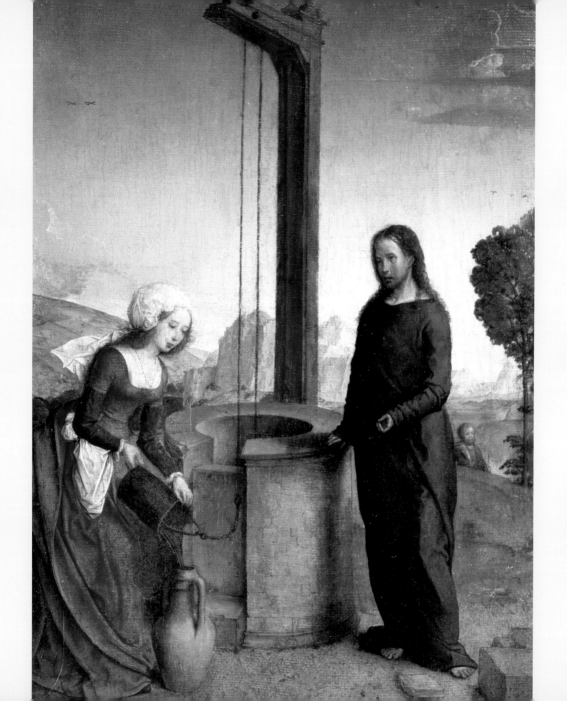

If I have told you earthly things, and ye believe not, how shall ye believe, if I tell you of heavenly things?

For God so loved the world, that he gave his only begotten Son, that whosoever believeth in him should not perish, but have everlasting life.

FROM THE GOSPEL OF ST JOHN, CHAPTER 3

THE WOMAN OF SAMARIA

Then cometh Jesus to a city of Samaria, which is called Sychar, near to the parcel of ground that Jacob gave to his son Joseph. Now Jacob's well was there. Jesus therefore, being wearied with his journey, sat thus on the well: and it was about the sixth hour. There cometh a woman of Samaria to draw water: Jesus saith unto her, Give me to drink. Then saith the woman of Samaria unto him, How is it that thou, being a Jew, askest drink of me, which am a woman of Samaria?

Jesus answered and said unto her, If thou

Opposite: *Christ and the Samaritan Woman*, by Juan de Flandes (1496–1519)

knewest the gift of God, and who it is that saith to thee, Give me to drink; thou wouldest have asked of him, and he would have given thee living water. The woman saith unto him, Sir, thou hast nothing to draw with, and the well is deep: from whence then hast thou that living water? Jesus answered and said unto her,

Whosoever drinketh of this water shall thirst again: But whosoever drinketh of the water that I shall give him shall never thirst; but the water that I shall give him shall be in him a well of water springing up into everlasting life.

The woman saith unto him, Sir, I perceive that thou art a prophet. Our fathers worshipped in this mountain; and ye say, that in Jerusalem is the place where men ought to worship. Jesus saith unto her,

Woman, believe me, the hour cometh, and now is, when the true worshippers shall worship the Father in spirit and in truth: for the Father seeketh such to worship him. God is a Spirit: and they that worship him must worship him in spirit and in truth.

FROM THE GOSPEL OF ST JOHN, CHAPTER 4

20. THE MIRACLE WORKER

To us it seems very obvious that Jesus should work miracles. After all he was God. For Jesus, it must have been a constant problem. These were the only years in human history in which God was visible. It was the vocation of Jesus to show us, physically, the immensity of God's love. So he must have longed to dispel all sadness and fear, to do away with hunger and sickness; yet God was determined that we should not be puppets. When his Son was on earth, the divine compassion could not but show itself in the occasional miracle. When Jesus was no longer physically present on earth, that compassion would be expressed through the grace of the Holy Spirit. By and large, there would no longer be material miracles, but spiritual miracles. God would always answer our prayer, but not by changing our circumstances. Jesus did not change his own circumstances, even when they became life threatening. After the time of the Incarnation, the prayer for a miracle would be answered by the Spirit coming to strengthen us so that we can accept whatever happens. He is there to support us in times of disaster and help us make the best of it; he is there to help us accept success with gratitude and joy.

THE MARRIAGE AT CANA

There was a marriage in Cana of Galilee; and the mother of Jesus was there. And when they wanted wine, the mother of Jesus saith unto him, They have no wine. Jesus saith unto her, Woman, what have I to do with thee? Mine hour is not yet come. His mother saith unto the servants, Whatsoever he saith unto you, do it. And there were set there six waterpots of stone. Jesus saith unto them, Fill the waterpots with water. And they filled them up to the brim. And he saith unto them, Draw out now, and bear unto the governor of the feast. And they bare it. When the ruler of the feast had tasted the water that was made wine, and knew not whence it was: the governor of the feast called the bridegroom, and saith unto him, Every man at the beginning doth set forth good wine; and when men have well drunk, then that which is worse: but thou hast kept the good wine until now.

FROM THE GOSPEL OF ST JOHN, CHAPTER 2

The feeding of the five thousand

After these things Jesus went over the sea of Galilee. And a great multitude followed him, because they saw his miracles which he did on them that were diseased.

When Jesus then lifted up his eyes, and saw a great company come unto him, he saith unto Philip, Whence shall we buy bread, that these may eat? And this he said to prove him: for he himself knew what he would do. Philip answered him, Two hundred pennyworth of bread is not sufficient for them, that every one of them may take a little. One of his disciples, Andrew, Simon Peter's brother, saith unto him, There is a lad here, which hath five barley loaves, and two small fishes: but what are they among so many? And Jesus said, Make the men sit down. Now there was much grass in the place. So the men sat down, in number about five thousand.

And Jesus took the loaves; and when he had given thanks, he distributed to the disciples, and the disciples to them that were set down; and likewise of the fishes as much as they would. When they were filled, he said unto his disciples, Gather up the fragments that remain, that nothing be lost. Therefore they gathered them together, and filled twelve baskets with the fragments of the five barley loaves, which remained over and above unto them that had eaten. Then those men, when they had seen the miracle that Jesus did, said, This is of a truth that prophet that should come into the world.

The day following, the people came to Capernaum, seeking for Jesus. And when they had found him they said unto him, Rabbi, when camest thou hither? Jesus answered them and said,

> Verily, verily, I say unto you, Ye seek me, not because ye saw the miracles, but because ye did eat of the loaves, and were filled. Labour not for the meat which perisheth, but for that meat which endureth unto everlasting life. I am the bread of life: he that cometh to me shall never hunger.

From the Gospel of St John, chapter 6

JESUS WALKS ON THE WATER

And straightway Jesus constrained his disciples to get into a ship, and to go before him unto the other side. And he went up into a mountain apart to pray. But the ship was now in the midst of the sea, tossed with waves: for the wind was contrary. And in the fourth watch of the night Jesus went unto them, walking on the sea. And when the disciples saw him they were troubled, saying, It is a spirit; and they cried out for fear. But straightway Jesus spake unto them, saying, Be of good cheer; it is I; be not afraid.

And Peter answered him and said, Lord, if it be thou, bid me come unto thee on the water. And he said, Come. And when Peter was come down out of the ship, he walked on the water, to go to Jesus. But when he saw the wind boisterous, he was afraid; and beginning to sink, he cried, saying, Lord, save me. And immediately Jesus stretched forth his hand, and caught him, and said unto him, O thou of little faith, wherefore didst thou doubt?

FROM THE GOSPEL OF ST MATTHEW, CHAPTER 14

Christ at the Sea of Galilee, by Alessandro Magnasco (1667–1749).

For most of human history, and even today (think of the tsunami) the sea has been the great image of the uncontrolled. At the beginning of the Bible, when God brought order out of chaos, his Spirit moved over the waters, which he alone could control. There are two instances in the Gospels in which Jesus is confronted by the savage power of the sea. In one he is asleep, not even dignifying the storm with his attention. In the other, he goes even further, walking across the maelstrom of the waves and summoning Peter to show his faith by leaving the boat and walking towards him. Magnasco shows the moment in which Peter suddenly realizes that he is doing the impossible and begins to sink. Jesus will save him, as he will save the terrified apostles in that other storm during which he is asleep. In both cases, he rebukes his friends: whether he sleeps through the tempest or walks on the water despite its violence, he feels they should have trust in him. Both times, the disciples begin to understand that calming the storm can only be the work of God and not of man. Who then, they wonder, is this Jesus?

JESUS HEALS TWO BLIND MEN

And as they departed from Jericho, a great multitude followed him. And, behold, two blind men sitting by the way side, when they heard that Jesus passed by, cried out, saying, Have mercy on us, O Lord, thou Son of David. And the multitude rebuked them, because they should hold their peace: but they cried the more, saying, Have mercy on us, O Lord, thou Son of David. And Jesus stood still, and called them, and said, What will ye that I shall do unto you? They say unto him, Lord, that our eyes may be opened. So Jesus had compassion on them, and touched their eyes: and immediately their eyes received sight, and they followed him.

FROM THE GOSPEL OF ST MATTHEW, CHAPTER 20

Christ Healing the Blind, by Nicolas Poussin (1594–1665)

When John the Baptist was in prison, he sent disciples, at what must have been a very dark moment for him (even the holiest can know doubt), to ask if Jesus were really the Messiah. Jesus sent a simple reply to his suffering friend. He said to tell him that the deaf were recovering their hearing, the blind their sight, the lame and the cripple their mobility. These three categories of miracles were obviously important on a level deeper than the physical. We are all deaf and blind and crippled, when it comes to understanding the love of God and our need to love our neighbour. When Jesus healed the blind, he was restoring eyesight, but also acting out a parable. It is a blessing indeed to be able to see the created world, but a far greater blessing to 'see' the uncreated beauty of God's love.

Poussin was a profoundly serious Christian, and all his biblical paintings have this double significance. Jesus is taking away the darkness of material blindness; and notice how the blind are brought to Jesus by other men – we cannot follow him and not be concerned with the

needs of other people. Jesus lays his hand on those damaged eyes, but everything in Poussin's great painting suggests that he is also healing a damaged soul. The men kneel, holding out their longing arms to him, and the serene sublimity of the landscape affirms that we are witnessing a miracle.

21. Sayings from the Sermon on the Mount

At the end of his Gospel, John admits ruefully that no books could possibly contain a record of all that Jesus said and did. Matthew tries his best to encapsulate that teaching in what has become known as the Sermon on the Mount. It was a highly demanding teaching, radical in its extremes of humility and generosity. The Jews had always thought (and this belief still lingers on in our contemporary world) that doing good brings material rewards. We still feel that when things go wrong for us, it indicates that we are not in God's favour. But Jesus turns the world upside down. He sees the have-nots, the sufferers, the vulnerable and downtrodden, as the blessed ones. Everything that our natural inclinations desire – such as success and power, public esteem and even justice – Jesus tells us to forget. What matters is forgiveness, lack of interest in one's self, complete trust in God (not that he will make things right for us, but that he will always hold us in the right). We instinctively judge other people, we have a need to feel that we are in the driving seat. No, says Jesus, give up all claims, however technically justified. Allow God to be in the driving seat and live in peace and love. G. K. Chesterton, looking sadly at the modern world, said that it was not that Christianity had failed, but that it had never been tried.

The Beatitudes

Jesus went up into a mountain: and when he was set, his disciples came unto him: and he opened his mouth, and taught them, saying,

Blessed are the poor in spirit: for theirs is the kingdom of heaven.
Blessed are they that mourn: for they shall be comforted.
Blessed are the meek: for they shall inherit the earth.

Blessed are they which do hunger and thirst after righteousness: for they shall be filled.
Blessed are the merciful: for they shall obtain mercy.
Blessed are the pure in heart: for they shall see God.
Blessed are the peacemakers: for they shall be called the children of God.
Blessed are they which are persecuted for righteousness' sake: for theirs is the kingdom of heaven.

From the Gospel of St Matthew, chapter 5

THE LAW OF LOVE

Ye have heard that it hath been said, An eye for an eye, and a tooth for a tooth: But I say unto you, that ye resist not evil: but whosoever shall smite thee on thy right cheek, turn to him the other also. And if any man will sue thee at the law, and take away thy coat, let him have thy cloke also. And whosoever shall compel thee to go a mile, go with him twain. Give to him that asketh thee, and from him that would borrow of thee turn not thou away.

Ye have heard that it hath been said, Thou shalt love thy neighbour, and hate thine enemy. But I say unto you, Love your enemies, bless them that curse you, do good to them that hate you, and pray for them which despitefully use you, and persecute you; that ye may be the children of your Father which is in heaven: for he maketh his sun to rise on the evil and on the good, and sendeth rain on the just and on the unjust.

Be ye therefore perfect, even as your Father which is in heaven is perfect.

FROM THE GOSPEL OF ST MATTHEW, CHAPTER 5

THE LORD'S PRAYER

When thou prayest, enter into thy closet, and when thou hast shut thy door, pray to thy Father. After this manner therefore pray ye:

> Our Father which art in heaven,
> Hallowed be thy name.
> Thy kingdom come.
> Thy will be done in earth, as it is in heaven.
> Give us this day our daily bread.
> And forgive us our debts, as we forgive our debtors.
> And lead us not into temptation, but deliver us from evil:
> For thine is the kingdom, and the power, and the glory,
> For ever.
> Amen.

FROM THE GOSPEL OF ST MATTHEW, CHAPTER 6

TRUST IN GOD

Lay not up for yourselves treasures upon earth, where moth and rust doth corrupt, and where thieves break through and

steal: but lay up for yourselves treasures in heaven, where neither moth nor rust doth corrupt, and where thieves do not break through nor steal: for where your treasure is, there will your heart be also.

Therefore I say unto you, Take no thought for your life, what ye shall eat, or what ye shall drink; nor yet for your body, what ye shall put on. Is not the life more than meat, and the body than raiment? Behold the fowls of the air: for they sow not, neither do they reap, nor gather into barns; yet your heavenly Father feedeth them. Consider the lilies of the field, how they grow; they toil not, neither do they spin: and yet I say unto you, that even Solomon in all his glory was not arrayed like one of these.

Wherefore, if God so clothe the grass of the field, which to day is, and to morrow is cast into the oven, shall he not much more clothe you, O ye of little faith? Therefore take no thought, saying, What shall we eat? or, What shall we drink? or, Wherewithal shall we be clothed? For your heavenly Father knoweth that ye have need of all these things. But seek ye first the kingdom of God, and his righteousness; and all these things shall be added unto you.

Take therefore no thought for the morrow: for the morrow shall take thought for the things of itself. Sufficient unto the day is the evil thereof.

FROM THE GOSPEL OF ST MATTHEW, CHAPTER 6

WISDOM AND JUDGEMENT

Judge not, that ye be not judged. For with what judgment ye judge, ye shall be judged: and with what measure ye mete, it shall be measured to you again.

Give not that which is holy unto the dogs, neither cast ye your pearls before swine, lest they trample them under their feet, and turn again and rend you.

Therefore all things whatsoever ye would that men should do to you, do ye even so to them: for this is the law and the prophets.

FROM THE GOSPEL OF ST MATTHEW, CHAPTER 7

22. The meaning of love

The Ten Commandments are really ten ways of expressing one commandment: the commandment to love. One of the scriptural definitions of God is that God himself is love; it is a quality so essential to his very being that without it God would not be God. Everything that Jesus did and said had love for its impulse, love for its meaning. For these 30-odd years human beings could actually see for themselves, in flesh and blood, what love was. Seeing, of course, is only part of the message. Love is not an intellectual understanding, though it is that as well, and it is certainly not an emotional response. Love is action. Jesus never speaks about 'feeling' love, but about responding to the needs of other people. We are all needy, if only in that we all need forgiveness. Jesus stresses often the need to show love by forgiving, by accepting the difference in other people, and respecting it. Since in our language the word 'love' often – in fact usually – does have emotional connotations, it is frequently better, I think, to replace it by 'reverence'. Reverence is being humble and respectful towards the other, whether the other is a sinner, a racial enemy, or an ungrateful friend. God holds these people in reverence, forgives and cherishes them. Jesus uses instance after instance to show us that we must do the same if we are to be his disciples.

In the house of Simon the Pharisee

One of the Pharisees desired him that he would eat with him. And he went into the Pharisee's house, and sat down to meat. And, behold, a woman in the city, which was a sinner, brought an alabaster box of ointment, and stood at his feet behind him weeping, and began to wash his feet with tears, and did wipe them with the hairs of her head, and kissed his feet, and anointed them with the ointment. Now when the Pharisee which had bidden him saw it, he spake within himself, saying, This man, if he were a prophet, would have known who and what manner of woman this is that toucheth him: for she is a sinner. And Jesus turned to the woman, and said unto Simon,

> Seest thou this woman? I entered into thine house, thou gavest me no water for my feet: but she hath washed my feet with tears, and wiped them with the hairs of her head. Thou gavest me no kiss: but this woman since the time

Feast in the House of Simon the Pharisee, by Peter Paul Rubens (1577–1640)

I came in hath not ceased to kiss my feet. My head with oil thou didst not anoint: but this woman hath anointed my feet with ointment. Wherefore I say unto thee, Her sins, which are many, are forgiven; for she loved much: but to whom little is forgiven, the same loveth little.

And he said to the woman, Thy faith hath saved thee; go in peace.

FROM THE GOSPEL OF ST LUKE, CHAPTER 7

THE TWO GREAT COMMANDMENTS

One of the scribes came, and asked him, Which is the first commandment of all? And Jesus answered him,

The first of all the commandments is, Hear, O Israel; The Lord our God is one Lord: and thou shalt love the Lord thy God with all thy heart, and with all thy soul, and with all thy mind, and with all thy strength: this is the first commandment. And the second is like, namely this, Thou shalt love thy neighbour as thyself. There is none other commandment greater than these.

FROM THE GOSPEL OF ST MARK, CHAPTER 12

THE GOOD SAMARITAN

Behold, a certain lawyer stood up, and tempted him, saying, Master, what shall I do to inherit eternal life? He said unto him, What is written in the law? How readest thou? And he answering said, Thou shalt love the Lord thy God with all thy heart, and thy neighbour as thyself. And he said unto him, Thou hast answered right: this do, and thou shalt live. But he, willing to justify himself, said unto Jesus, And who is my neighbour? And Jesus answering said,

A certain man went down from Jerusalem to Jericho, and fell among thieves, which stripped him of his raiment, and wounded him, and departed, leaving him half dead. And by chance there came down a certain priest that way: and when he saw him, he passed by on the other side. And likewise a Levite, when he was at the place, came and looked on him, and passed by on the other side.

But a certain Samaritan, as he journeyed, came where he was: and when he saw him, he had compassion on him, and went to him, and bound up his wounds, pouring in oil and wine, and set him on his own beast, and

brought him to an inn, and took care of him. And on the morrow when he departed, he took out two pence, and gave them to the host, and said unto him, Take care of him; and whatsoever thou spendest more, when I come again, I will repay thee.

Which now of these three, thinkest thou, was neighbour unto him that fell among the thieves?

And he said, He that shewed mercy on him. Then said Jesus unto him, Go, and do thou likewise.

From the Gospel of St Luke, chapter 10

THE PRODIGAL SON

A certain man had two sons: And the younger of them said to his father, Father, give me the portion of goods that falleth to me. And he divided unto them his living. And not many days after the younger son gathered all together, and took his journey into a far country, and there wasted his substance with riotous living.

And when he had spent all, there arose a mighty famine in that land; and he began

Opposite: *The Good Samaritan*, by Eugène Delacroix (1798–1863)

to be in want. And he went and joined himself to a citizen of that country; and he sent him into his fields to feed swine. And he would fain have filled his belly with the husks that the swine did eat: and no man gave unto him.

And when he came to himself, he said, How many hired servants of my father's have bread enough and to spare, and I perish with hunger! I will arise and go to my father, and will say unto him, Father, I have sinned against heaven, and before thee, And am no more worthy to be called thy son: make me as one of thy hired servants.

And he arose, and came to his father. But when he was yet a great way off, his father saw him, and had compassion, and ran, and fell on his neck, and kissed him. And the son said unto him, Father, I have sinned against heaven, and in thy sight, and am no more worthy to be called thy son. But the father said to his servants,

Bring forth the best robe, and put it on him; and put a ring on his hand, and shoes on his feet: And bring hither the fatted calf, and kill it; and let us eat, and be merry: For this my son was dead, and is alive again; he was lost, and is found.

And they began to be merry.

Now his elder son was in the field: and as he came and drew nigh to the house, he heard musick and dancing. And he called one of the servants, and asked what these things meant. And he said unto him, Thy brother is come; and thy father hath killed the fatted calf, because he hath received him safe and sound. And he was angry, and would not go in: therefore came his father out, and intreated him. And he answering said to his father,

> Lo, these many years do I serve thee, neither transgressed I at any time thy commandment: and yet thou never gavest me a kid, that I might make merry with my friends: but as soon as this thy son was come, which hath devoured thy living with harlots, thou hast killed for him the fatted calf.

And he said unto him,

> Son, thou art ever with me, and all that I have is thine. It was meet that we should make merry, and be glad: for this thy brother was dead, and is alive again; and was lost, and is found.

From the Gospel of St Luke, chapter 15

The Return of the Prodigal Son, by Rembrandt van Rijn (1606–1669)

If we had nothing of Jesus' teaching, except this one parable, we would still understand his message of love. It is his supreme example of the immensity, almost the folly, of God's love for us. Rembrandt, most tender of painters, is sensitive to every nuance of the prodigal's return. This is the bad son, the wilful spendthrift, who cared nothing for his father or his adult responsibilities, while the money lasted. It is only when he is starving and homeless that he recognizes the idiocy of his behaviour and makes the painful journey home. Rembrandt shows him in his ragged humiliation. It is not just that his father receives him back with such compassion: it is the father's eagerness that astonishes us. He is watching out always for this lost child, abundantly ready not just to forgive him, but to lavish upon him the shoes and the good clothes, the feasting and cherishing, that have been so wilfully disregarded. The other son (is that him on the right?), the good, prim, self-righteous son, cannot understand the father's attitude. Perhaps we cannot understand it either, but this is what it means to love.

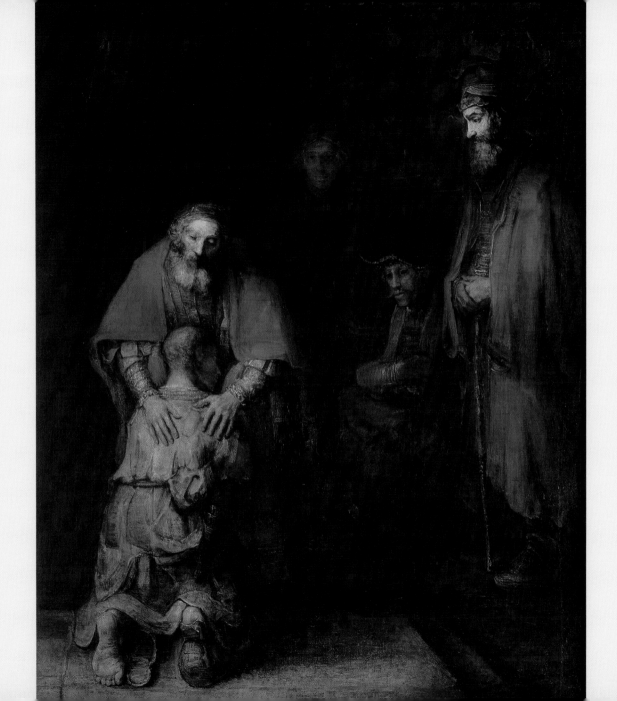

The woman taken in adultery

Early in the morning he came again into the temple. And the scribes and Pharisees brought unto him a woman taken in adultery; and when they had set her in the midst, they say unto him, Master, this woman was taken in adultery, in the very act. Now Moses in the law commanded us, that such should be stoned: but what sayest thou? But Jesus stooped down, and with his finger wrote on the ground, as though he heard them not. So when they continued asking him, he lifted up himself, and said unto them, He that is without sin among you, let him first cast a stone at her.

And they which heard it, being convicted by their own conscience, went out one by one, beginning at the eldest, even unto the last: and Jesus was left alone, and the woman standing in the midst. When Jesus saw none but the woman, he said unto her, Woman, where are those thine accusers? Hath no man condemned thee? She said, No man, Lord. And Jesus said unto her, Neither do I condemn thee: go, and sin no more.

FROM THE GOSPEL OF ST JOHN, CHAPTER 8

Christ and the Adulterous Woman, by Lorenzo Lotto (*c*.1480–1556)
Scholars agree that John did not actually write this passage. The style is different, and it is not always in chapter eight. It would seem that this was a floating page of manuscript that was so profoundly characteristic of Jesus it could not be disregarded. Lotto shows the very beginning of the story, when Jesus is surrounded by the avid and salacious faces of those who care nothing for the law, still less for the wretched woman, and merely want to embarrass Jesus. They know he honours the law. They also know that it would be impossible for him to condemn anyone to death. The next stage in this story, which Lotto does not show us, has Jesus crouching on the ground, mysteriously writing in the dust. Still on his knees, he makes the unforgettable suggestion that only someone who is sinless himself has the right to condemn the sinful woman. What is so moving is Jesus' attitude towards the woman's adultery. He knows she is sorry (that lovely head is bent in contrition), and he feels she needs no punishment, not even a reprimand. He trusts her, once that dense mob of accusers has melted shamefaced into the darkness, to show her repentance by changing her life.

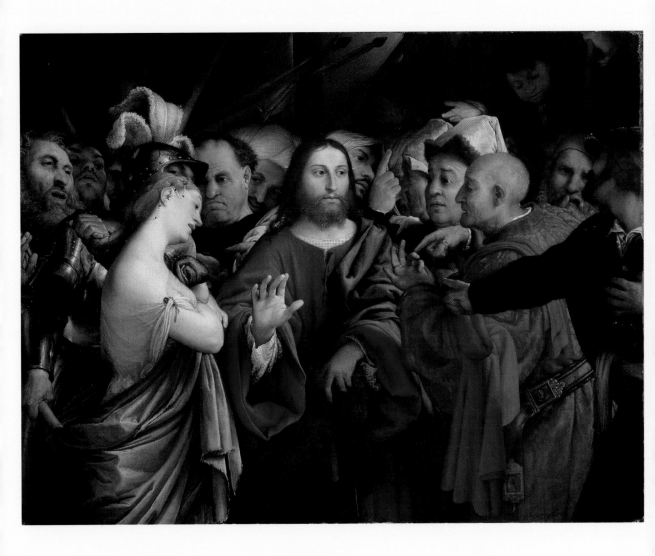

23. Being a disciple

The essence of discipleship is the willingness to take up one's cross and follow Jesus. But everyone has a different cross, and Jesus calls each of us to follow him in a different way. Sometimes, as we see in the parable of the sower, our readiness to hear him is affected by our temperament and circumstances. The implication here is that we can never judge others for their failure. Only God knows the nature of the soil into which he has cast his seed. Some people, if they are to follow him (and this is the parable of the rich fool), have to look long and hard at their attitude towards possessions. Others have to grapple with what it means to be 'defiled': what really makes us unclean? Most of us have to come to terms with our innate desire to be important. This is one of the constant themes of Jesus' teaching, one that is never sufficiently taken to heart: self-importance, self-satisfaction, even too much interest in ourselves, cuts us off from the grace of God.

The rich fool

Jesus said unto them, Take heed, and beware of covetousness: for a man's life consisteth not in the abundance of the things which he possesseth. And he spake a parable unto them, saying,

> The ground of a certain rich man brought forth plentifully: and he thought within himself, saying, What shall I do, because I have no room where to bestow my fruits? And he said, This will I do: I will pull down my barns, and build greater; and there will I bestow all my fruits and my goods. And I will say to my soul, Soul, thou hast much goods laid up for many years; take thine ease, eat, drink, and be merry. But God said unto him, Thou fool, this night thy soul shall be required of thee: then whose shall those things be, which thou hast provided? So is he that layeth up treasure for himself, and is not rich toward God.

From the Gospel of St Luke, chapter 12

The blind leading the blind

Then came to Jesus scribes and Pharisees, which were of Jerusalem, saying, Why do thy disciples transgress the tradition of

the elders? For they wash not their hands when they eat bread. And he called the multitude, and said unto them, Hear, and understand: Not that which goeth into the mouth defileth a man; but that which cometh out of the mouth, this defileth a man. Then came his disciples, and said unto him, Knowest thou that the Pharisees were offended, after they heard this saying? But he answered and said, Let them alone: they be blind leaders of the blind. And if the blind lead the blind, both shall fall into the ditch.

From the Gospel of St Matthew, chapter 15

The cost of discipleship

Then said Jesus unto his disciples,

> If any man will come after me, let him deny himself, and take up his cross, and follow me. For whosoever will save his life shall lose it: and whosoever will lose his life for my sake shall find it. For what is a man profited, if he shall gain the whole world, and lose his own soul? or what shall a man give in exchange for his soul?

From the Gospel of St Matthew, chapter 16

The sower

And he taught them many things by parables, and said unto them in his doctrine,

> Hearken; Behold, there went out a sower to sow: And it came to pass, as he sowed, some fell by the way side, and the fowls of the air came and devoured it up. And some fell on stony ground, where it had not much earth; and immediately it sprang up, because it had no depth of earth: But when the sun was up, it was scorched; and because it had no root, it withered away. And some fell among thorns, and the thorns grew up, and choked it, and it yielded no fruit. And other fell on good ground, and did yield fruit that sprang up and increased; and brought forth, some thirty, and some sixty, and some an hundred.

And when he was alone, they that were about him with the twelve asked of him the parable. And he said unto them,

> The sower soweth the word. And these are they by the way side, where the word is sown; but when they have heard, Satan cometh immediately, and taketh away the word that was sown in

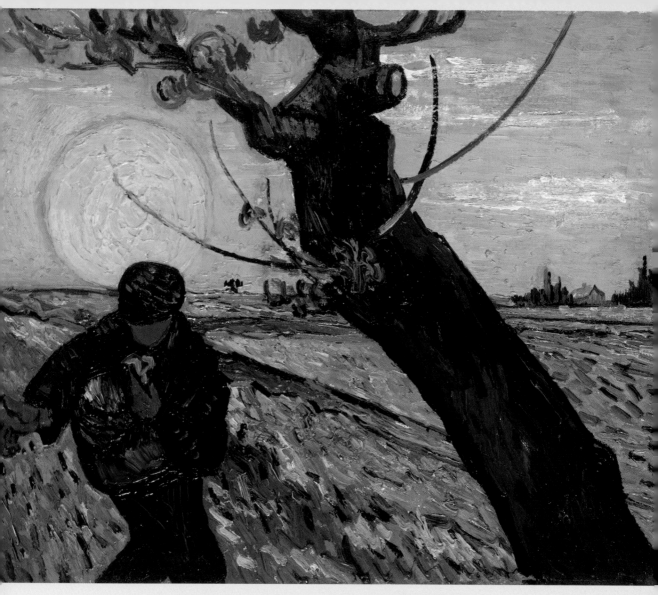

The Sower, by Vincent van Gogh (1853–1890)

their hearts. And these are they likewise which are sown on stony ground; who, when they have heard the word, immediately receive it with gladness; And have no root in themselves, and so endure but for a time: afterward, when affliction or persecution ariseth for the word's sake, immediately they are offended. And these are they which are sown among thorns; such as hear the word, And the cares of this world, and the deceitfulness of riches, and the lusts of other things entering in, choke the word, and it becometh unfruitful. And these are they which are sown on good ground; such as hear the word, and receive it, and bring forth fruit, some thirtyfold, some sixty, and some an hundred.

FROM THE GOSPEL OF ST MARK, CHAPTER 4

JESUS BLESSES THE CHILDREN

And they brought young children to him, that he should touch them: and his disciples rebuked those that brought them. But when Jesus saw it, he was much displeased, and said unto them,

Suffer the little children to come unto me, and forbid them not: for of such is the kingdom of God. Verily I say unto you, Whosoever shall not receive the kingdom of God as a little child, he shall not enter therein.

And he took them up in his arms, put his hands upon them, and blessed them. At the same time came the disciples unto Jesus, saying, Who is the greatest in the kingdom of heaven? And Jesus called a little child unto him, and set him in the midst of them, And said,

Verily I say unto you, Except ye be converted, and become as little children, ye shall not enter into the kingdom of heaven. Whosoever therefore shall humble himself as this little child, the same is greatest in the kingdom of heaven. And whoso shall receive one such little child in my name receiveth me.

But whoso shall offend one of these little ones which believe in me, it were better for him that a millstone were hanged about his neck, and that he were drowned in the depth of the sea. Take heed that ye despise not one of these little ones; for I say unto you, that in heaven their angels do always behold the face of my Father which is in heaven.

FROM THE GOSPEL OF ST MARK, CHAPTER 10,
AND THE GOSPEL OF ST MATTHEW, CHAPTER 18

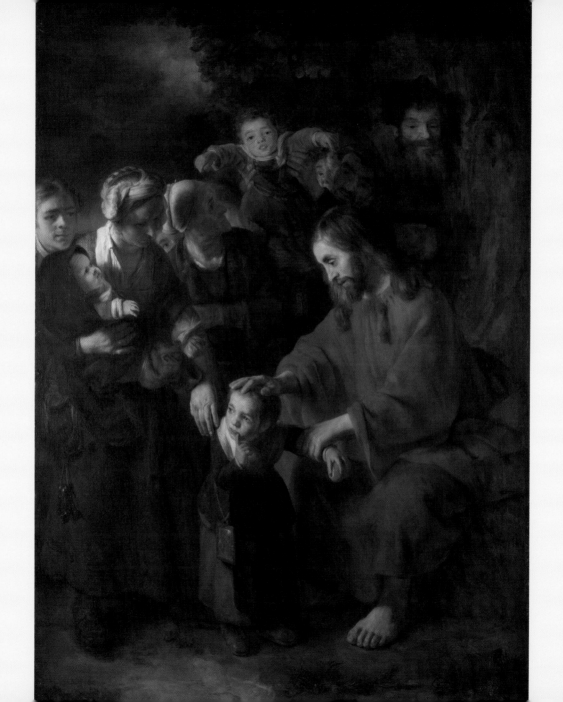

Christ Blessing the Children, by Nicolaes Maes (1634–1693)

Nicholaes Maes was one of Rembrandt's pupils, and it was very much in the spirit of his teacher that he painted this affectionate scene. In itself, this could seem an insignificant incident: the apostles did not want to be bothered by women with their children, and Jesus sees this as more than just male arrogance. It is that, indeed, but it is an attitude that reveals a contempt, even if a benign contempt, for the powerless. There is a teaching here that is very close to the heart of Christ. Unless we accept our powerlessness and allow God to be our strength, we are not living in the truth. Children are inherently powerless, the most vulnerable of human creatures. Maes shows Jesus laying a tender hand upon the head of a small child who takes no notice of him. Little ones cannot always distinguish between kindness and abuse. To offer that abuse is a hideous sin, one of the few that Jesus denounces with passion; yet, equally passionate, is his insistence that the humility of a child is something that his followers must value and imitate.

24. The road to Jerusalem

Jesus knew that it would be in Jerusalem, the Holy City, that he would finally confront the powers of darkness. Although the apostles were very slow to recognize it, the fate of John the Baptist made it all too clear that contemporary Palestine could not accept the challenge of God's love. Jesus tried to prepare his friends for the inevitable end, and we can see in Peter, always their spokesman, how conflicted they were. On the one hand, Peter knows that Jesus is more than merely man. On the other, he cannot bear to listen to what Jesus is telling him will destroy all their hopes for a glorious messiah. Jesus is not the messiah that Jews expected: he is much more. The transfiguration is a unique instance of Jesus revealing his numinous power, and revealing it precisely to his three closest apostles. Peter, James and John are granted a vision, both to strengthen them for the temptations ahead and to warn them of those temptations. Jesus speaks to his friends more and more openly about his death. At the same time, in the raising of Lazarus, he shows them his control over death. When he is dragged away to be crucified they should be able to remember this.

The beheading of John the Baptist

At that time Herod the tetrarch heard of the fame of Jesus, And said unto his servants, This is John the Baptist; he is risen from the dead; and therefore mighty works do shew forth themselves in him.

For Herod had laid hold on John, and bound him, and put him in prison for Herodias' sake, his brother Philip's wife. For John said unto him, It is not lawful for thee to have her. And when he would have put him to death, he feared the multitude, because they counted him as a prophet.

But when Herod's birthday was kept, the daughter of Herodias danced before them, and pleased Herod. Whereupon he promised with an oath to give her whatsoever she would ask. And she, being before instructed of her mother, said, Give me here John Baptist's head in a charger. And the king was sorry: nevertheless for the oath's sake, and them which sat with him at meat, he commanded it to be given her.

And he sent, and beheaded John in the prison. And his head was brought in a charger, and given to the damsel: and she brought it to her mother. And his disciples

came, and took up the body, and buried it, and went and told Jesus.

From the Gospel of St Matthew, chapter 14

Peter's confession

When Jesus came into the coasts of Caesarea Philippi, he asked his disciples, saying, Whom do men say that I the Son of man am? And they said, Some say that thou art John the Baptist: some, Elias; and others, Jeremias, or one of the prophets. He saith unto them, But whom say ye that I am? And Simon Peter answered and said, Thou art the Christ, the Son of the living God. And Jesus answered and said unto him,

> Blessed art thou, Simon Barjona: for flesh and blood hath not revealed it unto thee, but my Father which is in heaven. And I say also unto thee, that thou art Peter, and upon this rock I will build my church; and the gates of hell shall not prevail against it. And I will give unto thee the keys of the kingdom of heaven.

From that time forth began Jesus to shew unto his disciples, how that he must go unto Jerusalem, and suffer many things of the elders and chief priests and scribes, and be killed, and be raised again the third day.

Then Peter took him, and began to rebuke him, saying, Be it far from thee, Lord: this shall not be unto thee. But he turned, and said unto Peter, Get thee behind me, Satan: thou art an offence unto me: for thou savourest not the things that be of God, but those that be of men.

From the Gospel of St Matthew, chapter 16

The transfiguration

After six days Jesus taketh with him Peter, and James, and John, and leadeth them up into an high mountain apart by themselves: and he was transfigured before them. And his raiment became shining, exceeding white as snow; so as no fuller on earth can white them.

And there appeared unto them Elias with Moses: and they were talking with Jesus. And Peter answered and said to Jesus, Master, it is good for us to be here: and let us make three tabernacles; one for thee, and one for Moses, and one for Elias. For he wist not what to say; for they were

sore afraid. And there was a cloud that overshadowed them: and a voice came out of the cloud, saying, This is my beloved Son: hear him. And suddenly, when they had looked round about, they saw no man any more, save Jesus only with themselves.

FROM THE GOSPEL OF ST MARK, CHAPTER 9

JESUS HEALS A MAN BORN BLIND

And as Jesus passed by, he saw a man which was blind from his birth. And his disciples asked him, saying, Master, who did sin, this man, or his parents, that he was born blind? Jesus answered, Neither hath this man sinned, nor his parents: but that the works of God should be made manifest in him. When he had thus spoken, he spat on the ground, and made clay of the spittle, and he anointed the eyes of the blind man with the clay, And said unto him, Go, wash in the pool of Siloam. He went his way therefore, and washed, and came seeing.

The neighbours therefore, and they which before had seen him that he was blind, said, Is not this he that sat and begged? Therefore said they unto him, How were

The Transfiguration, by Duccio di Buoninsegna (*c*.1235–*c*.1319)

This is an event that essentially defies painting. All the elements of the story can be painted, except the supernatural brightness with which the human figure of Jesus was irradiated. On the slopes of Mount Tabor we see Peter, John and James, all three overwhelmed by such an extraordinary sight. John and James are speechless with loving wonder, while Peter, as ever, explodes into rapturous (and foolish) response. As well as their lord and master, gleaming with heavenly brightness, they see on the mountain two heavenly figures. There is Moses, representing the law, and there is Elias, representing the prophets. Even more astonishing, they hear the voice of God solemnly reminding them that Jesus is his beloved Son and summoning them to obedience. Duccio uses gold inlays in an attempt to show the dazzle of Jesus' transfigured person. In its quiet dignity, it is a good attempt, but this is truly something that only the heart at prayer can 'see'.

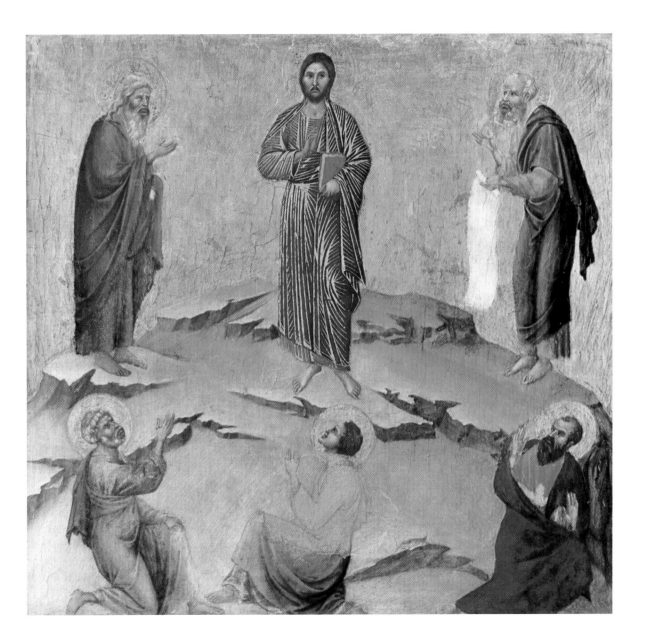

thine eyes opened? He answered and said, A man that is called Jesus made clay, and anointed mine eyes, and said unto me, Go to the pool of Siloam, and wash: and I went and washed, and I received sight. Then said they unto him, Where is he? He said, I know not.

They brought to the Pharisees him that aforetime was blind. And it was the sabbath day when Jesus made the clay, and opened his eyes. Therefore said some of the Pharisees, This man is not of God, because he keepeth not the sabbath day. Others said, How can a man that is a sinner do such miracles? And there was a division among them.

They say unto the blind man again, What sayest thou of him, that he hath opened thine eyes? He said, He is a prophet. But the Jews did not believe concerning him, that he had been blind, and received his sight, and said unto him, Give God the praise: we know that this man is a sinner. He answered and said, Whether he be a sinner or no, I know not: one thing I know, that, whereas I was blind, now I see.

Then said they to him again, What did he to thee? how opened he thine eyes? He answered them, I have told you already, and ye did not hear: wherefore would ye

hear it again? will ye also be his disciples? Then they reviled him, and said, Thou art his disciple; but we are Moses' disciples. We know that God spake unto Moses: as for this fellow, we know not from whence he is. The man answered and said unto them, Why herein is a marvellous thing, that ye know not from whence he is, and yet he hath opened mine eyes. If this man were not of God, he could do nothing. They answered and said unto him, Thou wast altogether born in sins, and dost thou teach us? And they cast him out.

Jesus heard that they had cast him out; and when he had found him, he said unto him, Dost thou believe on the Son of God? He answered and said, Who is he, Lord, that I might believe on him? And Jesus said unto him, Thou hast both seen him, and it is he that talketh with thee. And he said, Lord, I believe. And he worshipped him.

And Jesus said, For judgment I am come into this world, that they which see not might see; and that they which see might be made blind.

From the Gospel of St John, chapter 9

THE RAISING OF LAZARUS

Now a certain man was sick, named Lazarus, of Bethany, the town of Mary and her sister Martha. Now Jesus loved Martha, and her sister, and Lazarus. When he had heard therefore that he was sick, he abode two days still in the same place where he was. Then after that saith he to his disciples, Let us go into Judaea again.

Then when Jesus came, he found that he had lain in the grave four days already. Now Bethany was nigh unto Jerusalem, about fifteen furlongs off: And many of the Jews came to Martha and Mary, to comfort them concerning their brother.

Then Martha, as soon as she heard that Jesus was coming, went and met him: but Mary sat still in the house. Then said Martha unto Jesus, Lord, if thou hadst been here, my brother had not died. But I know, that even now, whatsoever thou wilt ask of God, God will give it thee. Jesus saith unto her, Thy brother shall rise again. Martha saith unto him, I know that he shall rise again in the resurrection at the last day. Jesus said unto her,

I am the resurrection, and the life: he that believeth in me, though he were dead, yet shall he live: And whosoever liveth and believeth in me shall never die.

Then he groaned in the spirit, and was troubled, And said, Where have ye laid him? They said unto him, Lord, come and see. Jesus wept.

Jesus therefore again groaning in himself cometh to the grave. It was a cave, and a stone lay upon it. Jesus said, Take ye away the stone. And Jesus lifted up his eyes, and said, Father, I thank thee that thou hast heard me. And when he thus had spoken, he cried with a loud voice, Lazarus, come forth. And he that was dead came forth, bound hand and foot with graveclothes: and his face was bound about with a napkin. Jesus saith unto them, Loose him, and let him go.

Then many of the Jews which came to Mary, and had seen the things which Jesus did, believed on him. But some of them went their ways to the Pharisees, and told them what things Jesus had done.

FROM THE GOSPEL OF ST JOHN, CHAPTER 11

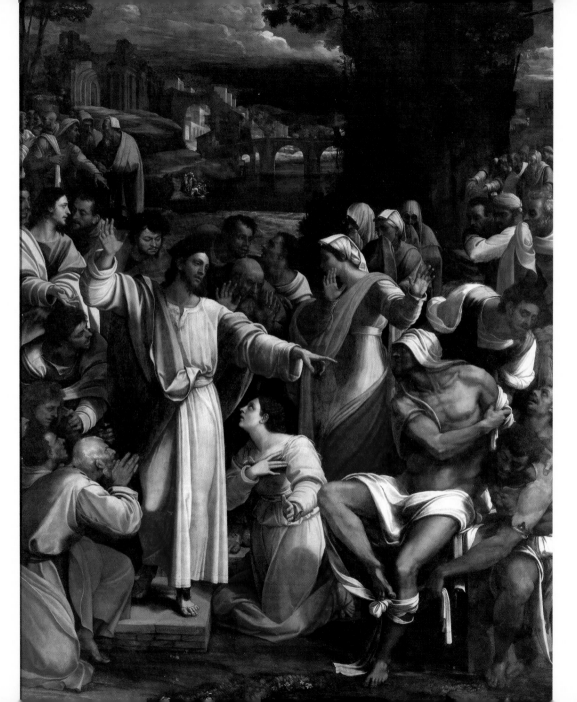

The Raising of Lazarus, by Sebastiano del Piombo (1485–1547)

This is Jesus' greatest miracle, his final revelation of divine love. Lazarus has been dead for four days and is already beginning to decay, and the Gospel shows Jesus deliberately waiting for the days to pass, so that it can become clear to all who see this miracle that death is no obstacle to God. Lazarus is not resurrected, he is resuscitated. One day Lazarus will die again, but when that day comes it will be a passage into eternal life. The resurrection of Jesus, which, of course, has not yet happened, will mean that death has lost its power. That meaning is played out here as Jesus shows his effortless raising of his friend Lazarus.

Del Piombo was probably helped by Michelangelo in planning this great painting. Although it is full of characters – Mary, Martha, the apostles, the bystanders – this scene is dominated by the lordly gesture of Jesus, who himself is life, and the muscular body of Lazarus, struggling back into life. Ironically, the divine power that Jesus shows in this miracle frightens the Pharisees into their final determination to destroy Jesus.

25. The darkness gathers

The last week of Jesus' life is dense with sacred incident. He enters Jerusalem, ignoring all threats, and is acclaimed by the people. Knowing that his time is short, he braves the throngs in the Temple, challenging their values by casting out all that he feels to be unworthy of his Father's house. And then, having done all that is possible to prepare them, he has a solemn farewell gathering of the apostles. Jesus knew this was his 'last supper', but one would have thought that the apostles would have been aware of the importance of what he was doing and saying in that upper room. Perhaps they did not want to understand? Look at what he reveals to them in the space of a few hours: he has instituted that greatest of all sacraments, the Eucharist, and fed them on his own living body and blood; he has emphasized once more the utter necessity of humility by washing their feet; he has spoken to them as never before of his closeness to the Father and revealed his impending betrayal. Yet, even then, they are able to ignore the agony he will suffer in the Garden of Gethsemane, as if unaware that these are their last hours in his earthly presence. They cannot bring themselves to believe what they know to be true: just like us.

The Triumphal Entry

It came to pass, when he was come nigh to the mount called the mount of Olives, he sent two of his disciples, saying, Go ye into the village over against you; in the which at your entering ye shall find a colt tied, whereon yet never man sat: loose him, and bring him hither. And they brought him to Jesus: and they cast their garments upon the colt, and they set Jesus thereon. And as he went, they spread their clothes in the way.

And when he was come nigh, even now at the descent of the mount of Olives, the whole multitude of the disciples began to rejoice and praise God with a loud voice for all the mighty works that they had seen; saying, Blessed be the King that cometh in the name of the Lord: peace in heaven, and glory in the highest.

From the Gospel of St Luke, chapter 19

The Cleansing of the Temple

Jesus went into the temple, and began to cast out them that sold and bought in the temple, and overthrew the tables of the

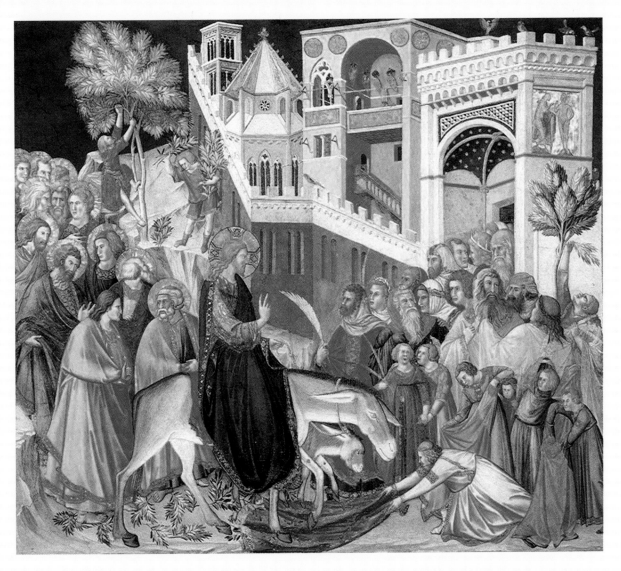

The Entry of Christ into Jerusalem, by Pietro Lorenzetti (fourteenth century)

moneychangers, and the seats of them that sold doves; And would not suffer that any man should carry any vessel through the temple. And he taught, saying unto them, Is it not written, My house shall be called of all nations the house of prayer? But ye have made it a den of thieves. And the scribes and chief priests heard it, and sought how they might destroy him: for they feared him, because all the people was astonished at his doctrine.

FROM THE GOSPEL OF ST MARK, CHAPTER 11

THE LAST SUPPER

Now the first day of the feast of unleavened bread the disciples came to Jesus, saying unto him, Where wilt thou that we prepare for thee to eat the passover? And he said, Go into the city to such a man, and say unto him, The Master saith, My time is at hand; I will keep the passover at thy house with my disciples. And the disciples did as Jesus had appointed them; and they made ready the passover.

Now when the even was come, he sat down with the twelve. And as they did eat, he said, Verily I say unto you, that one of you shall betray me. And they were exceeding sorrowful, and began every one of them to say unto him, Lord, is it I? And he answered and said,

> He that dippeth his hand with me in the dish, the same shall betray me. The Son of man goeth as it is written of him: but woe unto that man by whom the Son of man is betrayed! It had been good for that man if he had not been born.

Then Judas, which betrayed him, answered and said, Master, is it I? He said unto him, Thou hast said.

And as they were eating, Jesus took bread, and blessed it, and brake it, and gave it to the disciples, and said, Take, eat; this is my body. And he took the cup, and gave thanks, and gave it to them, saying, Drink ye all of it; for this is my blood of the new testament, which is shed for many for the remission of sins.

And supper being ended, the devil having now put into the heart of Judas Iscariot, Simon's son, to betray him; Jesus riseth from supper, and laid aside his garments; and took a towel, and girded himself. After that he poureth water into a bason, and began to wash the disciples' feet, and to wipe them with the towel wherewith he was girded.

Then cometh he to Simon Peter: and Peter saith unto him, Lord, thou shalt never wash my feet. Jesus answered him, If I wash thee not, thou hast no part with me. Simon Peter saith unto him, Lord, not my feet only, but also my hands and my head.

After he had washed their feet, and had taken his garments, and was set down again, he said unto them,

> Let not your heart be troubled: ye believe in God, believe also in me. In my Father's house are many mansions: if it were not so, I would have told you. I go to prepare a place for you. And if I go and prepare a place for you, I will come again, and receive you unto myself; that where I am, there ye may be also. And whither I go ye know, and the way ye know.

Thomas saith unto him, Lord, we know not whither thou goest; and how can we know the way? Jesus saith unto him,

> I am the way, the truth, and the life: no man cometh unto the Father, but by me. If ye had known me, ye should have known my Father also: and from henceforth ye know him, and have seen him.

Philip saith unto him, Lord, shew us the Father, and it sufficeth us. Jesus saith unto him,

> Have I been so long time with you, and yet hast thou not known me, Philip? He that hath seen me hath seen the Father.

> Peace I leave with you, my peace I give unto you: not as the world giveth, give I unto you. Let not your heart be troubled, neither let it be afraid.

> As the Father hath loved me, so have I loved you: continue ye in my love. If ye keep my commandments, ye shall abide in my love; even as I have kept my Father's commandments, and abide in his love.

> This is my commandment, that ye love one another, as I have loved you. Greater love hath no man than this, that a man lay down his life for his friends.

> These things I have spoken unto you, that in me ye might have peace. In the world ye shall have tribulation: but be of good cheer; I have overcome the world.

From the Gospel of St Matthew, chapter 26, and the Gospel of St John, chapters 13, 14, 15, 16

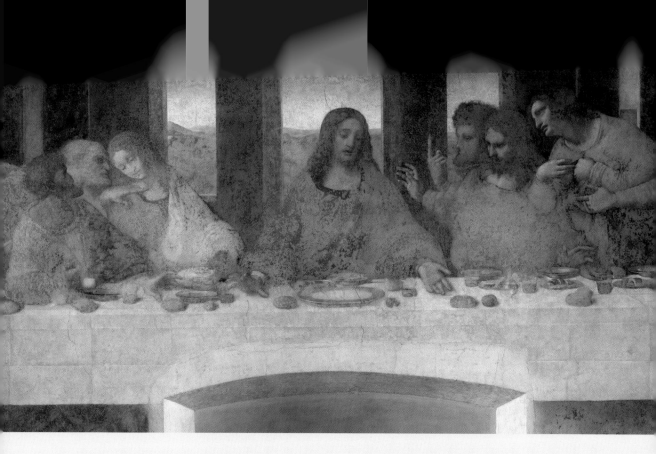

The Last Supper, by Leonardo da Vinci
(1452–1519)

It always seems to me that it is sadly
appropriate that the greatest of all Last
Supper paintings, Leonardo's fresco in the
monks' refectory in Milan, should have
begun to fade almost as soon as it was

painted. Insatiable of experimentation,
Leonardo ignored the established
rules for fresco painting and tried an
innovatory technique. It did not work,
and restoration has been incessant ever
since. Why I think this fading of the
paint is appropriate, though tragic, is

because what Jesus did at the Last Supper exceeds our human understanding. He gave his Church the Eucharist, a mystical means of communion with his risen body. If Christians received this Holy Communion just once in their lives, with what awed reverence they would prepare for that unimaginable moment. Yet, because the gift is offered at every Mass, daily if we choose, we can miss the sublime and transforming power of this most holy sacrament. Leonardo shows the loneliness of Jesus. He is giving himself, mystically, crowning his life of sacrifice, yet the apostles do not understand. Leonardo, with his marvellous power to show character and reaction, sees them as more concerned with his accusation of betrayal. That betrayal was indeed almost incomprehensible, humanly speaking, yet the eucharistic gift is infinitely more mysterious. Nothing Leonardo ever painted is as overpowering in its mystery as this damaged fresco.

THE AGONY IN THE GARDEN

When they had sung an hymn, they went out into the mount of Olives. Then saith Jesus unto them, All ye shall be offended because of me this night. Peter answered and said unto him, Though all men shall be offended because of thee, yet will I never be offended. Jesus said unto him, Verily I say unto thee, that this night, before the cock crow, thou shalt deny me thrice. Peter said unto him, Though I should die with thee, yet will I not deny thee. Likewise also said all the disciples.

Then cometh Jesus with them unto a place called Gethsemane, and saith unto the disciples, Sit ye here, while I go and pray yonder. And he took with him Peter and the two sons of Zebedee, and began to be sorrowful and very heavy. Then saith he unto them, My soul is exceeding sorrowful, even unto death: tarry ye here, and watch with me. And he went a little further, and fell on his face, and prayed, saying, O my Father, if it be possible, let this cup pass from me: nevertheless not as I will, but as thou wilt.

And he cometh unto the disciples, and findeth them asleep, and saith unto Peter, What, could ye not watch with me one

hour? Watch and pray, that ye enter not into temptation: the spirit indeed is willing, but the flesh is weak.

He went away again the second time, and prayed, saying, O my Father, if this cup may not pass away from me, except I drink it, thy will be done. And he came and found them asleep again: for their eyes were heavy. And he left them, and went away again, and prayed the third time, saying the same words. Then cometh he to his disciples, and saith unto them,

> Sleep on now, and take your rest: behold, the hour is at hand, and the Son of man is betrayed into the hands of sinners.

FROM THE GOSPEL OF ST MATTHEW, CHAPTER 26

Christ in the Garden of Olives, by Sandro Botticelli (1445–1510)

After the Last Supper, Jesus led his disciples to the Garden of Gethsemane. He intended to spend the night in prayer, as he often did, but for once he asked three of the apostles, Peter, James and John, to stay with him. Here we see the loneliness of Jesus. He had never needed support, and now that he did, and was asking for it, the apostles were too insensitive to realize his inner suffering. He went alone to pray, to wrestle with the certainty of the terrible death that was only hours away. Humanly, it would have helped him to be joined in this prayer by his friends. Botticelli makes it painfully clear that the friends are wholly oblivious – they have gone to sleep. Jesus is alone and isolated, fenced off from all human support. The Gospels tell us occasionally of Jesus' emotions: he could be angry, he could be distressed, he could be full of joy. But this is the one sole time when he was in anguish, sweating heavily under the sheer pressure of his desire to continue his apostolate and yet to be obedient to his beloved Father. Sometimes we are given the impression that the saints are glad to suffer, that it is a mark of their sanctity. But the saint of saints, Jesus himself, saw suffering and torture and

cruelty for what they were, hideous and evil. There is great comfort for us weak sinners in the agony in the garden. The only thing Jesus wanted was his Father's will: please God, that is what we want too. His Father sent an angel to strengthen him, and in one form or another, his Father will send his angel to strengthen us.

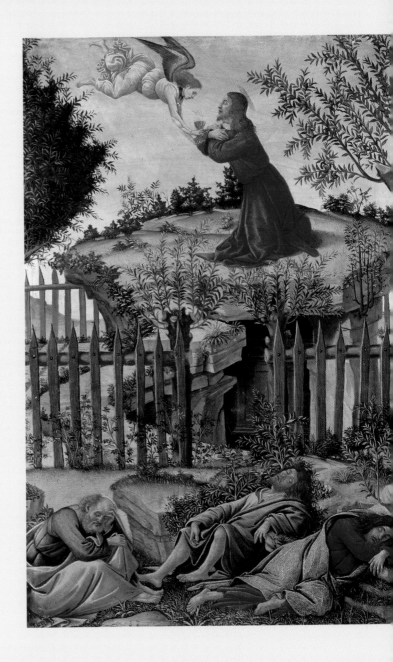

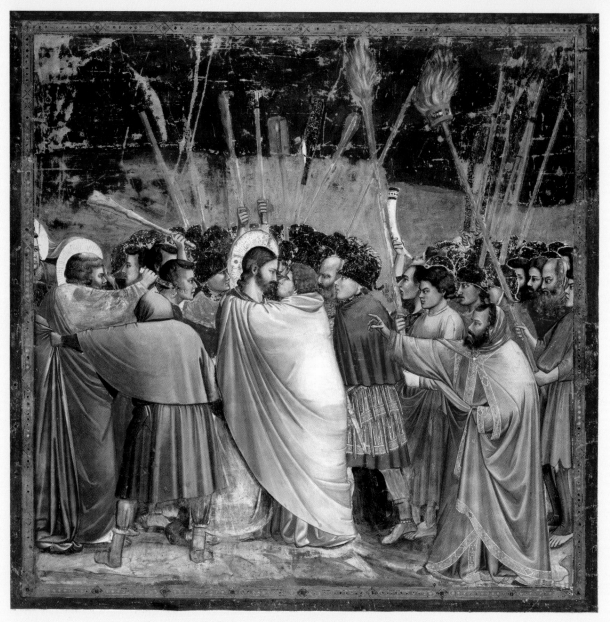

The Betrayal of Christ, by Giotto di Bondone (*c.*1266–1337)

JUDAS BETRAYS HIS MASTER

And while he yet spake, lo, Judas, one of
the twelve, came, and with him a great
multitude with swords and staves, from
the chief priests and elders of the people.
Now he that betrayed him gave them a
sign, saying, Whomsoever I shall kiss, that
same is he: hold him fast. And forthwith
he came to Jesus, and said, Hail, master;
and kissed him.

And Jesus said unto him, Friend,
wherefore art thou come? Then came
they, and laid hands on Jesus, and took
him. And, behold, one of them which
were with Jesus stretched out his hand,
and drew his sword, and struck a servant
of the high priest's, and smote off his ear.
Then said Jesus unto him, Put up again thy
sword into his place: for all they that take
the sword shall perish with the sword.

Then all the disciples forsook him, and
fled.

FROM THE GOSPEL OF ST MATTHEW, CHAPTER
26

26. THE WILLING SACRIFICE

Jesus did not go passively into death. He accepted it. At every stage, Jesus was offering himself for the sake of the world. His sacrifice began with the betrayal by his friend Judas. It intensified as he was rejected by the other apostles, who fled away in dismay, and by the explicit denial by his dear Peter. This is not a denial that would endure, as Jesus would have known. But the denial and rejection by the authorities, first the Jewish high priest and then the Roman governor, those would endure. Those who refuse to be humble, forgiving and loving, cannot but condemn the Jesus who holds out an ideal so contrary to self-interest. The physical destruction of the Son of God took place within a very few hours. From his arrest in the early morning until his crucifixion at noon, he endured incessant physical pain: scourged, crowned with thorns, and then crucified. Yet it was the pain in his heart that was the greater. His Father had sent him to the world to teach the meaning of love. Might Jesus have concluded that he had failed? If that fear darkened his heart, he endured that too for the sake of all who have lived, were living and who will live. By this free sacrifice, he showed us the meaning of God as never before. Now we know that God loves us to the death, and will be with us in whatever we ourselves will suffer. Jesus made suffering redemptive.

PETER'S DENIAL

Then took they Jesus, and led him, and brought him into the high priest's house. And Peter followed afar off. And when they had kindled a fire in the midst of the hall, and were set down together, Peter sat down among them. But a certain maid beheld him as he sat by the fire, and earnestly looked upon him, and said, This man was also with him. And he denied him, saying, Woman, I know him not.

And after a little while another saw him, and said, Thou art also of them. And Peter said, Man, I am not. And about the space of one hour after another confidently affirmed, saying, Of a truth this fellow also was with him: for he is a Galilaean. And Peter said, Man, I know not what thou sayest.

And immediately, while he yet spake, the cock crew. And the Lord turned, and looked upon Peter. And Peter remembered the word of the Lord, how he had said

unto him, Before the cock crow, thou shalt deny me thrice. And Peter went out, and wept bitterly.

From the Gospel of St Luke, chapter 22

witnesses? Behold, now ye have heard his blasphemy. What think ye? They answered and said, He is guilty of death.

From the Gospel of St Matthew, chapter 26

The trial before Caiaphas

Now the chief priests, and elders, and all the council, sought false witness against Jesus, to put him to death; but found none: yea, though many false witnesses came, yet found they none. At the last came two false witnesses, and said, This fellow said, I am able to destroy the temple of God, and to build it in three days. And the high priest arose, and said unto him, Answerest thou nothing? What is it which these witness against thee?

But Jesus held his peace. And the high priest answered and said unto him, I adjure thee by the living God, that thou tell us whether thou be the Christ, the Son of God. Jesus saith unto him, Thou hast said: nevertheless I say unto you, Hereafter shall ye see the Son of man sitting on the right hand of power, and coming in the clouds of heaven. Then the high priest rent his clothes, saying, He hath spoken blasphemy; what further need have we of

The trial before Pilate

When the morning was come they led him away, and delivered him to Pontius Pilate the governor. Then Judas, which had betrayed him, when he saw that he was condemned, repented himself, and cast down the pieces of silver in the temple, and departed, and went and hanged himself.

Then led they Jesus from Caiaphas unto the hall of judgment: Pilate then went out unto them, and said, What accusation bring ye against this man? They answered and said unto him, If he were not a malefactor, we would not have delivered him up unto thee. Then said Pilate unto Jesus, Art thou the King of the Jews? Jesus answered him, Sayest thou this thing of thyself, or did others tell it thee of me? Pilate answered, Am I a Jew? Thine own nation and the chief priests have delivered thee unto me: what hast thou done? Jesus answered,

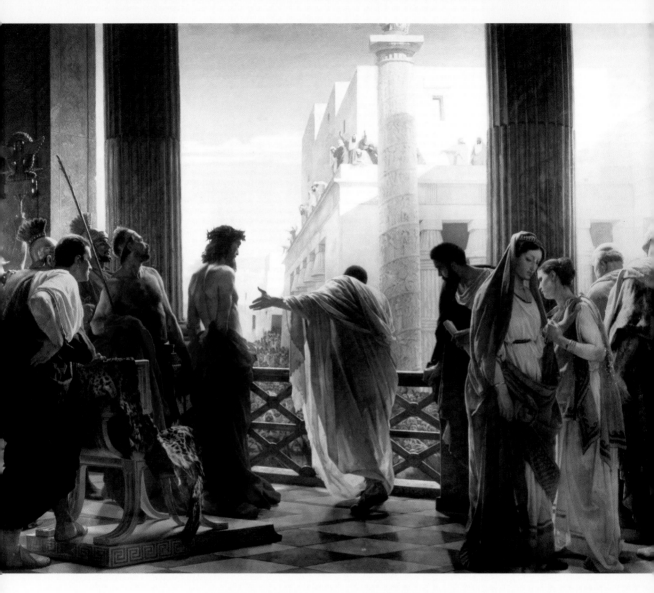

Ecce Homo, by Antonio Ciseri (1821–1891)

My kingdom is not of this world: if my kingdom were of this world, then would my servants fight, that I should not be delivered to the Jews: but now is my kingdom not from hence.

Pilate therefore said unto him, Art thou a king then? Jesus answered,

Thou sayest that I am a king. To this end was I born, and for this cause came I into the world, that I should bear witness unto the truth. Every one that is of the truth heareth my voice.

Pilate saith unto him, What is truth? And when he had said this, he went out again unto the Jews, and saith unto them, I find in him no fault at all. But the chief priests and elders cried out the more, saying, Let him be crucified. When Pilate saw that he could prevail nothing, but that rather a tumult was made, he took water, and washed his hands before the multitude, saying, I am innocent of the blood of this just person: see ye to it.

Then the soldiers of the governor took Jesus into the common hall, and gathered unto him the whole band of soldiers.

And they stripped him, and put on him a scarlet robe. And when they had platted a crown of thorns, they put it upon his head, and a reed in his right hand: and they bowed the knee before him, and mocked him, saying, Hail, King of the Jews! And they spit upon him, and took the reed, and smote him on the head.

Then came Jesus forth, wearing the crown of thorns. And Pilate saith unto them, Behold the man!

FROM THE GOSPEL OF ST MATTHEW, CHAPTER 27, AND THE GOSPEL OF ST JOHN, CHAPTERS 18, 19

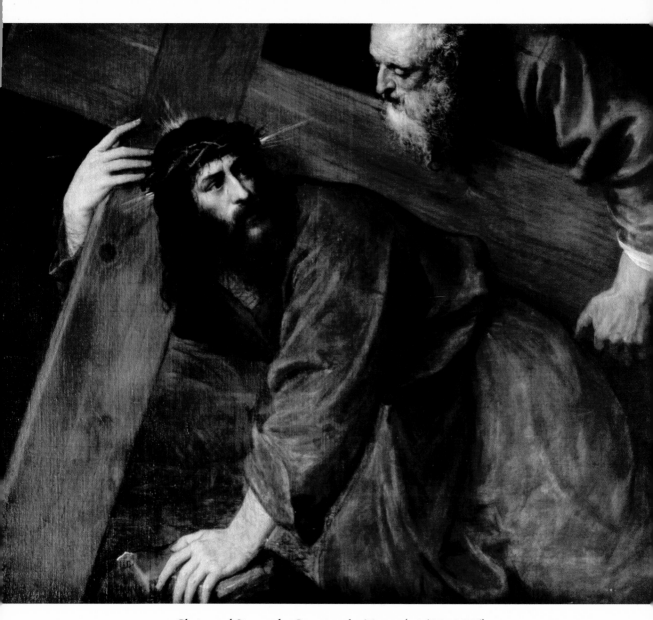

Christ and Simon the Cyrenian, by Titian (*c.*1489–1576)

THE CRUCIFIXION

As they led him away, they laid hold upon one Simon, a Cyrenian, coming out of the country, and on him they laid the cross, that he might bear it after Jesus. And there followed him a great company of people, and of women, which also bewailed and lamented him.

And there were also two other malefactors, led with him to be put to death. And when they were come to the place, which is called Calvary, there they crucified him, and the malefactors, one on the right hand, and the other on the left. Then said Jesus, Father, forgive them; for they know not what they do.

And they parted his raiment, and cast lots. And the people stood beholding. And the rulers also with them derided him, saying, He saved others; let him save himself, if he be Christ, the chosen of God. And the soldiers also mocked him, coming to him, and offering him vinegar, And saying, If thou be the king of the Jews, save thyself. And a superscription also was written over him in letters of Greek, and Latin, and Hebrew, THIS IS THE KING OF THE JEWS.

And one of the malefactors which were hanged railed on him, saying, If thou be Christ, save thyself and us. But the other answering rebuked him. And he said unto Jesus, Lord, remember me when thou comest into thy kingdom. And Jesus said unto him, Verily I say unto thee, To day shalt thou be with me in paradise.

Now from the sixth hour there was darkness over all the land unto the ninth hour. And about the ninth hour Jesus cried with a loud voice, saying, Eli, Eli, lama sabachthani? that is to say, My God, my God, why hast thou forsaken me?

Some of them that stood there, when they heard that, said, This man calleth for Elias. And straightway one of them ran, and took a spunge, and filled it with vinegar, and put it on a reed, and gave him to drink. And when Jesus had cried with a loud voice, he said, Father, into thy hands I commend my spirit: and having said thus, he gave up the ghost.

FROM THE GOSPEL OF ST LUKE, CHAPTER 23
AND THE GOSPEL OF ST MATTHEW, CHAPTER 27

Crucifixion, June 2008, by Craigie Aitchison (1926–2009)

The crucifixion is the great Christian emblem. It marks out the presence of a church, it hangs on the walls of Christian homes, it is printed on prayer books, it is held to the heart of the dying and needy and believers generally. In art, the tendency is often to make very vivid the terrible suffering so willingly undergone for our sake. This is very hard to look at: here is one we love, dying of torture. There are a few crucifixions that stress the inner truth of this death: that Jesus accepted with enormous happiness that he had accomplished all that his Father willed. Shortly before his death, Craigie Aitchison painted this most extraordinary of crucifixions. The world has been reduced to absolutes, in which only nature is innocent. The earth has become desert, yet from the desert Jesus is drawing new life, the scarlet of a poppy. The very presence of the cross has already created a strip of living green against which we can make out the tremulous figure of an animal, Aitchison's beloved Bedlington dog. But above these regulated strips of land, into the immense darkness of the night of our evil, soars Christ on the cross, a luminous body blazing with the fire of love. His features are consumed in the intensity of his passionate sacrifice. Over his head hovers the skeletal outline of the Holy Spirit. There are stars in the sky catching fire from the fire of Jesus, and we see the great curve of the rainbow, which God promised would be a sign of his covenant with humankind. Aitchison is showing us not what the crucifixion looked like, but what it truly meant.

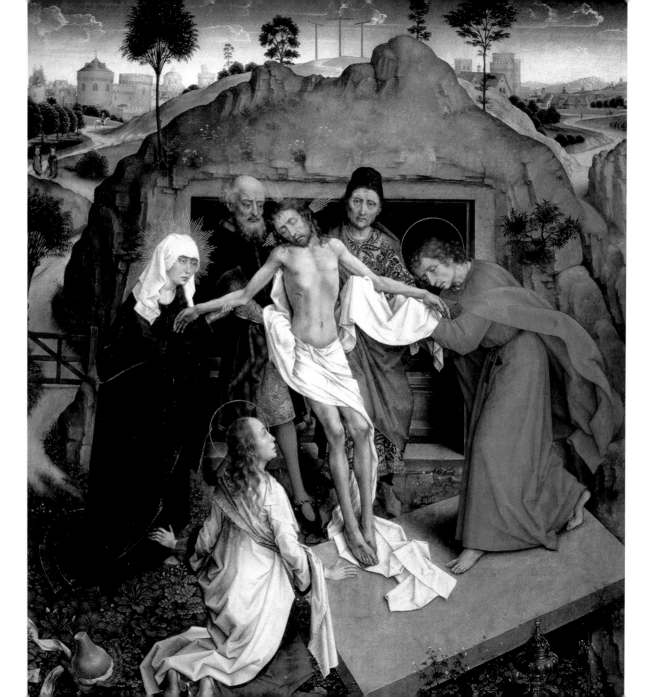

The entombment

And after this Joseph of Arimathaea, being a disciple of Jesus, but secretly for fear of the Jews, besought Pilate that he might take away the body of Jesus: and Pilate gave him leave. He came therefore, and took the body of Jesus. And there came also Nicodemus, which at the first came to Jesus by night, and brought a mixture of myrrh and aloes, about an hundred pound weight. Then took they the body of Jesus, and wound it in linen clothes with the spices, as the manner of the Jews is to bury. Now in the place where he was crucified there was a garden; and in the garden a new sepulchre, wherein was never man yet laid. There laid they Jesus therefore because of the Jews' preparation day; for the sepulchre was nigh at hand.

From the Gospel of St John, chapter 19

Opposite: *The Entombment of Christ*, by Rogier van der Weyden (*c*.1399–1464)

27. The defeat of death

After the darkness of the Passion, there is almost a springtime lightness about the resurrection stories. Jesus had promised his friends that he would rise from the dead, yet not one of them understood how literal and how tremendous was this promise. The central belief of Christianity is not that Jesus died, but that Jesus died and rose again. He conquered death. He proved that he would go into death and come out into eternal life, and that he would take us in our turn, with him. The resurrection stories show the early Christians struggling to come to terms with what has happened. The meaning of human life has changed: it will not end with death. It is Mary Magdalene who first encounters the risen Jesus, bearing his wounds and yet radiantly, overwhelmingly alive. The two grieving disciples, who had no notion of the resurrection, have the extraordinary experience of walking with Jesus along the road to Emmaus, and hearing from him how the Messiah could only come to glory through suffering. (Suffering has ceased to be pointless, it can be united with the suffering of Jesus.) When the apostles saw him, it took them utterly by surprise. They did then believe, and we have the touching story of the absent Thomas, who felt he could not believe unless he saw. Here Jesus has a word of comfort for all of us who do not see: he says that our condition, believing without visible proof, is the greater blessedness.

The resurrection

In the end of the sabbath, as it began to dawn toward the first day of the week, came Mary Magdalene and the other Mary to see the sepulchre. And, behold, there was a great earthquake: for the angel of the Lord descended from heaven, and came and rolled back the stone from the door, and sat upon it. His countenance was like lightning, and his raiment white as snow: And for fear of him the keepers did shake, and became as dead men. And the angel answered and said unto the women,

> Fear not ye: for I know that ye seek Jesus, which was crucified. He is not here: for he is risen, as he said. Come, see the place where the Lord lay. And go quickly, and tell his disciples that he is risen from the dead; and, behold, he goeth before you into Galilee; there shall ye see him: lo, I have told you.

From the Gospel of St Matthew, chapter 28

Touch me not

The first day of the week cometh Mary Magdalene early, when it was yet dark, unto the sepulchre, and seeth the stone taken away from the sepulchre. Then she runneth, and cometh to Simon Peter, and to the other disciple, whom Jesus loved, and saith unto them, They have taken away the Lord out of the sepulchre, and we know not where they have laid him. Peter therefore went forth, and that other disciple, and came to the sepulchre. So they ran both together: and the other disciple did outrun Peter, and came first to the sepulchre. And he stooping down, and looking in, saw the linen clothes lying; yet went he not in.

Then cometh Simon Peter following him, and went into the sepulchre, and seeth the linen clothes lie, And the napkin, that was about his head, not lying with the linen clothes, but wrapped together in a place by itself. Then went in also that other disciple, which came first to the sepulchre, and he saw, and believed.

Then the disciples went away again unto their own home. But Mary stood without at the sepulchre weeping: and as she wept, she stooped down, and looked into the sepulchre, And seeth two angels in white sitting, the one at the head, and the other at the feet, where the body of Jesus had lain. And they say unto her, Woman, why weepest thou? She saith unto them, Because they have taken away my Lord, and I know not where they have laid him. And when she had thus said, she turned herself back, and saw Jesus standing, and knew not that it was Jesus.

Jesus saith unto her, Woman, why weepest thou? Whom seekest thou? She, supposing him to be the gardener, saith unto him, Sir, if thou have borne him hence, tell me where thou hast laid him, and I will take him away. Jesus saith unto her, Mary. She turned herself, and saith unto him, Rabboni; which is to say, Master. Jesus saith unto her,

> Touch me not; for I am not yet ascended to my Father: but go to my brethren, and say unto them, I ascend unto my Father, and your Father; and to my God, and your God.

FROM THE GOSPEL OF ST JOHN, CHAPTER 20

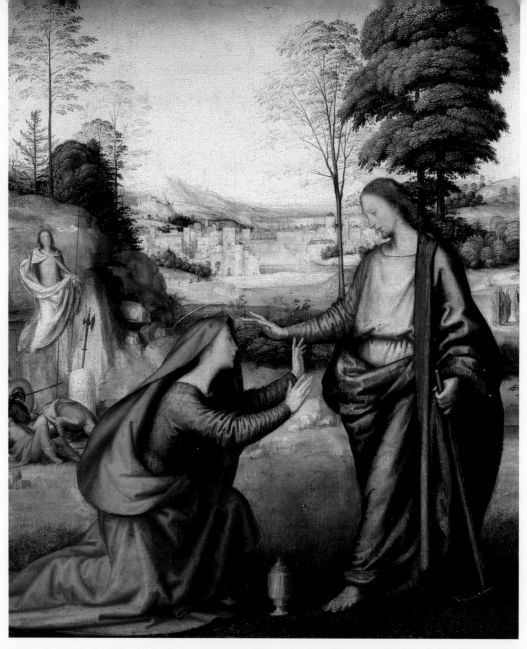

Noli me Tangere, by Fra Bartolommeo (1472–1517)

THE SUPPER AT EMMAUS

Behold, two of them went that same day to a village called Emmaus, which was from Jerusalem about threescore furlongs. And they talked together of all these things which had happened. And it came to pass, that, while they communed together and reasoned, Jesus himself drew near, and went with them. But their eyes were holden that they should not know him. And he said unto them, What manner of communications are these that ye have one to another, as ye walk, and are sad? And the one of them, whose name was Cleopas, answering said unto him, Art thou only a stranger in Jerusalem, and hast not known the things which are come to pass therein these days? And he said unto them, What things? And they said unto him,

> Concerning Jesus of Nazareth, which was a prophet mighty in deed and word before God and all the people: and how the chief priests and our rulers delivered him to be condemned to death, and have crucified him. But we trusted that it had been he which should have redeemed Israel.

Then he said unto them, O fools, and slow of heart to believe all that the prophets have spoken: Ought not Christ to have suffered these things, and to enter into his glory? And beginning at Moses and all the prophets, he expounded unto them in all the scriptures the things concerning himself.

And they drew nigh unto the village, whither they went: and he made as though he would have gone further. But they constrained him, saying, Abide with us: for it is toward evening, and the day is far spent. And he went in to tarry with them. And it came to pass, as he sat at meat with them, he took bread, and blessed it, and brake, and gave to them. And their eyes were opened, and they knew him; and he vanished out of their sight. And they said one to another, Did not our heart burn within us, while he talked with us by the way, and while he opened to us the scriptures?

FROM THE GOSPEL OF ST LUKE, CHAPTER 24

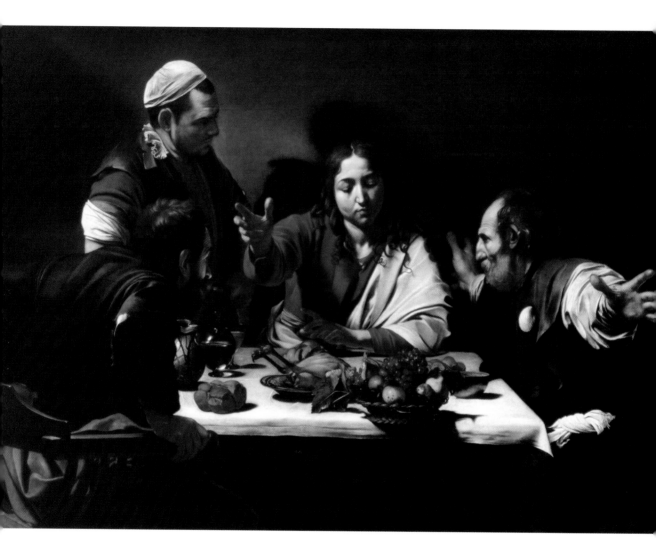

The Supper at Emmaus, by Michelangelo Mirisi da Caravaggio (1571–1610)

As they drew nearer to Emmaus, the stranger who was accompanying the two disciples made as if to leave them. They begged him to join them for supper. No artist, no mind however imaginative, can picture the appearance of one who has risen from the dead. These two did not recognize Jesus; they only begged him to stay because they were so engrossed by his conversation. It was only when they sat together at table and Jesus blessed the bread and broke it, that they suddenly recognized what must have been a characteristic gesture. Breaking the bread and blessing it: that is the Eucharist. It is how the Eucharist is celebrated to this day, and always will be. For us too, Jesus reveals himself in the 'breaking of the bread', though as we expect it, we are not astonished as are these two disciples. Better perhaps if we did feel astonishment, because the eucharistic sacrifice is the most overwhelming of sacred gifts. Caravaggio does not paint Jesus as is customary, lightly bearded, grave and compassionate of face. That Jesus they would have recognized. But this is a Jesus who is eternally young, though still utterly the same.

DOUBTING THOMAS

They rose up the same hour, and returned to Jerusalem, and found the eleven gathered together. And they told what things were done in the way, and how he was known of them in breaking of bread. And as they thus spake, Jesus himself stood in the midst of them, and saith unto them, Peace be unto you. But Thomas, one of the twelve, called Didymus, was not with them when Jesus came. The other disciples therefore said unto him, We have seen the Lord. But he said unto them, Except I shall see in his hands the print of the nails, and put my finger into the print of the nails, and thrust my hand into his side, I will not believe.

And after eight days again his disciples were within, and Thomas with them: then came Jesus, the doors being shut, and stood in the midst, and said, Peace be unto you. Then saith he to Thomas, Reach hither thy finger, and behold my hands; and reach hither thy hand, and thrust it into my side: and be not faithless, but believing. And Thomas answered and said unto him, My Lord and my God.

FROM THE GOSPEL OF ST LUKE, CHAPTER 24, AND THE GOSPEL OF ST JOHN, CHAPTER 20

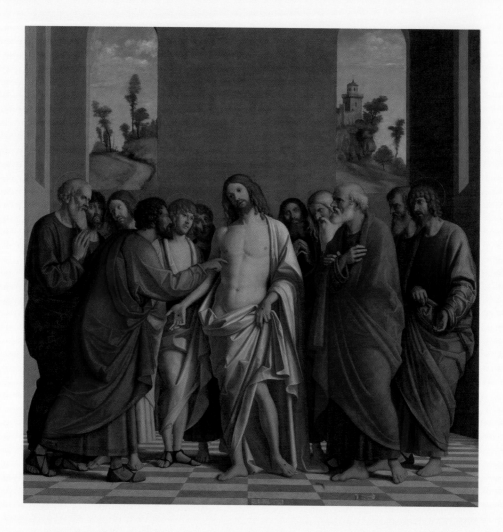

The Incredulity of Saint Thomas, by Cima da Conegliano (*c.*1459–*c.*1517)

28. The Church is born

Jesus of course founded the Church, in the sense that he drew together a body of apostles and chose Peter as their head. This 'little flock', as he called them, were those to whom he had poured out the riches of his teaching. He called them his 'friends', because he had shared with them everything that he received from the Father. Yet this little group was not 'the Church' in the sense we know it today. They had much to experience and suffer before there was even the beginning of a solid body of believers. (We sometimes forget that it is this body of believers that is the Church, and religious authority – the hierarchy – is not the Church but merely part of it.) First, Jesus had to end his stay on earth, by the Ascension, though he had promised that his Spirit, the Holy Spirit, would always be with the Church, strengthening it and enlightening it. In the end, however long it takes, the Church will always get it right – patience is a great virtue. Christians show their faith by being willing to die for it, and this passionate conviction dominates the life and the thinking of Saul, who becomes Paul. It is he, more than any of the apostles, who forms the early faithful into what is recognizably a Church.

The Ascension

After that Jesus through the Holy Ghost had given commandments unto the apostles he shewed himself alive after his passion by many infallible proofs, being seen of them forty days: and, being assembled together with them, commanded them that they should not depart from Jerusalem, but wait for the promise of the Father, which, saith he, ye have heard of me.

And when he had spoken these things, while they beheld, he was taken up; and a cloud received him out of their sight.

FROM THE ACTS OF THE APOSTLES, CHAPTER 1

The Day of Pentecost

When the day of Pentecost was fully come, they were all with one accord in one place. And suddenly there came a sound from heaven as of a rushing mighty wind, and it filled all the house where they were sitting. And there appeared unto them cloven tongues like as of fire, and it sat upon each of them. And they were all filled with the Holy Ghost, and began to speak with other tongues, as the Spirit gave them utterance.

And there were dwelling at Jerusalem Jews, devout men, out of every nation under

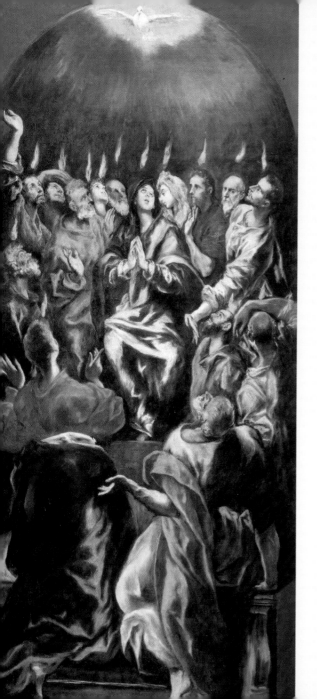

Pentecost, by El Greco (1551–1614)

The coming of the Holy Spirit is the fulfilment of the Incarnation. God was visible among us for only a few decades, but because Jesus sent us the Spirit, the third person of the blessed Trinity, he remains active but invisible. When Jesus was born, there were angels singing in the heavens and proclaiming the wonder to the shepherds. When he sends us his Holy Spirit, there are far more dramatic signs: a great wind and parted tongues of fire and the strange ability to speak in tongues. This was an experience unlike any other in the Scriptures. The apostles (always shown in art with Mary) were drawn out of themselves into the intensity of God in an indescribable fashion. El Greco is the artist most able to convey this experience. His style is unmistakable, with his elongated figures and swirling colours. Here we feel that the figures are elongated because they are being drawn up to that luminous dove above them, and the unrest of their bodies and their garments is occasioned by the mighty wind of divine power. It is Mary who seems able to look most directly at this incursion of fiery love, because she is already profoundly united to God. But all the others are drawn according to their own capacity. And so it will be with us. We will receive the Spirit of love in accordance with our desire for him.

heaven. Now when this was noised abroad, the multitude came together, and were confounded, because that every man heard them speak in his own language. And they were all amazed and marvelled, saying one to another, Behold, are not all these which speak Galilaeans? And how hear we every man in our own tongue, wherein we were born? And they were all amazed, and were in doubt, saying one to another, What meaneth this? Others mocking said, These men are full of new wine.

But Peter, standing up with the eleven, lifted up his voice, and said unto them,

> Ye men of Judaea, and all ye that dwell at Jerusalem, be this known unto you, and hearken to my words: for these are not drunken, as ye suppose, seeing it is but the third hour of the day. But this is that which was spoken by the prophet Joel; And it shall come to pass in the last days, saith God, I will pour out of my Spirit upon all flesh: and your sons and your daughters shall prophesy, and your young men shall see visions, and your old men shall dream dreams: and it shall come to pass, that whosoever shall call on the name of the Lord shall be saved.

And with many other words did he testify and exhort, saying, Save yourselves from this untoward generation. Then they that gladly received his word were baptized: and the same day there were added unto them about three thousand souls.

FROM THE ACTS OF THE APOSTLES, CHAPTER 2

THE STONING OF STEPHEN

In those days, the word of God increased; and the number of the disciples multiplied in Jerusalem greatly; and a great company of the priests were obedient to the faith. And Stephen, full of faith and power, did great wonders and miracles among the people. Then there arose certain of the synagogue, which said, We have heard him speak blasphemous words against Moses, and against God. And they stirred up the people, and the elders, and the scribes, and came upon him, and caught him, and brought him to the council.

And all that sat in the council, looking stedfastly on him, saw his face as it had been the face of an angel. Then said the high priest, Are these things so? And he said,

> Ye do always resist the Holy Ghost: as your fathers did, so do ye. Which

of the prophets have not your fathers persecuted? And they have slain them which shewed before of the coming of the Just One; of whom ye have been now the betrayers and murderers.

When they heard these things, they were cut to the heart, and they gnashed on him with their teeth. But he, being full of the Holy Ghost, looked up stedfastly into heaven, and said, Behold, I see the heavens opened, and the Son of man standing on the right hand of God.

Then they cried out with a loud voice, and stopped their ears, and ran upon him with one accord, And cast him out of the city, and stoned him: and the witnesses laid down their clothes at a young man's feet, whose name was Saul. And they stoned Stephen, calling upon God, and saying, Lord, lay not this sin to their charge. And when he had said this, he fell asleep.

As for Saul, he made havock of the church, entering into every house, and haling men and women committed them to prison.

FROM THE ACTS OF THE APOSTLES, CHAPTERS 6—7, 8

THE CONVERSION OF SAUL

Saul, yet breathing out threatenings and slaughter against the disciples of the Lord, went unto the high priest, and desired of him letters to Damascus to the synagogues, that if he found any of this way, whether they were men or women, he might bring them bound unto Jerusalem.

And as he journeyed, he came near Damascus: and suddenly there shined round about him a light from heaven: and he fell to the earth, and heard a voice saying unto him, Saul, Saul, why persecutest thou me? And he said, Who art thou, Lord? And the Lord said, I am Jesus whom thou persecutest: it is hard for thee to kick against the pricks. And he trembling and astonished said, Lord, what wilt thou have me to do? And the Lord said unto him, Arise, and go into the city, and it shall be told thee what thou must do. And the men which journeyed with him stood speechless, hearing a voice, but seeing no man.

And Saul arose from the earth; and when his eyes were opened, he saw no man: but they led him by the hand, and brought

him into Damascus. And he was three days without sight, and neither did eat nor drink.

And there was a certain disciple at Damascus, named Ananias; and to him said the Lord in a vision, Ananias. And he said, Behold, I am here, Lord. And the Lord said unto him,

> Arise, and go into the street which is called Straight, and inquire in the house of Judas for one called Saul, of Tarsus: for, behold, he prayeth, and hath seen in a vision a man named Ananias coming in, and putting his hand on him, that he might receive his sight.

Then Ananias answered, Lord, I have heard by many of this man, how much evil he hath done to thy saints at Jerusalem: And here he hath authority from the chief priests to bind all that call on thy name. But the Lord said unto him, Go thy way: for he is a chosen vessel unto me. And Ananias went his way, and entered into the house; and putting his hands on him said, Brother Saul, the Lord, even Jesus, that appeared unto thee in the way as thou camest, hath sent me, that thou mightest

receive thy sight, and be filled with the Holy Ghost. And immediately there fell from his eyes as it had been scales: and he received sight forthwith, and arose, and was baptized.

Then was Saul certain days with the disciples which were at Damascus. And straightway he preached Christ in the synagogues, that he is the Son of God. And after that many days were fulfilled, the Jews took counsel to kill him: but their laying await was known of Saul. And they watched the gates day and night to kill him. Then the disciples took him by night, and let him down by the wall in a basket.

And when Saul was come to Jerusalem, he spake boldly in the name of the Lord Jesus, and disputed against the Grecians: but they went about to slay him. Which when the brethren knew, they brought him down to Caesarea, and sent him forth to Tarsus.

FROM THE ACTS OF THE APOSTLES, CHAPTER 9

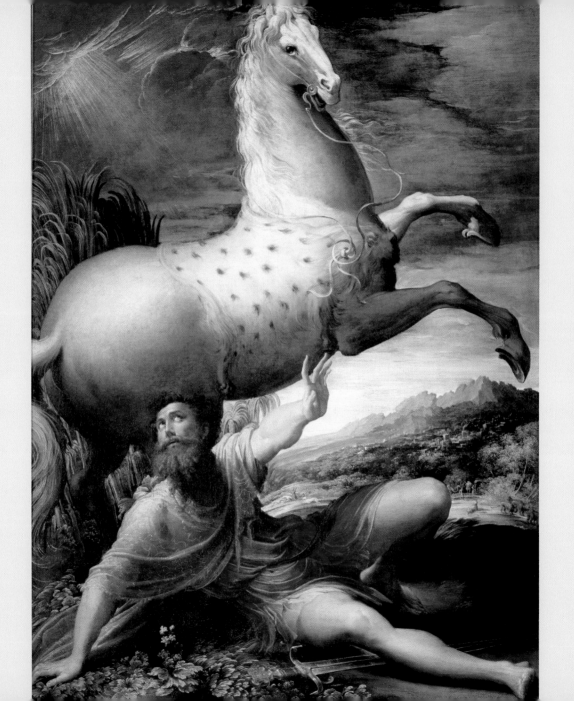

The Conversion of Saint Paul, by
Francesco Parmigianino (1503–1540)

Jesus 'founded' the Church, but it was
Paul who organized it. No one has ever
understood more deeply what Jesus
taught, and because of the passionate
devotion to Jesus that came from this
understanding, Paul was able to teach the
early converts. Yet it could so easily have
been otherwise. Before Paul encountered
the living Jesus, when he was still the
Jewish Saul, he rejected completely any
faith in this crucified man as the Messiah;
so one of the great pivotal events in
Christian history is Paul's conversion. It
seems to happen so suddenly, when he was
on his way to Damascus to urge on the
persecution of the early Church. He was
thrown to the ground, and artists always
consider this overthrow as taking place
from a horse. It is unlikely that Saul could
have afforded a horse, the steed of the
wealthy, and yet we relish the symbolism.
He is blinded, towered over by this great
prancing beast, and Jesus speaks to him.
Saul/Paul's instant acceptance of the voice
of Jesus suggests that his conversion was
not as sudden as it appears. Or rather, he
had always been seeking God, but in the
wrong place. It was not a conversion from
sinfulness but from mistaken devotion. If
he is to follow Jesus he must be humbled,
stripped of his strident self-confidence,
and that is precisely what Parmigianino
shows us. Stretched on the ground he is
lower than the animal, and yet his sightless
eyes are set on the infinite heaven above.

PAUL AND THE ATHENIANS

They that conducted Paul* brought him unto Athens: and his spirit was stirred in him, when he saw the city wholly given to idolatry. Then certain philosophers of the Epicureans, and of the Stoicks, encountered him. And they took him, and brought him unto Areopagus, saying, May we know what this new doctrine, whereof thou speakest, is? For thou bringest certain strange things to our ears: we would know therefore what these things mean. Then Paul stood in the midst of Mars' hill, and said,

> Ye men of Athens, I perceive that in all things ye are too superstitious. For as I passed by, and beheld your devotions, I found an altar with this inscription, TO THE UNKNOWN GOD. Whom therefore ye ignorantly worship, him declare I unto you.

> God that made the world and all things therein, seeing that he is Lord of heaven and earth, dwelleth not in temples made with hands; neither is worshipped with men's hands, as though he needed any thing, seeing he giveth to all life, and breath, and all things; for in him we live, and move, and have our being; as certain also of your own poets have said, For we are also his offspring.

> Forasmuch then as we are the offspring of God, we ought not to think that the Godhead is like unto gold, or silver, or stone, graven by art and man's device. And the times of this ignorance God winked at; but now commandeth all men every where to repent: because he hath appointed a day, in the which he will judge the world in righteousness by that man whom he hath ordained; whereof he hath given assurance unto all men, in that he hath raised him from the dead.

And when they heard of the resurrection of the dead, some mocked: and others said, We will hear thee again of this matter. So Paul departed from among them.

FROM THE ACTS OF THE APOSTLES, CHAPTER 17

* After his conversion, Saul became known as Paul (Acts 13.9)

29. EARLY CHRISTIAN WISDOM

In the Gospels, Jesus meets with little understanding, even from the apostles. Although they did not understand, they remembered, thank God, or we would not have the Gospels. But they were slow to enter into the deep meaning of what Jesus had said. It is a source of unending wonder, and infinite cause for gratitude, that when Jesus sent the Holy Spirit, that Spirit found so many eager hearts that could enter into this sacred teaching. Within a few years of the Crucifixion, Paul was writing his extraordinary letters to the churches that were springing up in the countries around Palestine. No theologian in the centuries ahead is more profound than Paul, but he is not alone among the apostles in the depth of his wisdom. There is John, another supreme theologian, and the great and tender anonymous Christian who wrote the letter to the Hebrews. So rich is this early Christian wisdom that one cannot really 'read' it. After every line, or even every few words, one has to stop and ponder. These writers hold out a vision of what it means to be completely possessed by the love of God. It is as if they were reverently unpacking the compressed wisdom of the words of Jesus. He spoke, they write; but they write only to bring us into living contact with what he spoke.

GOD'S LOVING PURPOSE

I reckon that the sufferings of this present time are not worthy to be compared with the glory which shall be revealed in us. For we know that the whole creation groaneth and travaileth in pain together until now. And not only they, but ourselves also, which have the firstfruits of the Spirit, even we ourselves groan within ourselves, waiting for the adoption, to wit, the redemption of our body. And we know that all things work together for good to them that love God, to them who are the called according to his purpose. For whom he did foreknow, he also did predestinate to be conformed to the image of his Son, that he might be the firstborn among many brethren.

What shall we then say to these things? If God be for us, who can be against us? Who shall separate us from the love of Christ? Shall tribulation, or distress, or persecution, or famine, or nakedness, or peril, or sword? Nay, in all these things we are more than conquerors through him that loved us. For I am persuaded, that neither death, nor life, nor angels,

nor principalities, nor powers, nor things present, nor things to come, nor height, nor depth, nor any other creature, shall be able to separate us from the love of God, which is in Christ Jesus our Lord.

FROM THE EPISTLE OF ST PAUL TO THE ROMANS, CHAPTER 8

THE GREATEST GIFT

Though I speak with the tongues of men and of angels, and have not charity, I am become as sounding brass, or a tinkling cymbal. And though I have the gift of prophecy, and understand all mysteries, and all knowledge; and though I have all faith, so that I could remove mountains, and have not charity, I am nothing. And though I bestow all my goods to feed the poor, and though I give my body to be burned, and have not charity, it profiteth me nothing.

Charity suffereth long, and is kind; charity envieth not; charity vaunteth not itself, is not puffed up, doth not behave itself unseemly, seeketh not her own, is not easily provoked, thinketh no evil; rejoiceth not in iniquity, but rejoiceth in the truth; beareth all things, believeth all things, hopeth all things, endureth all things. Charity never faileth: but whether there be prophecies, they shall fail; whether there be tongues, they shall cease; whether there be knowledge, it shall vanish away. For we know in part, and we prophesy in part. But when that which is perfect is come, then that which is in part shall be done away.

When I was a child, I spake as a child, I understood as a child, I thought as a child: but when I became a man, I put away childish things. For now we see through a glass, darkly; but then face to face: now I know in part; but then shall I know even as also I am known. And now abideth faith, hope, charity, these three; but the greatest of these is charity.

FROM THE FIRST EPISTLE OF ST PAUL TO THE CORINTHIANS, CHAPTER 13

THE CHRISTIAN HOPE

Now this I say, brethren, that flesh and blood cannot inherit the kingdom of God; neither doth corruption inherit incorruption. Behold, I shew you a mystery; We shall not all sleep, but we shall all be changed, in a moment, in the

twinkling of an eye, at the last trump: for the trumpet shall sound, and the dead shall be raised incorruptible, and we shall be changed. For this corruptible must put on incorruption, and this mortal must put on immortality. So when this corruptible shall have put on incorruption, and this mortal shall have put on immortality, then shall be brought to pass the saying that is written, Death is swallowed up in victory. O death, where is thy sting? O grave, where is thy victory? The sting of death is sin; and the strength of sin is the law. But thanks be to God, which giveth us the victory through our Lord Jesus Christ.

FROM THE FIRST EPISTLE OF ST PAUL TO THE CORINTHIANS, CHAPTER 15

THE GREAT HIGH PRIEST

God, who at sundry times and in divers manners spake in time past unto the fathers by the prophets, hath in these last days spoken unto us by his Son, whom he hath appointed heir of all things, by whom also he made the worlds; who being the brightness of his glory, and the express image of his person, and upholding all things by the word of his power, when he had by himself purged our sins, sat down on the right hand of the Majesty on high; being made so much better than the angels, as he hath by inheritance obtained a more excellent name than they.

For it became him, for whom are all things, and by whom are all things, in bringing many sons unto glory, to make the captain of their salvation perfect through sufferings. For verily he took not on him the nature of angels; but he took on him the seed of Abraham. Wherefore in all things it behoved him to be made like unto his brethren, that he might be a merciful and faithful high priest in things pertaining to God, to make reconciliation for the sins of the people. For in that he himself hath suffered being tempted, he is able to succour them that are tempted.

Seeing then that we have a great high priest, that is passed into the heavens, Jesus the Son of God, let us hold fast our profession. For we have not an high priest which cannot be touched with the feeling of our infirmities; but was in all points tempted like as we are, yet without sin. Let us therefore come boldly unto the throne of grace, that we may obtain mercy, and find grace to help in time of need.

FROM THE EPISTLE TO THE HEBREWS, CHAPTERS 1—2, 4

GOD IS LOVE

If we love one another, God dwelleth in us, and his love is perfected in us. And we have known and believed the love that God hath to us. God is love; and he that dwelleth in love dwelleth in God, and God in him. There is no fear in love; but perfect love casteth out fear: because fear hath torment. He that feareth is not made perfect in love. We love him, because he first loved us. If a man say, I love God, and hateth his brother, he is a liar: for he that loveth not his brother whom he hath seen, how can he love God whom he hath not seen? And this commandment have we from him, that he who loveth God love his brother also.

FROM THE FIRST EPISTLE OF ST JOHN, CHAPTER 4

SOME APOSTOLIC APHORISMS

God is no respecter of persons.
Acts 10.34

It is more blessed to give than to receive.
Acts 20.35

The wages of sin is death; but the gift of God is eternal life.
Romans 6.23

The fruit of the spirit is love, joy, peace, longsuffering, gentleness, goodness, faith, meekness, temperance: against such there is no law.
Galatians 5.22–23

Whatsoever a man soweth, that shall he also reap.
Galatians 6.7

Let not the sun go down upon your wrath.
Ephesians 4.26

The love of money is the root of all evil.
1 Timothy 6.10

Unto the pure all things are pure.
Titus 1.15

Let brotherly love continue.
Hebrews 13.1

Be not forgetful to entertain strangers: for thereby some have entertained angels unawares.
Hebrews 13.2

Be swift to hear, slow to speak.
James 1.19

Charity shall cover a multitude of sins.
1 Peter 4.8

30. Visions of the End

There is nothing in the Scriptures, either the Old or New Testament, that seems as bizarre to us as the Books of Prophecy. They stand out for what we can only call their weirdness, but this is because the authors are writing in a literary genre with which we are mostly unfamiliar. When John speaks of crowns and beasts and bottomless pits, he is using poetic language to refer to political events. The Christians, like the Jews before them, were menaced by a world in which they had no power. Yet they knew that the real power was with God, so they could make the chaos of the world intelligible to themselves by transforming it into fantasy and resolving it in the triumph of God. John's Book of Revelation can be overlooked in our search for spiritual wisdom, if we concentrate too much upon the symbols. Everything in the New Testament is about Jesus. Here, it may be more oblique at times, and yet the very unreality of the imagery can make the beauty of the Christian message shine all the more clearly.

The throne of God

I looked, and, behold, a door was opened in heaven. And immediately I was in the spirit: and, behold, a throne was set in heaven, and one sat on the throne. And round about the throne were four and twenty seats: and upon the seats I saw four and twenty elders sitting, clothed in white raiment; and they had on their heads crowns of gold.

And before the throne there was a sea of glass like unto crystal: and in the midst of the throne, and round about the throne, were four beasts full of eyes before and behind.

And the first beast was like a lion, and the second beast like a calf, and the third beast had a face as a man, and the fourth beast was like a flying eagle. And the four beasts had each of them six wings about him; and they were full of eyes within: and they rest not day and night, saying, Holy, holy, holy, Lord God Almighty, which was, and is, and is to come.

From the Revelation of St John, chapter 4

The four horsemen

And I saw in the right hand of him that sat on the throne a book written within and

on the backside, sealed with seven seals. And I saw a strong angel proclaiming with a loud voice, Who is worthy to open the book, and to loose the seals thereof? And I beheld, and, lo, in the midst of the throne and of the four beasts, and in the midst of the elders, stood a Lamb as it had been slain, having seven horns and seven eyes, which are the seven Spirits of God sent forth into all the earth.

And I saw when the Lamb opened one of the seals, and I heard, as it were the noise of thunder, one of the four beasts saying, Come and see. And I saw, and behold a white horse: and he that sat on him had a bow; and a crown was given unto him: and he went forth conquering, and to conquer.

And when he had opened the second seal, I heard the second beast say, Come and see. And there went out another horse that was red: and power was given to him that sat thereon to take peace from the earth, and that they should kill one another: and there was given unto him a great sword.

And when he had opened the third seal, I heard the third beast say, Come and see. And I beheld, and lo a black horse; and he that sat on him had a pair of balances in his hand. And I heard a voice in the midst of the four beasts say, A measure of wheat for a penny, and three measures of barley for a penny; and see thou hurt not the oil and the wine.

And when he had opened the fourth seal, I heard the voice of the fourth beast say, Come and see. And I looked, and behold a pale horse: and his name that sat on him was Death, and Hell followed with him.

From the Revelation of St John, chapters 5, 6

The final battle

And I saw three unclean spirits, working miracles, which go forth unto the kings of the earth and of the whole world, to gather them to the battle of that great day of God Almighty. And he gathered them together into a place called in the Hebrew tongue Armageddon.

And I saw heaven opened, and behold a white horse; and he that sat upon him was called Faithful and True, and in righteousness he doth judge and make war. And the armies which were in heaven followed him upon white horses, clothed

in fine linen, white and clean. And I saw the kings of the earth, and their armies, gathered together to make war against him that sat on the horse, and against his army.

And I saw an angel come down from heaven, having the key of the bottomless pit and a great chain in his hand. And he laid hold on the dragon, that old serpent, which is the Devil, and Satan, and bound him a thousand years, And cast him into the bottomless pit, and shut him up, and set a seal upon him, that he should deceive the nations no more.

FROM THE REVELATION OF ST JOHN, CHAPTERS 16, 19, 20

THE LAST JUDGEMENT

I saw a great white throne, and I saw the dead, small and great, stand before God; and the books were opened: and another book was opened, which is the book of life: and the dead were judged out of those things which were written in the books, according to their works. And the sea gave up the dead which were in it; and death and hell delivered up the dead which were in them: and they were judged every man

according to their works. And death and hell were cast into the lake of fire.

FROM THE REVELATION OF ST JOHN, CHAPTER 20

THE CELESTIAL CITY

I saw a new heaven and a new earth: for the first heaven and the first earth were passed away; and there was no more sea. And I heard a great voice out of heaven saying,

> Behold, the tabernacle of God is with men, and he will dwell with them, and they shall be his people, and God himself shall be with them, and be their God. And God shall wipe away all tears from their eyes; and there shall be no more death, neither sorrow, nor crying, neither shall there be any more pain: for the former things are passed away.

And there came unto me one of the seven angels. And he carried me away in the spirit to a great and high mountain, and shewed me that great city, the holy Jerusalem, descending out of heaven from God. And the foundations of the wall of the city were garnished with all manner

of precious stones. The first foundation was jasper; the second, sapphire; the third, a chalcedony; the fourth, an emerald; the fifth, sardonyx; the sixth, sardius; the seventh, chrysolite; the eighth, beryl; the ninth, topaz; the tenth, a chrysoprasus; the eleventh, a jacinth; the twelfth, an amethyst. And the twelve gates were twelve pearls; every several gate was of one pearl: and the street of the city was pure gold, as it were transparent glass. And I saw no temple therein: for the Lord God Almighty and the Lamb are the temple of it. And the city had no need of the sun, neither of the moon, to shine in it: for the glory of God did lighten it, and the Lamb is the light thereof.

And the nations of them which are saved shall walk in the light of it: and the kings of the earth do bring their glory and honour into it. And the gates of it shall not be shut at all by day: for there shall be no night there. And they shall bring the glory and honour of the nations into it. And there shall in no wise enter into it any thing that defileth, neither whatsoever worketh abomination, or maketh a lie: but they which are written in the Lamb's book of life.

And he shewed me a pure river of water of life, clear as crystal, proceeding out of the throne of God and of the Lamb. In the midst of the street of it, and on either side of the river, was there the tree of life, which bare twelve manner of fruits, and yielded her fruit every month: and the leaves of the tree were for the healing of the nations. And there shall be no more curse. And he said unto me,

I am Alpha and Omega, the beginning and the end, the first and the last. Blessed are they that do his commandments, that they may have right to the tree of life, and may enter in through the gates into the city.

He which testifieth these things saith, Surely I come quickly. Amen. Even so, come, Lord Jesus.

FROM THE REVELATION OF ST JOHN, CHAPTERS 21, 22

Saint John the Evangelist on Patmos, by Hans Memling (1433–1494)

Whether the John who wrote the Book of Revelation is the same John who wrote the Gospel is uncertain: scholars on the whole think not. But it is the vision itself that matters, not to whom it was given. After all, it was given for all of us, it is God's revelation, and John was merely the Christian whose heart was pure enough to see and record it. It was a tremulous vision, with wave after wave of events and images. Only the inspiration of the Holy Spirit would have enabled the visionary to order it and lay it out for his readers. Memling shows us a young John, alone on the little island of Patmos, and yet surrounded by an endless flow of the extraordinary. No one painting could touch on every element of this terrifying and yet consoling vision. John himself is not terrified, because his heart is set on the Lord Jesus as is clear from his touching last words: 'Come, Lord Jesus'. This is how the great book of the Bible ends. It culminates in this expression of humble and reverent longing. It is an expression of simple trust, because trust is the mark of our belief in the reality of God's fatherhood.

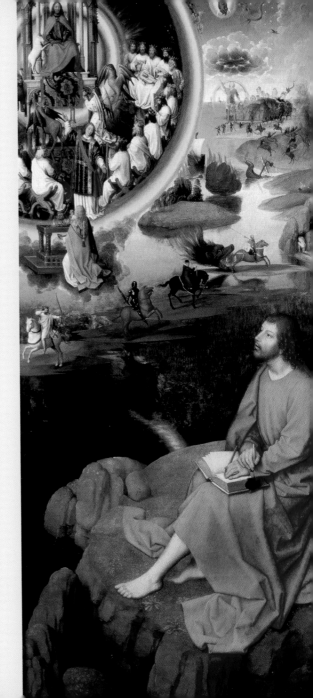

Picture acknowledgements

Page 1 *Creation of the Birds* (mosaic), Cathedral, Monreale, Italy, © 2011 Photo SCALA, Florence; **5** *God the Father Measuring the Universe*, from *The Bible Moralisée*, Vienna, Austrian National Library, photo: akg-images/Erich Lessing; **8** *Expulsion from Paradise*, by Masaccio, SuperStock/SuperStock; **11** *The Animals Entering the Ark*, by Jan Brueghel the Elder, Musée des Beaux-Arts, Pau, France/Giraudon/The Bridgeman Art Library; **15** *Trinity of the Old Testament*, by Andrei Rublev, Tretyakov State Gallery, Moscow, Russia, © 2011 Andrea Jemolo/SCALA, Florence; **19** *Eliezer and Rebekah*, by Nicolas Poussin, Peter Willi/SuperStock; **25** *Jacob Wrestles with the Angel*, by Eugène Delacroix, Fine Art Images/SuperStock; **29** *Joseph and Potiphar's Wife*, c.1630–32 (oil on canvas) by Gentileschi, Orazio (c.1563–c.1639) The Royal Collection, © 2011 Her Majesty Queen Elizabeth II/The Bridgeman Art Library; **38** *Moses and the Burning Bush*, by Raphael, Logge, The Vatican City, © 2011 Photo SCALA, Florence; **45** *Pharaoh's Hosts Engulfed in the Red Sea*, by Lucas Cranach the Elder, SuperStock/SuperStock; **49** *Moses with the Tables of the Law*, by Rembrandt van Rijn, Fine Art Images/SuperStock; **57** *The Death of Sisera*, by Palma Il Giovane (Jacopo Negretti), Musée d'Art Thomas Henry, Cherbourg, France/Giraudon/The Bridgeman Art Library; **63** *Samson and Delilah*, by Peter Paul Rubens, National Gallery, London, UK, © 2011 The National Gallery, London/SCALA, Florence; **69** *Summer (Ruth and Boaz)*, by Nicolas Poussin, Peter Willi/SuperStock; **78** *David and Goliath*, by Edgar Degas, Fitzwilliam Museum, University of Cambridge, UK/The Bridgeman Art Library; **83** *Bathsheba at her Bath*, by Rembrandt van Rijn, Peter Willi/SuperStock; **92** *The Queen of Sheba before Solomon*, by Konrad Witz, Image Asset Management Ltd/SuperStock; **97** *Elijah in the Wilderness*, by Dirk Bouts, Fine Art Images/SuperStock; **101** *Elijah Taken Up in a Chariot of Fire*, by Giuseppe Angeli, Samuel H. Kress Collection, image courtesy of the National Gallery of Art, Washington; **106** *Jonah and the Whale*, by Albert Herbert, Private Collection/England & Co. Gallery, London/The Bridgeman Art Library; **111** *Belshazzar's Feast*, by Rembrandt van Rijn, National Gallery, London, UK, © 2011 The National Gallery, London/SCALA, Florence; **120** *Job Being Scolded by his Wife*, by Albrecht Dürer, Städel Museum, Frankfurt am Main, © Städel Museum – ARTOTHEK; **127** *The Prophet Isaiah*, by Marc Chagall, Fine Art Images/SuperStock; **131** *Christ Crowned with Thorns*, by Hieronymus Bosch, Monasterio de El Escorial, Spain/The Bridgeman Art Library; **133** *Virgin and Child*, image courtesy of the Temple Gallery; **135** *The Annunciation*, predella panel from the St Lucy Altarpiece, by Domenico Veneziano, Fitzwilliam Museum, University of Cambridge, UK/The Bridgeman Art Library; **138** *The Mystic Nativity*, by Sandro Botticelli, Fine Art Images/SuperStock; **141** *Rest on the Flight Into Egypt*, by Orazio Gentileschi, Louvre, Paris, France, © 2011 Photo SCALA, Florence; **145** *The Baptism*

of Christ, by Piero della Francesca, National Gallery, London, UK, © 2011 The National Gallery, London/SCALA, Florence; **148** *Christ and the Samaritan Woman*, by Juan de Flandes, Peter Willi/SuperStock; **153** *Christ at the Sea of Galilee*, by Alessandro Magnasco, Samuel H. Kress Collection, image courtesy of the National Gallery of Art, Washington; **155** *Christ Healing the Blind*, by Nicolas Poussin, Peter Willi/SuperStock; **160** *Feast in the House of Simon the Pharisee*, by Peter Paul Rubens, Hermitage Museums, St Petersburg, Russia, © 2011 Photo SCALA, Florence; **162** *The Good Samaritan*, by Eugène Delacroix, Private Collection, © 2011 White Images/SCALA, Florence; **165** *The Return of the Prodigal Son*, by Rembrandt van Rijn, Hermitage Museums, St Petersburg, Russia, © 2011 Photo SCALA, Florence; **167** *Christ and the Adulterous Woman*, by Lorenzo Lotto, Louvre, Paris, France, © 2011 Photo SCALA, Florence; **170** *The Sower*, by Vincent van Gogh, Fine Art Images/SuperStock; **172** *Christ Blessing the Children*, by Nicolaes Maes, National Gallery, London, UK, © 2011 The National Gallery , London/SCALA, Florence; **177** *The Transfiguration*, by Duccio di Buoninsegna, Image Asset Management Ltd/SuperStock; **180** *The Raising of Lazarus*, by Sebastiano del Piombo, Fine Art Images/SuperStock; **183** *The Entry of Christ into Jerusalem*, by Pietro Lorenzetti, Fine Art Images/SuperStock; **186** *The Last Supper*, detail, central group with Christ, by Leonardo da Vinci, Milan, Monastery S. Maria delle Grazie, refectory, Photo: akg-images/Pietro Baguzzi; **189** *Christ in the Garden of Olives*, by Sandro Botticelli, Capilla Real, Granada, Spain, © 2011 Photo SCALA, Florence; **190** *The Betrayal of Christ*, by Giotto di Bondone, SuperStock/SuperStock; **194** *Ecce Homo*, by Antonio Ciseri, SuperStock/SuperStock; **196** *Christ and Simon the Cyrenian*, by Titian, SuperStock/SuperStock; **198** *Crucifixion, June 2008*, by Craigie Aitchison, courtesy of Timothy Taylor Gallery; **200** *The Entombment of Christ*, by Rogier van der Weyden, Fine Art Images/SuperStock; **204** *Noli me Tangere*, by Fra Bartolommeo, SuperStock/SuperStock; **206** *The Supper at Emmaus*, by Michelangelo Mirisi da Caravaggio, The Bridgeman Art Library, London/SuperStock; **208** *The Incredulity of Saint Thomas*, by Cima da Conegliano, The National Gallery, London, UK, © 2011 The National Gallery, London/SCALA, Florence; **210** *Pentecost*, by El Greco, Peter Willi/SuperStock; **214** *The Conversion of Saint Paul*, by Francesco Parmigianino, Vienna, Kunsthistorisches Museum, Photo: akg-images/Erich Lessing; **225** *Saint John the Evangelist on Patmos*, by Hans Memling, from the Mystic Marriage of St Catherine Triptych, Memling Museum, Bruges, Belgium/The Bridgeman Art Library.

Every effort has been made to acknowledge fully the sources of material reproduced in this book. The publisher apologizes for any omissions that may remain and, if notified, will ensure that full acknowledgements are made in a subsequent edition.